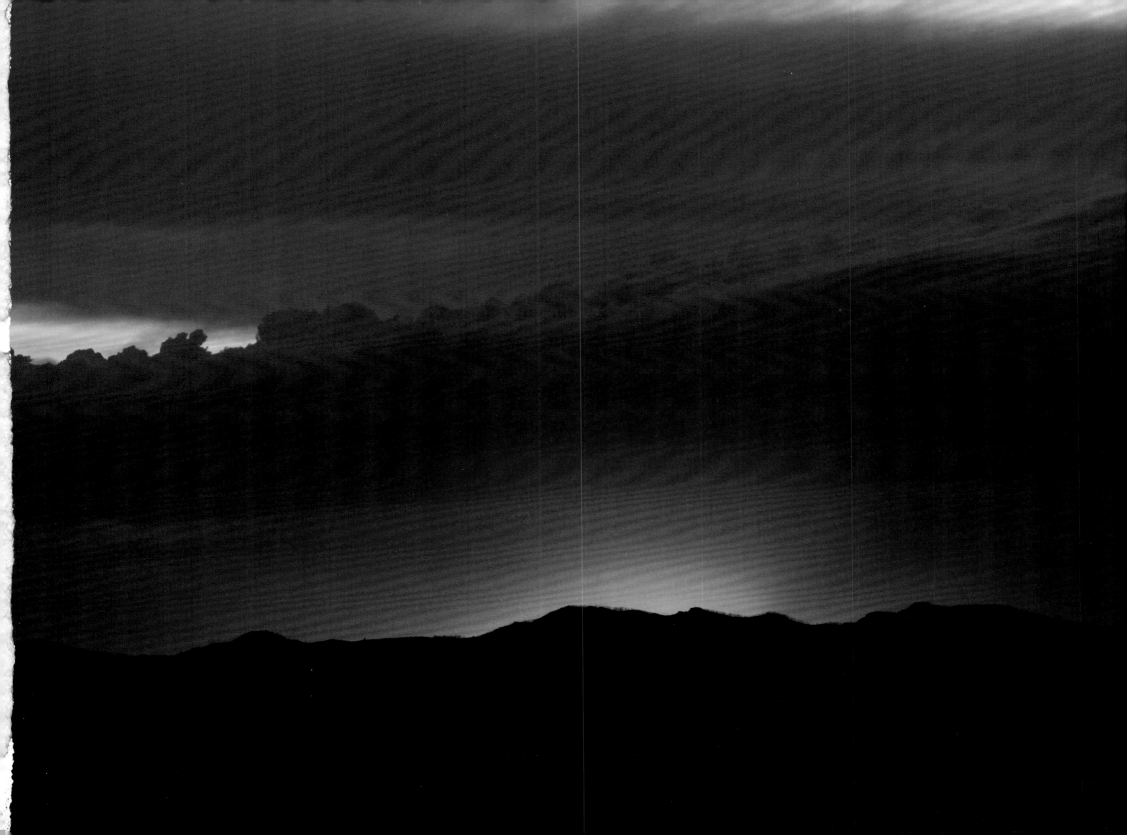

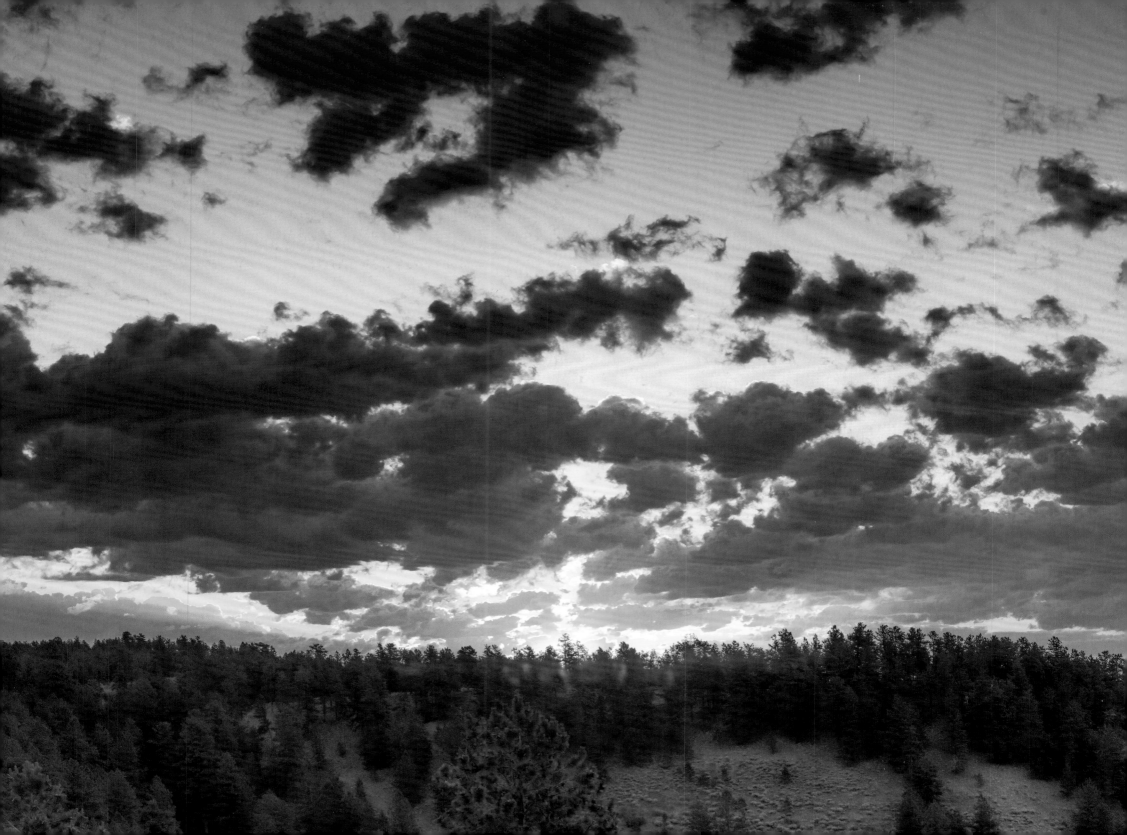

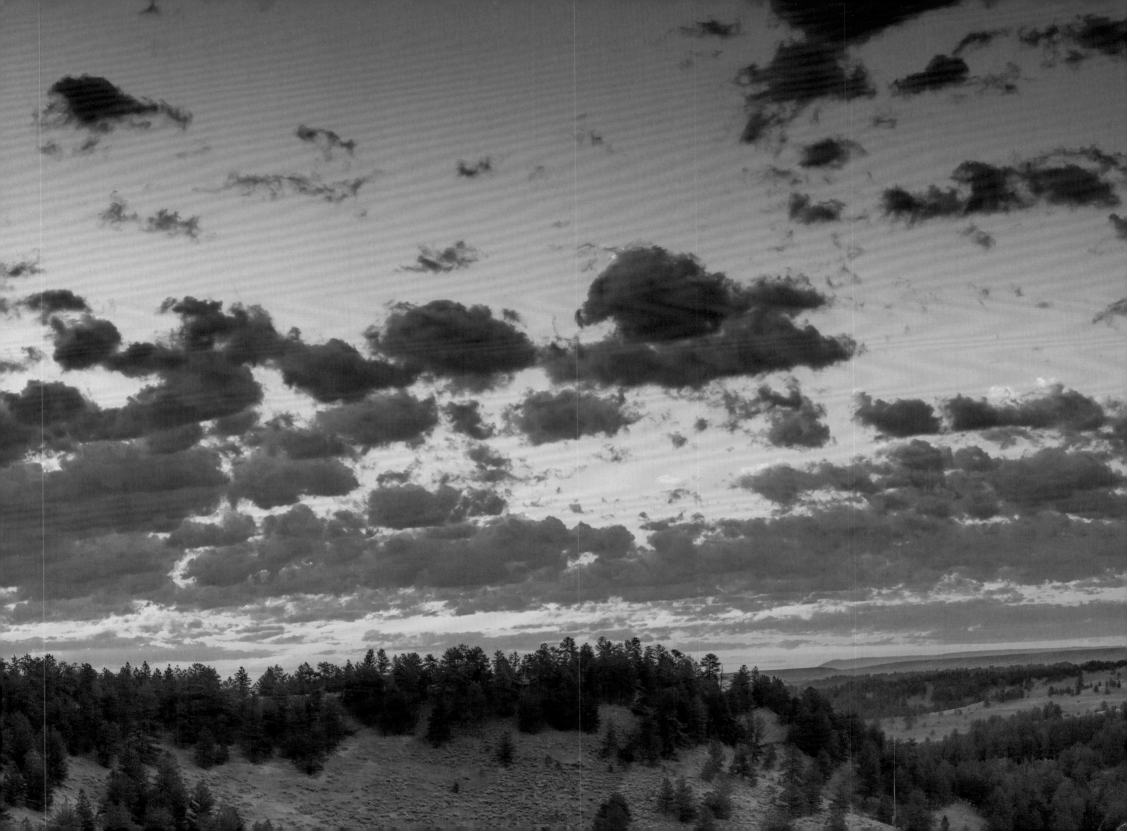

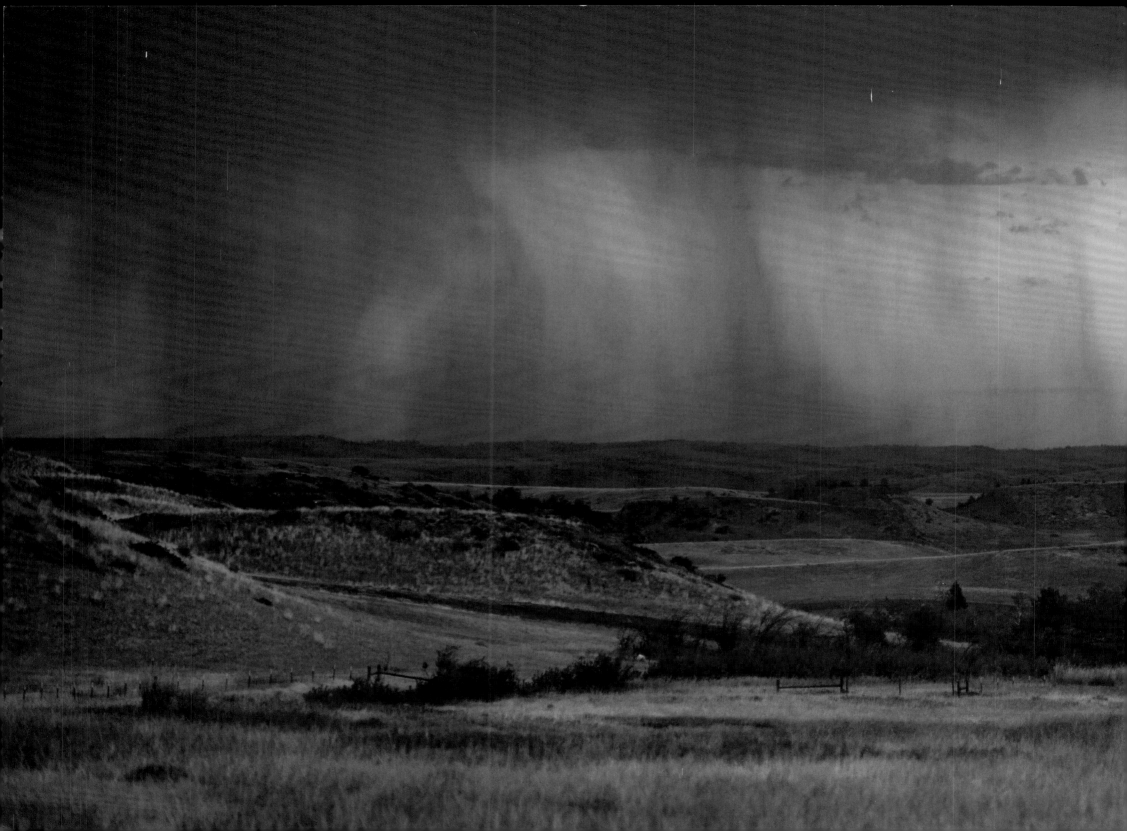

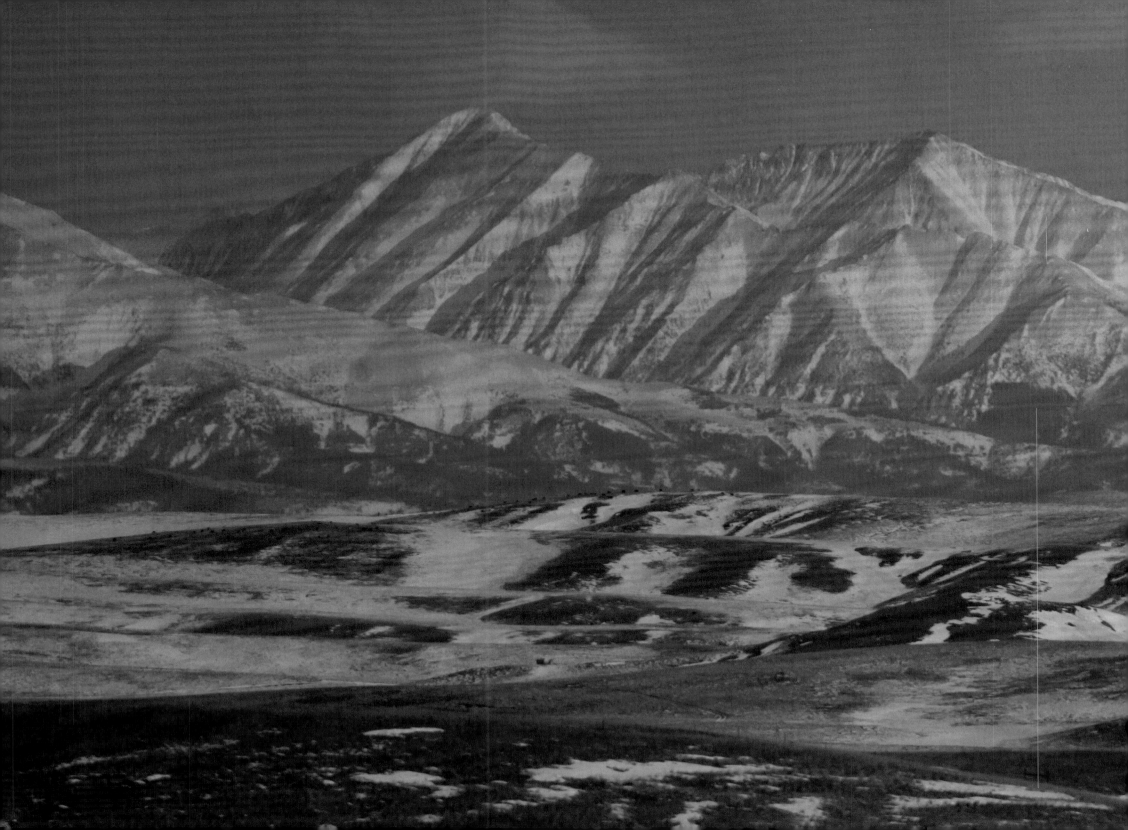

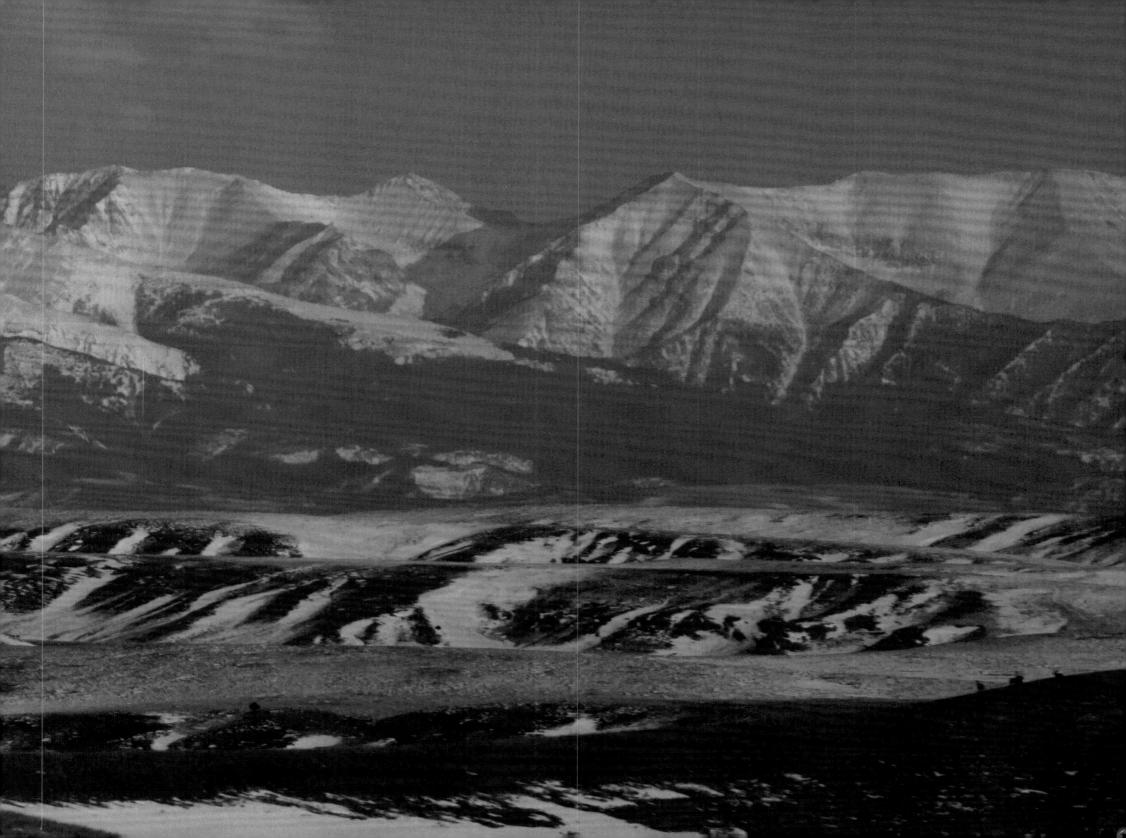

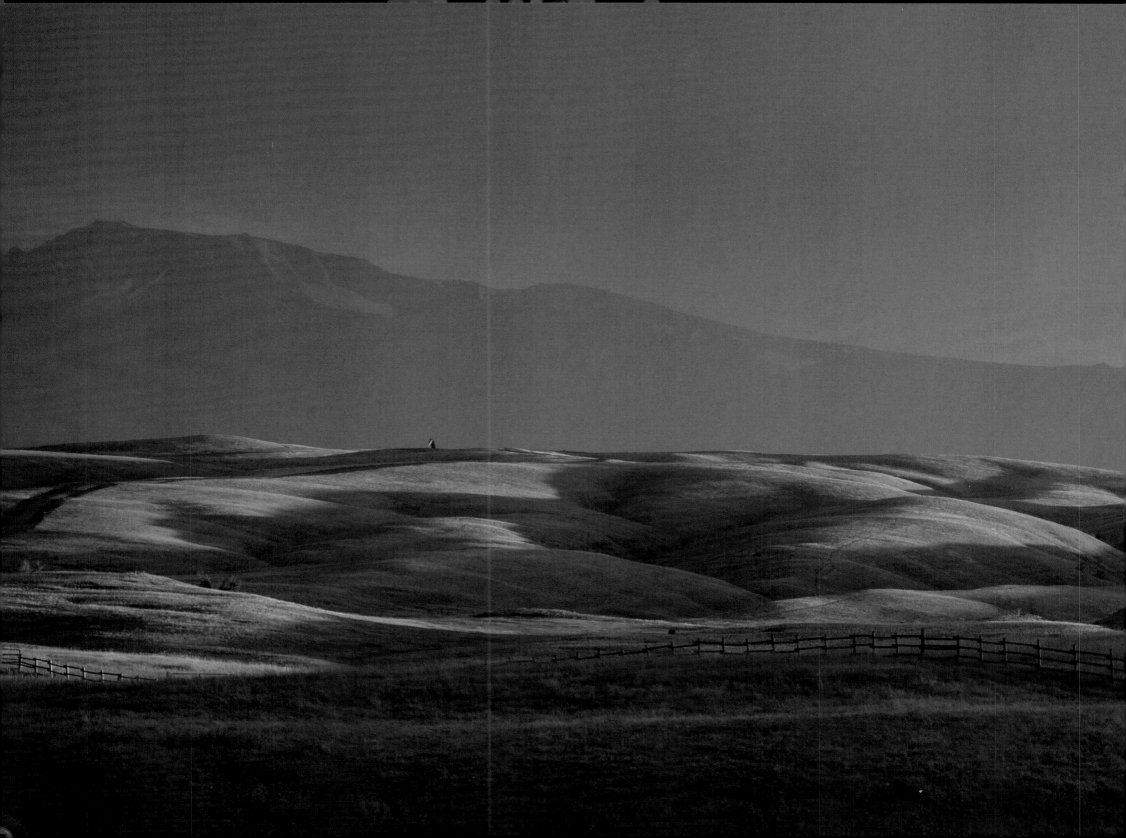

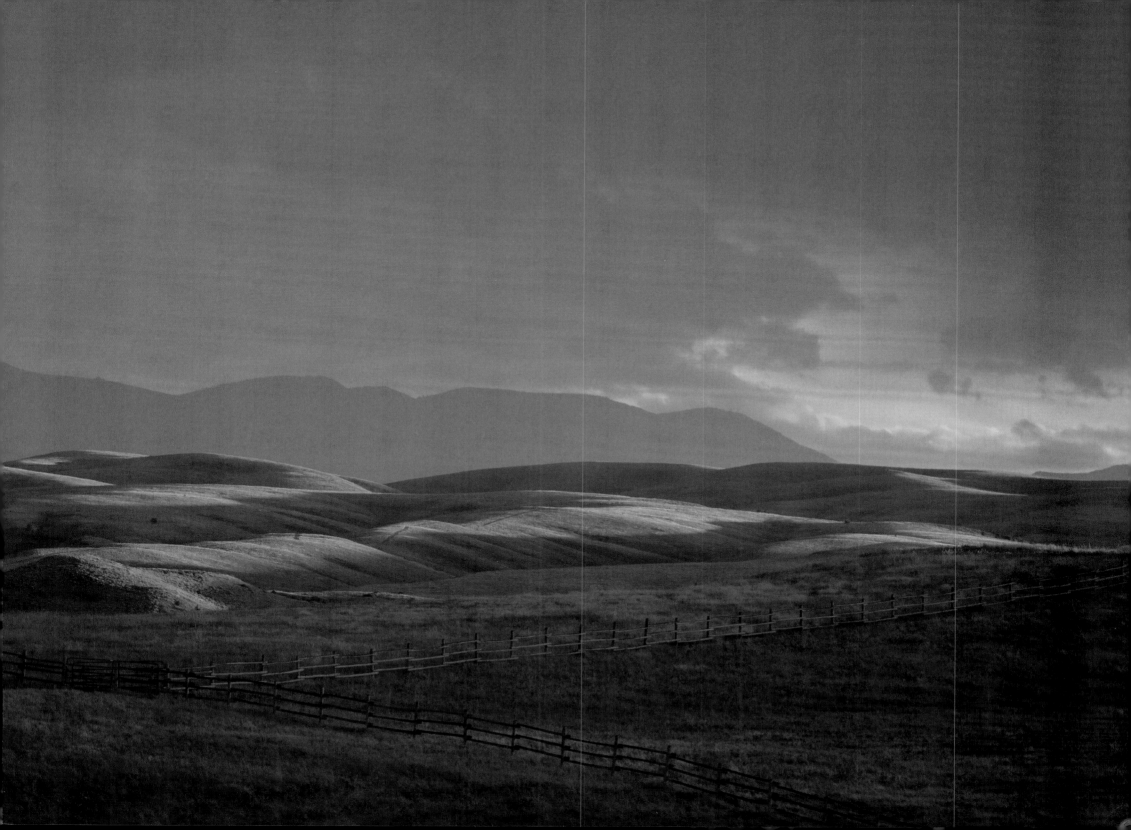

TIPPET RISE

PRINCETON ARCHITECTURAL PRESS · NEW YORK

ART CENTER

PETER AND CATHY HALSTEAD

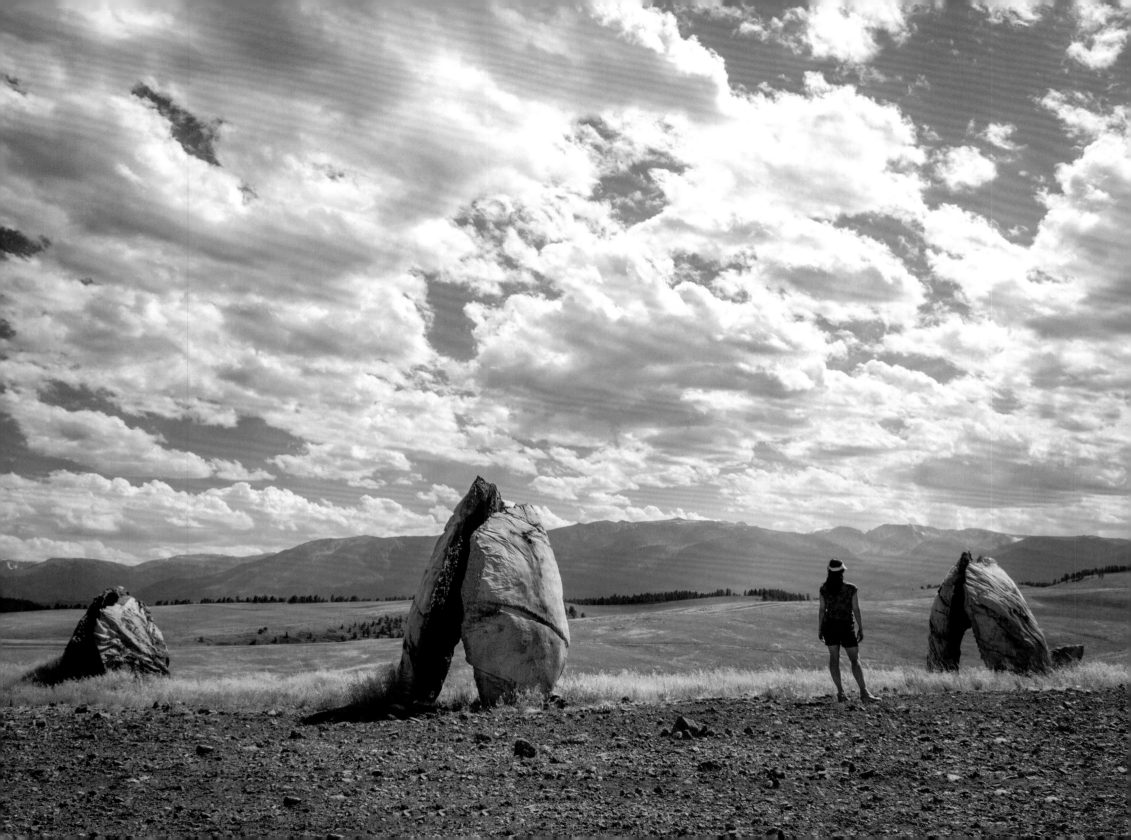

Contents

Preface: The Spirit of Tippet Rise

Tippet Rise comes from who we are.

We started as individuals who wanted to make something for our family. Who wanted to make something that could be run as a family.

We wanted to get away from the big corporations, skyscrapers, cubicles—all the phenomena of our lifetime. We wanted to create a spirit of place where the land welcomed people who would cultivate the soil and trade in the daily kindnesses and hand waves of the small towns we grew up in. We wanted to celebrate life on the land.

This is what led us to want to have art in the valleys, cradled in the hills, protected by the canyons. That art had to be the kind that does not fight or dominate the land, or claim its self-importance, but instead seems to come from the land, made of the same rocks and dirt and wood as the land, art that does not disturb a valley but makes it somehow vaster, welcoming, spiritual.

When art is freed from the four walls of a museum and from the confines of a city, suddenly it relates to the world in a way that enriches the landscape, enriches the experience of viewing it, of touching it, of being next to it, of being under it, of imagining how this wonderful creation is part of the world.

The same is true for music. In an incredible landscape, our minds become free to think about music in a way that is moving and personal and universal all at the same time.

We wanted a concert space that feels like an artist's living room, valleys devoted to only one work, personal art happening in immense cosmic landscapes, works of music that embrace the land, sunsets that magnify concerts. We did not know until we held them that concerts could celebrate accessibility, warmth, closeness, and nature.

We have had so many meaningful experiences throughout our lives that have been in beautiful natural settings with amazing music. The combination of art, music, and the outdoors moves us deeply, and we hoped to create something in Montana that will move everyone who comes to visit.

PETER AND CATHY HALSTEAD

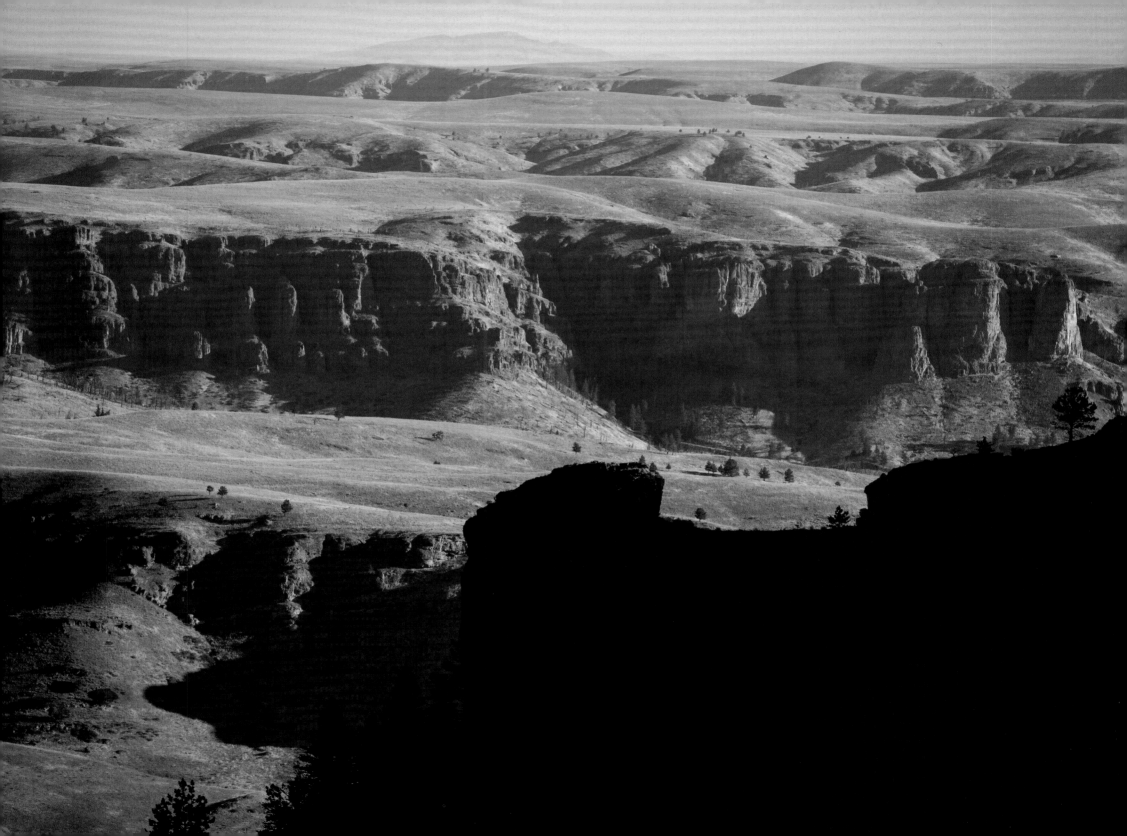

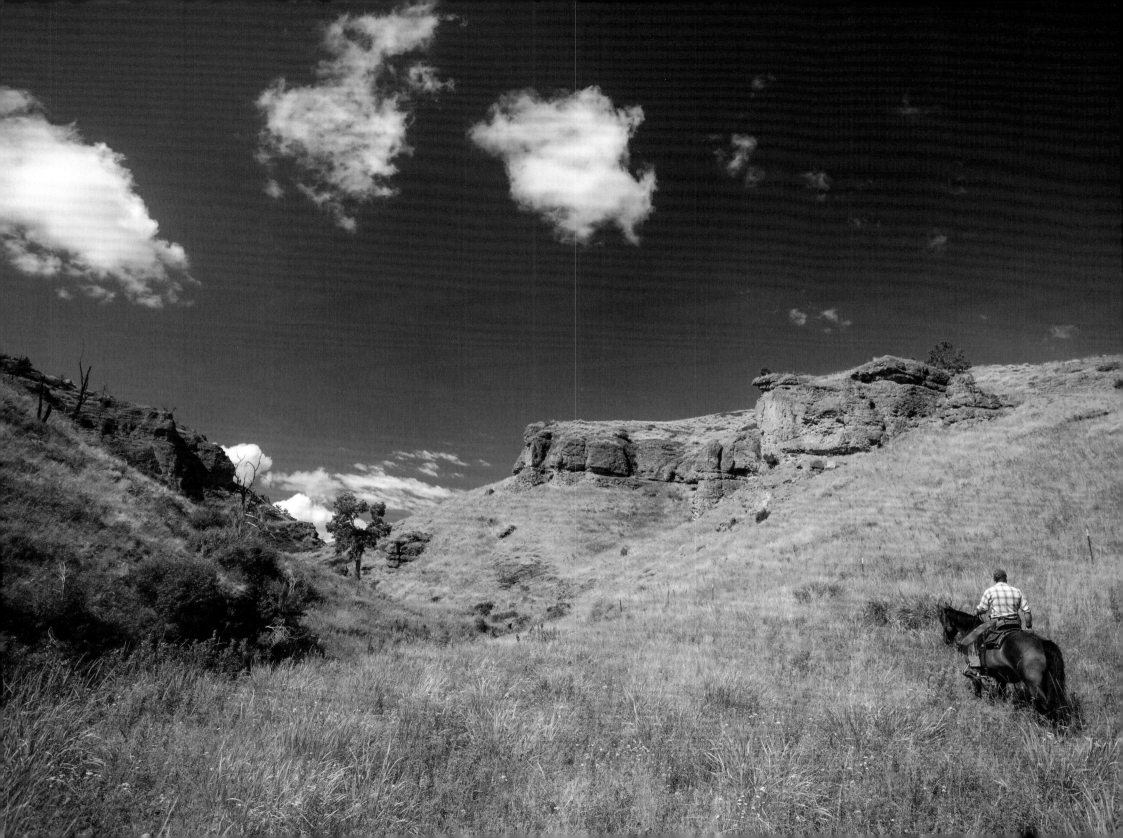

Second Childhood

Clouds that hang like cows in sky,
Cows that pull like clouds
On grass in window panes that blind
Us with a sky of clouded glass;

Sky that pulls like wind on blinds,
Sun that hangs like blinds on wind,
Wind that darkens minds with sky,
Glass that winds up blinds like sun;

Blinds of sky and grass
Hang us in a pane of wind
And windowed cows, as
If mind lost sight like eyes

Lose sky, and blinding glass
Grew clear as cows on grass
And wind on sky when eyes and minds
Grew dark as window's blinds.

* All of the poems in this book are written by Peter Halstead,
 unless otherwise noted.

SCULPTURES

PHOTOGRAPHS BY **ERIK PETERSEN**

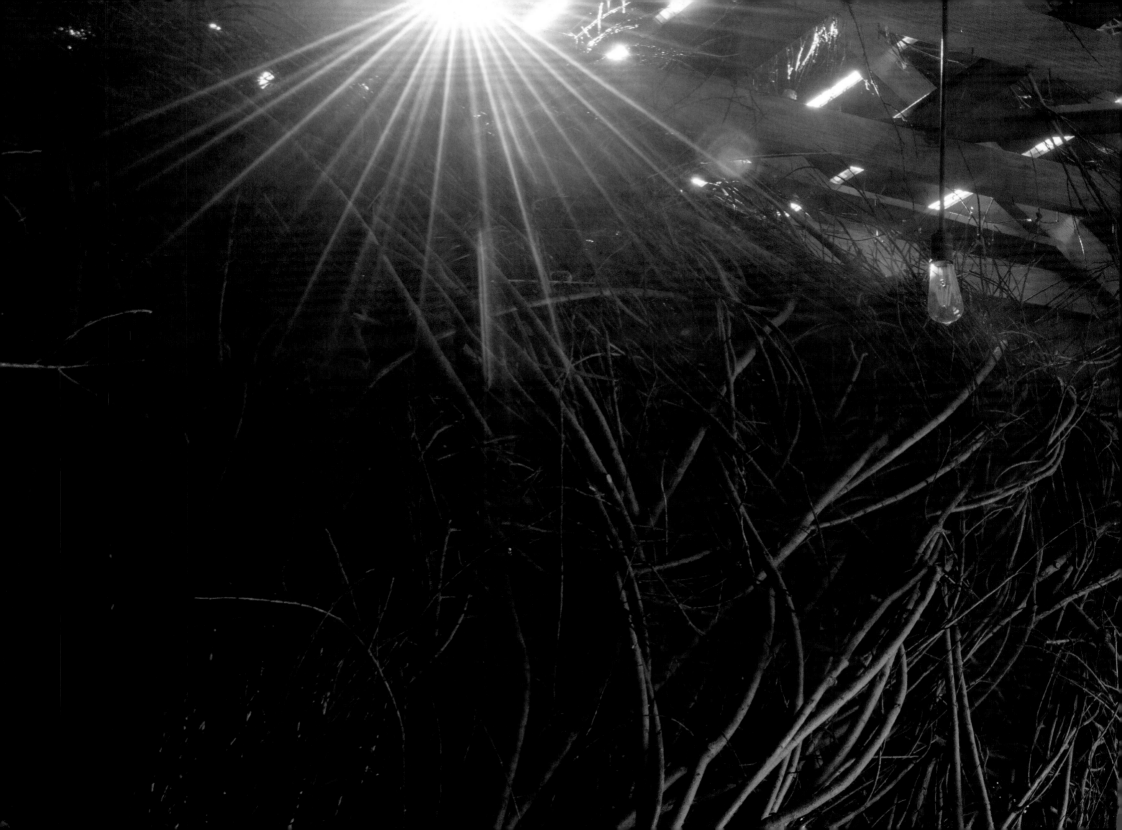

PATRICK DOUGHERTY

DAYDREAMS

Daydreams, 2015
Willow saplings

Playing Hooky

My visit to Tippet Rise included a tour of turn-of-the-century one-room schools that still sit plaintively in the Montana landscape. These derelict remnants of learning occupy the most beautiful places and leave the explorer wondering how any child could concentrate in the midst of such allure. My favorite schoolhouse sits forlornly several miles from Tippet Rise, window glass long gone and roof flapping in the wind. As I stood on its worn-out porch and looked back as though through the eyes of those pioneer children, I imagined what a challenge it would be to go inside and turn away from the freedom of the unruly prairie.

My idea of bringing a schoolhouse to Tippet Rise coalesced when Peter Halstead joked that the best parts of his education were his daydreams of escape and his desire to embrace the world beyond the classroom. I began to imagine a sculptural work that contrasted book learning tethered to a desk with the rambunctious potential of the natural world. *Daydreams* is constructed within and atop a replica of a prairie schoolhouse, built new to look old and to provide the backdrop for the sculpture.

The sculpture is a reaction to the memories that haunt the old prairie schoolhouse. It is a sculpture that celebrates ideas of wistful escape and indulges bucolic fantasies of nature as headmaster and the wind as a learning aid. The work, composed of five interior and two connecting exterior elements, is entitled *Daydreams* for all the dreams of the wild that sustain children as they endure the drone of imparted knowledge.

PATRICK DOUGHERTY

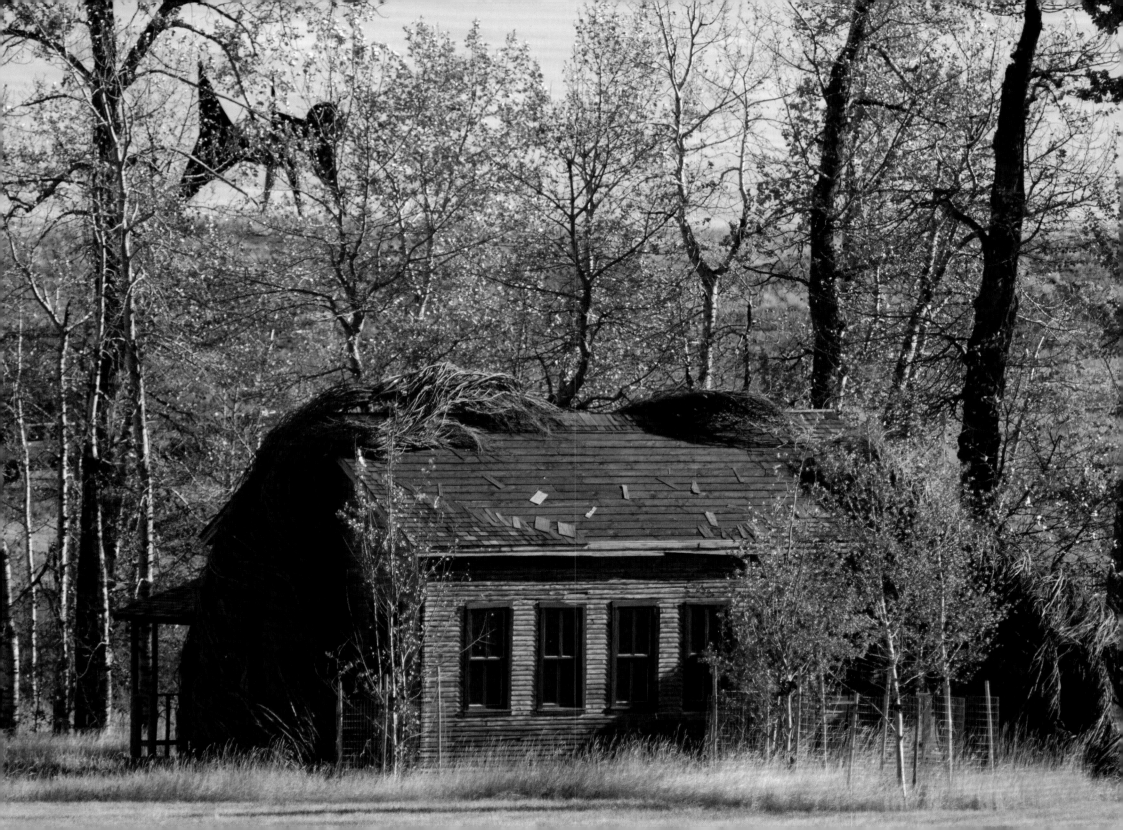

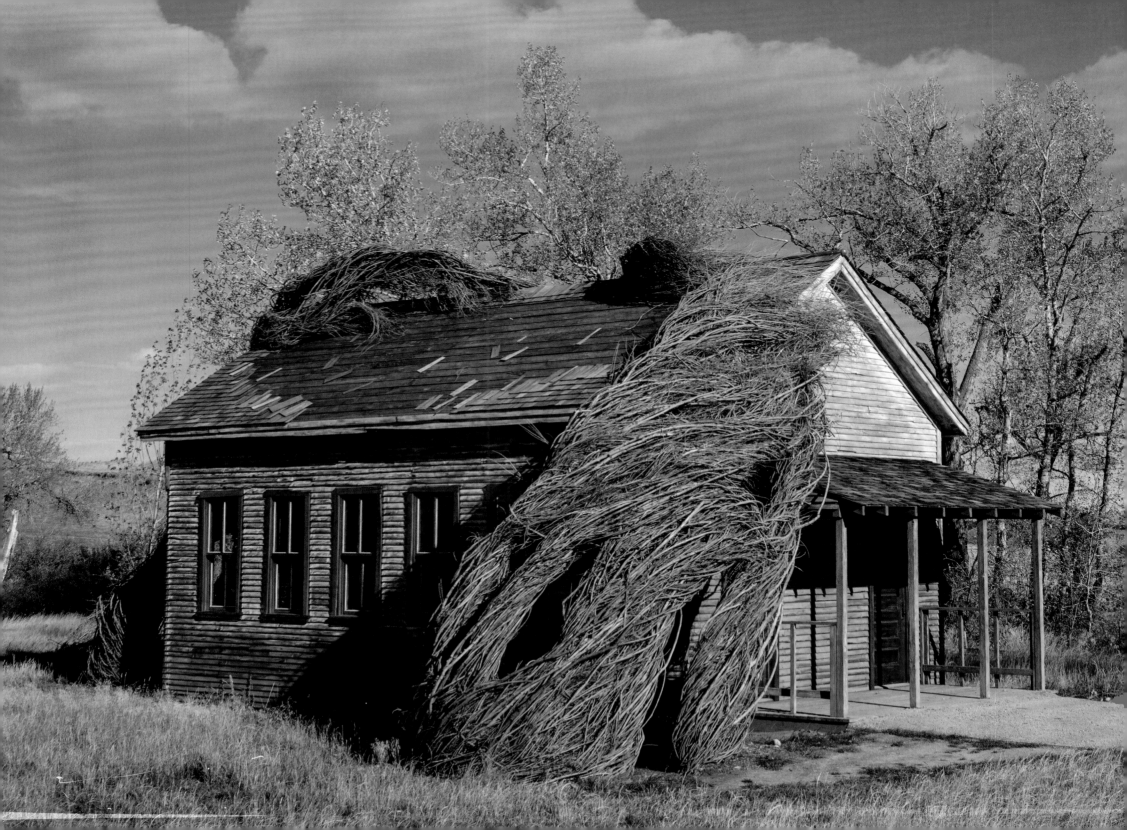

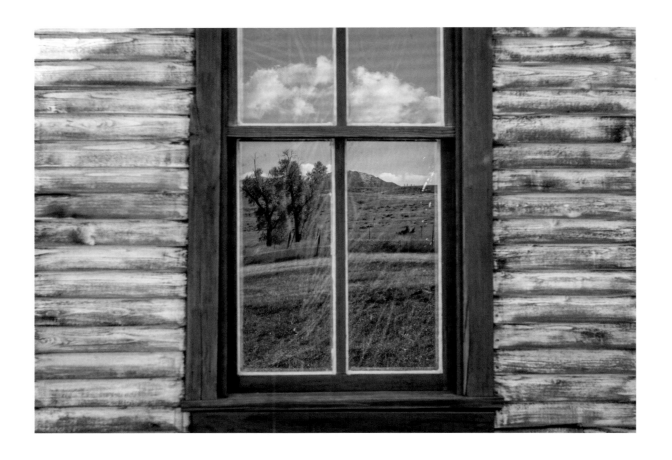

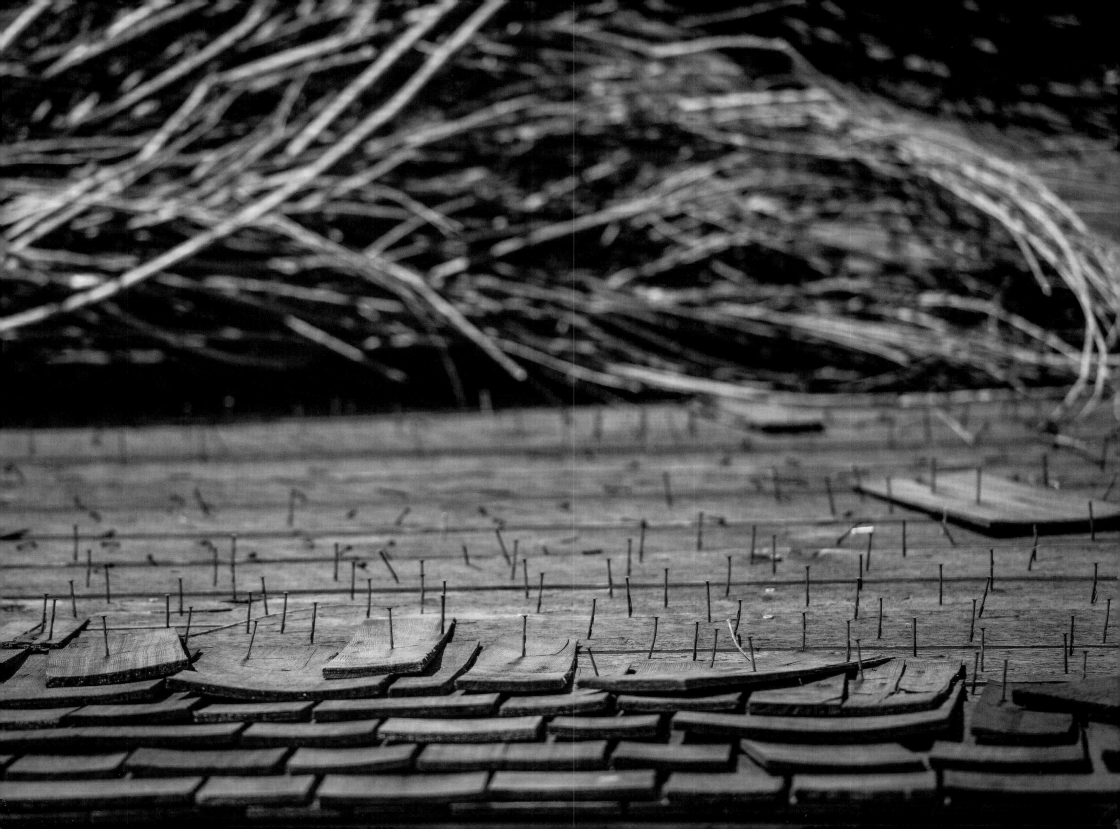

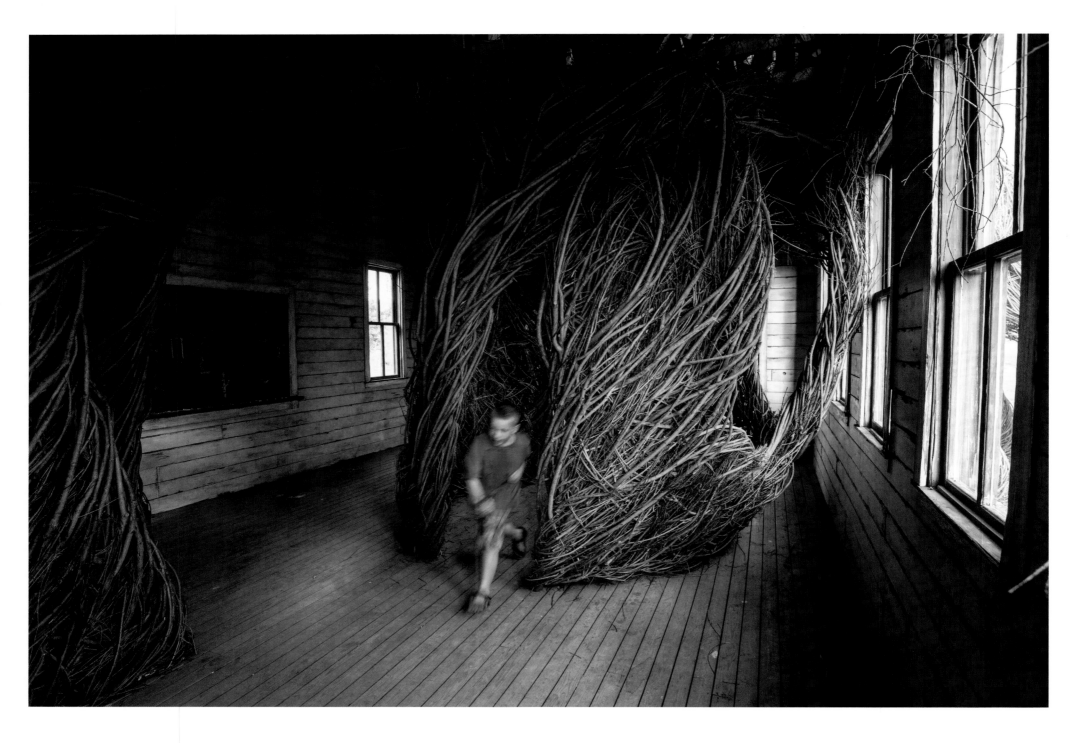

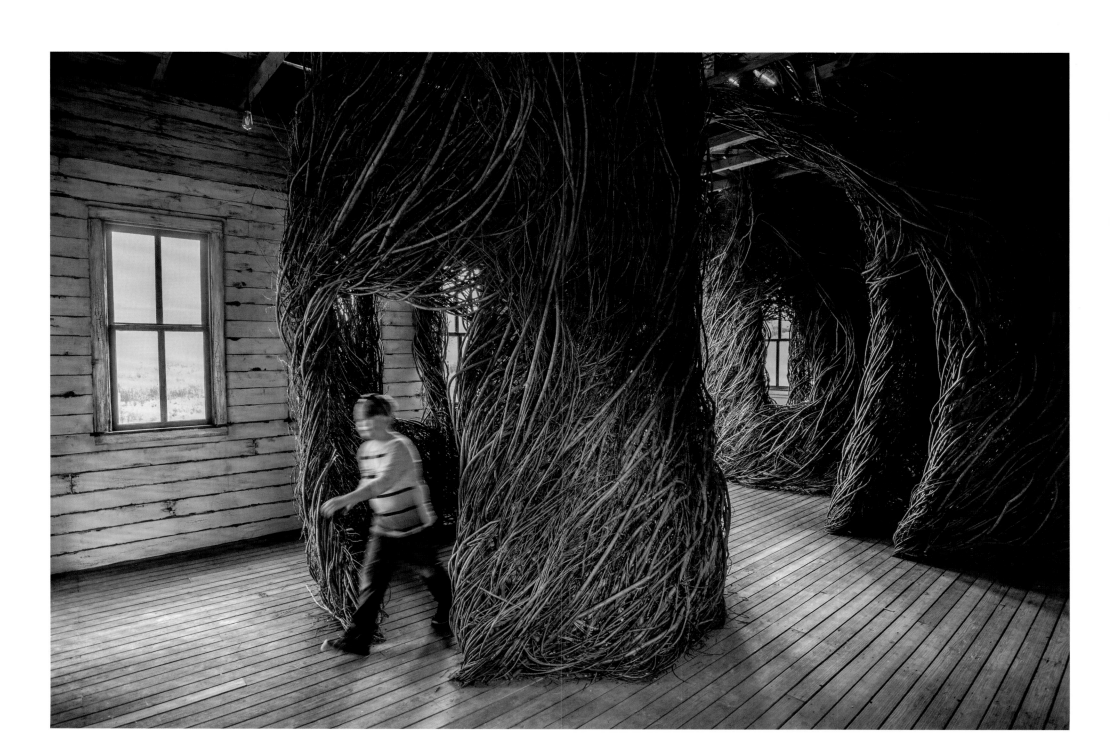

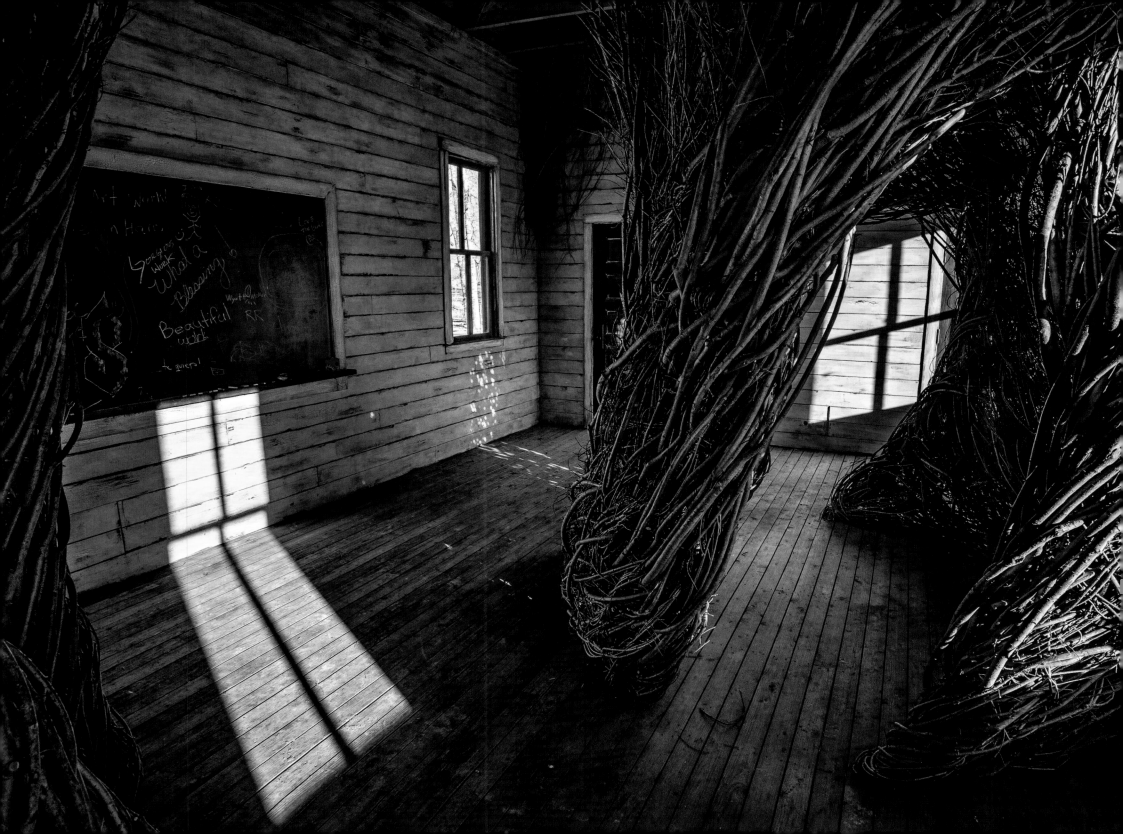

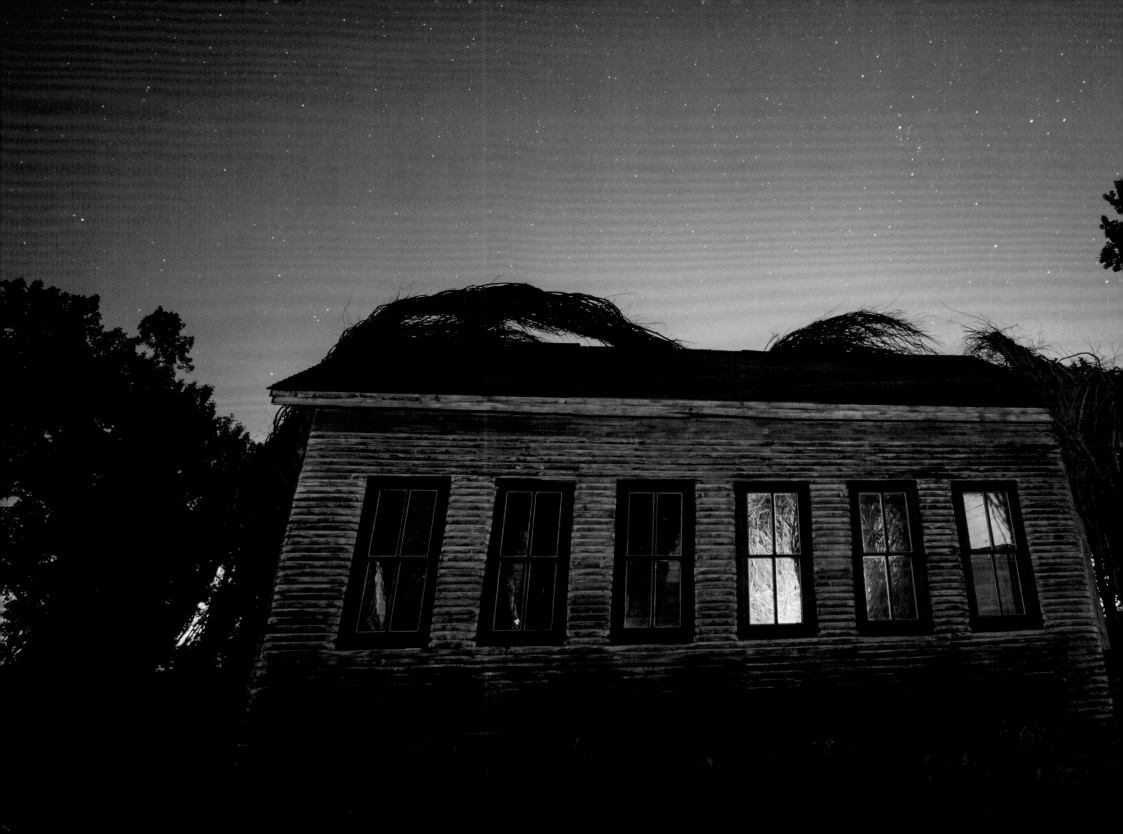

Chalk

At first light
You pull me toward
Spaces where day's white
Blackboard

Takes me back to night,
Erases what just seems
A way to write
But in fact is dreams.

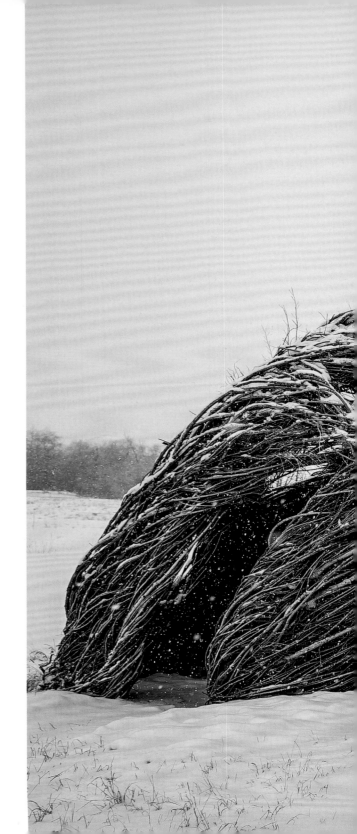

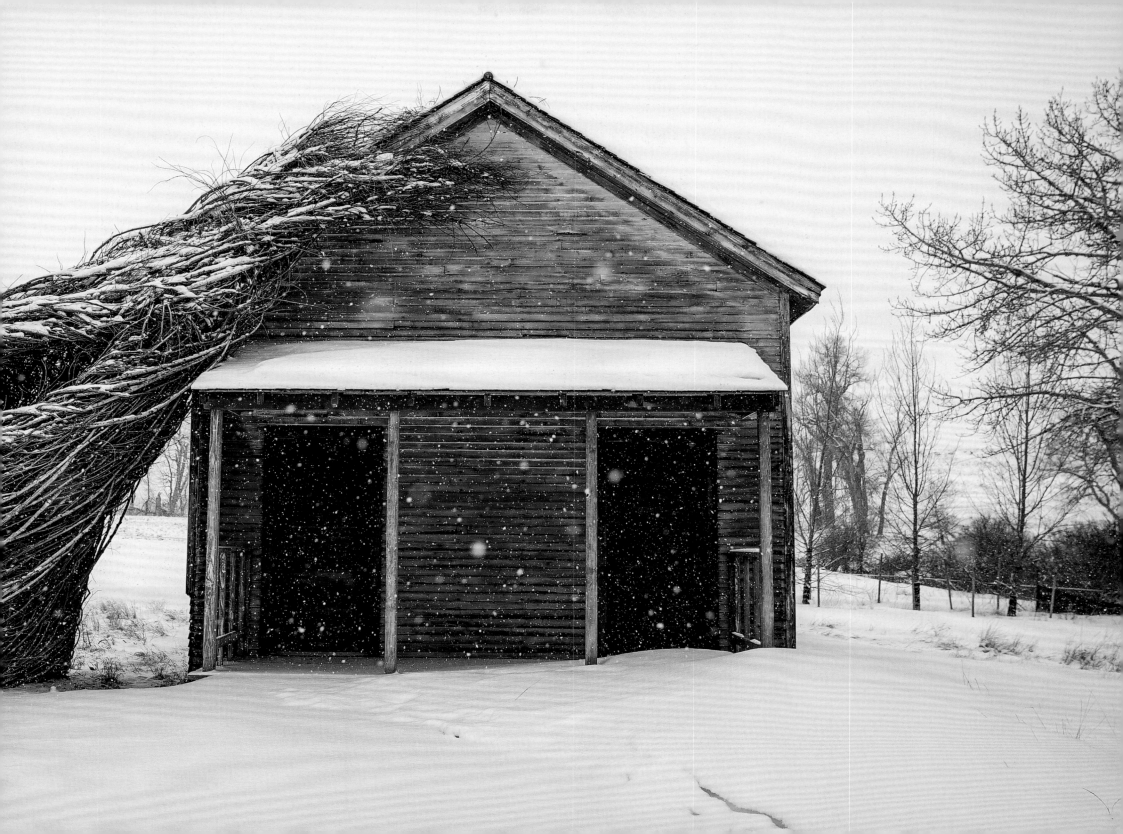

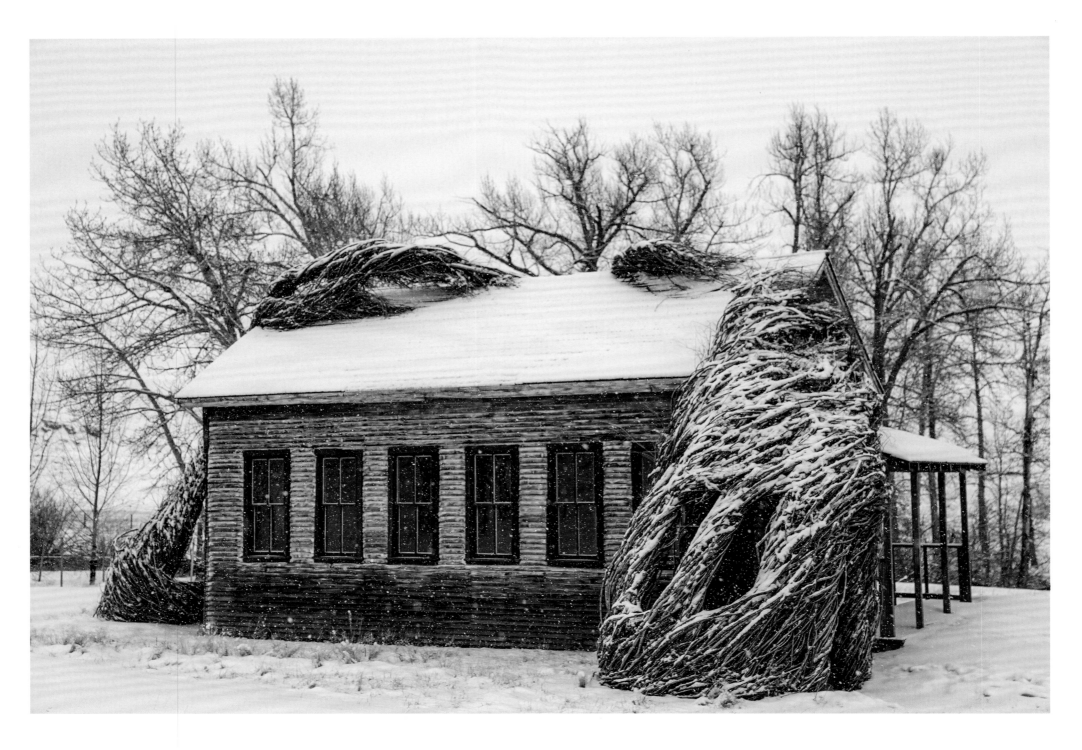

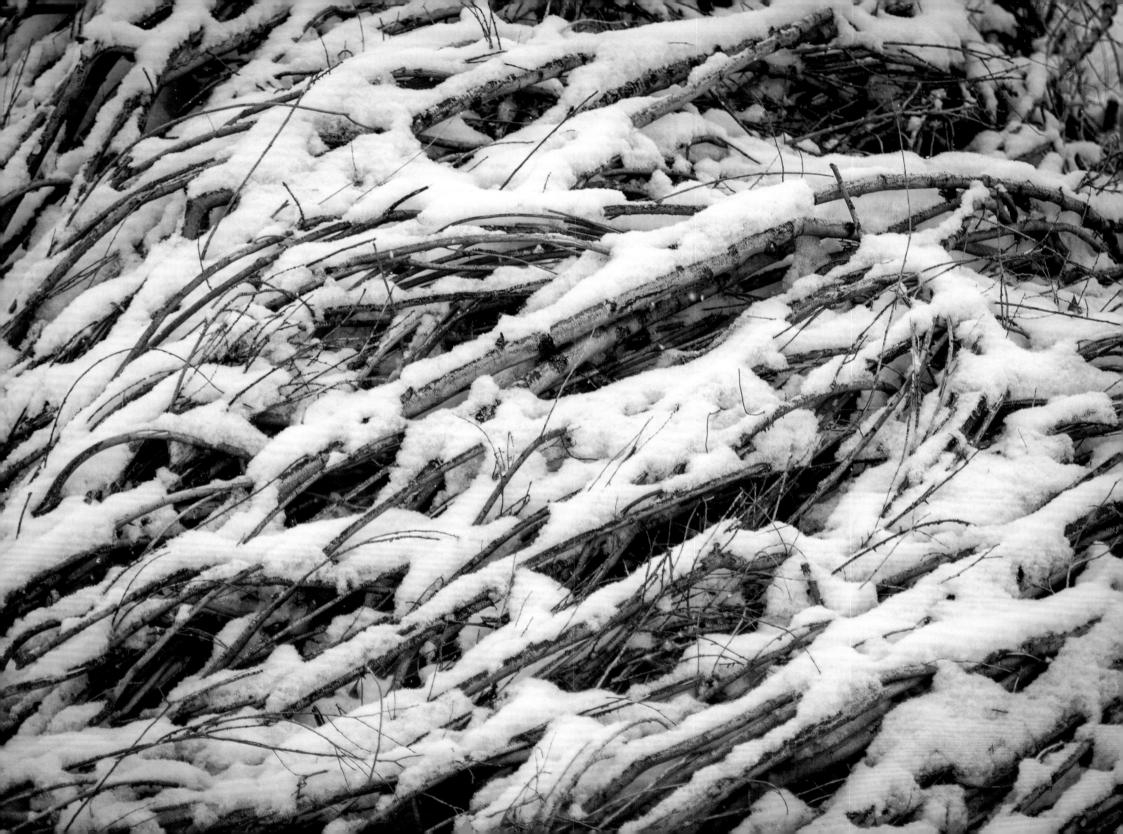

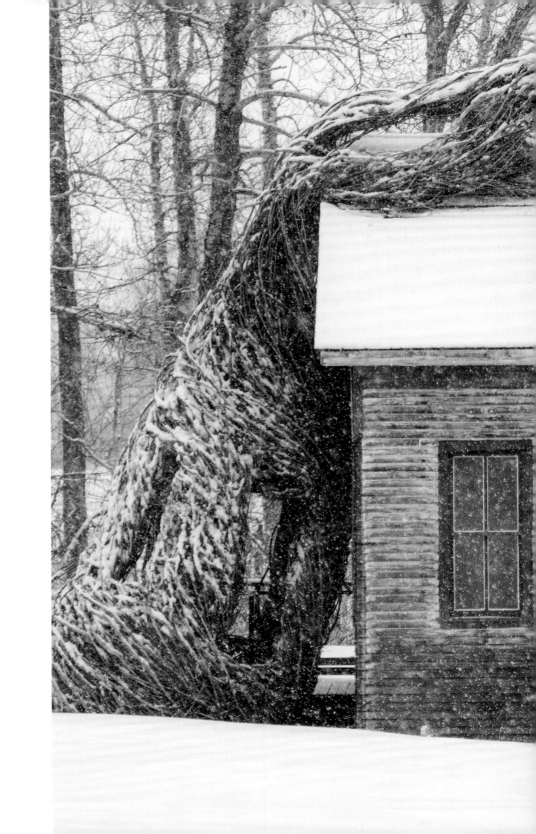

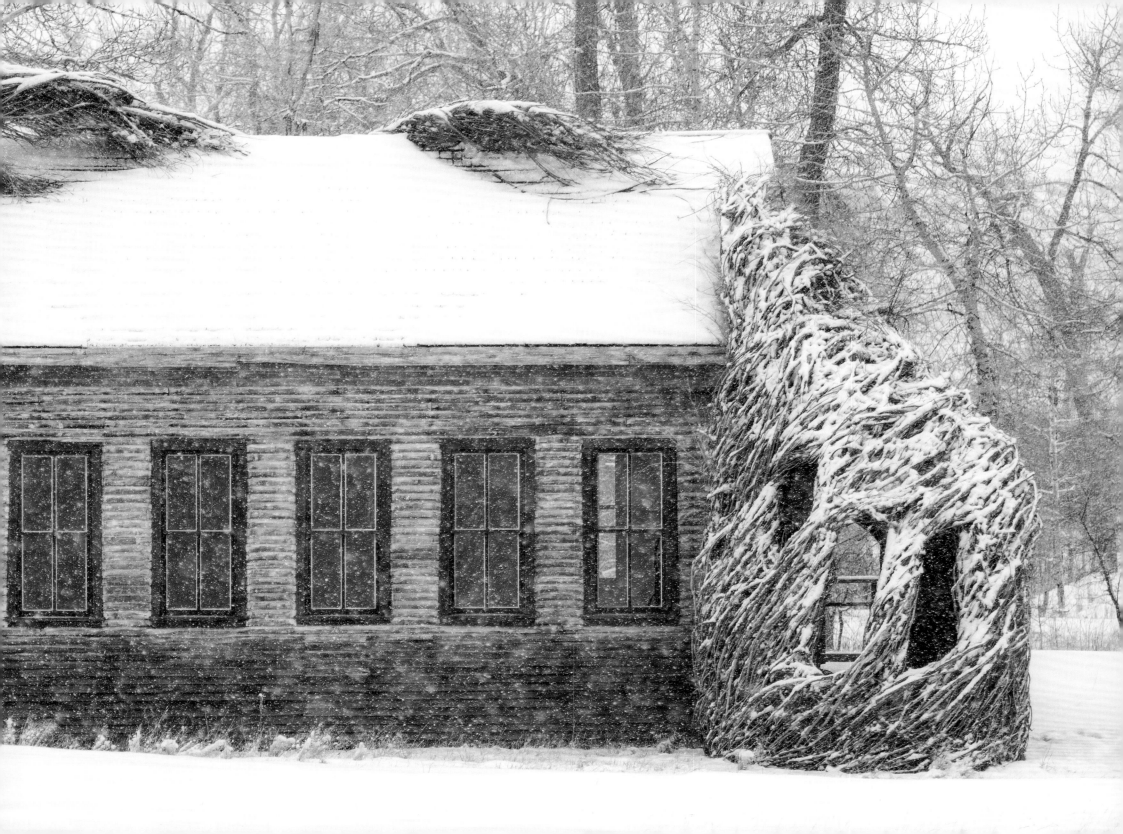

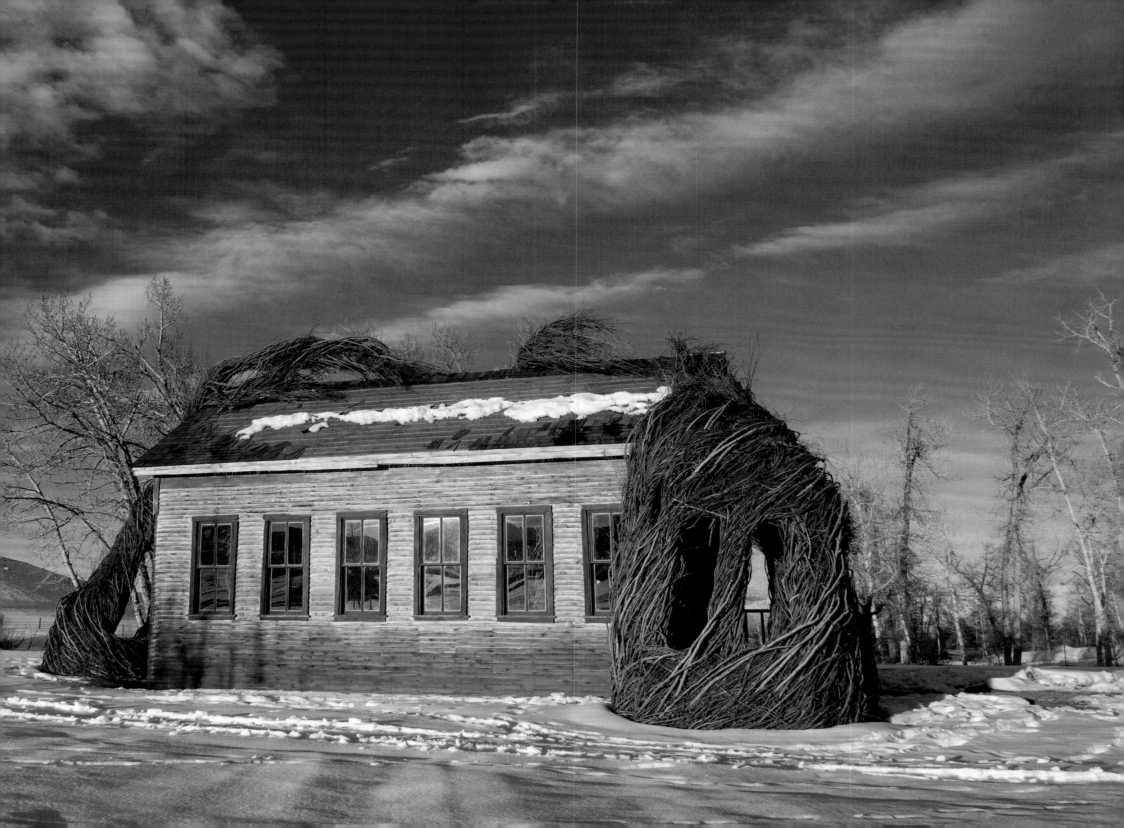

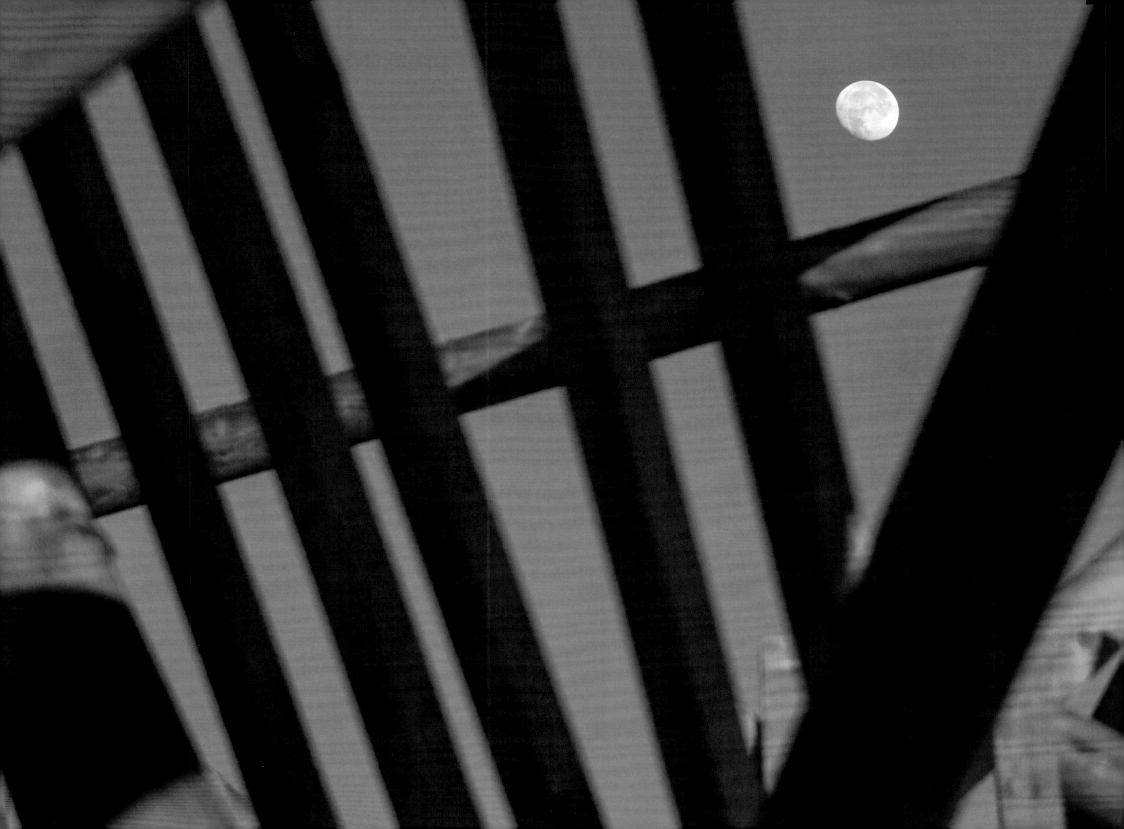

STEPHEN TALASNIK

SATELLITE #5: PIONEER

Satellite #5: Pioneer, 2016
Yellow cedar with steel footing

Bringing the Sky Down

The topography of Tippet Rise is reminiscent of the lunar surface, as seen in the early black-and-white images captured by NASA satellites, an expansive infinite panorama that served as a staging area for exploration and adventure. These unmanned vehicles, inspired by the unfettered curiosity of a generation destined for discovery, embodied the nation's ambition for risk and conquest. The launch of Pioneer in 1973 served as a visionary metaphor as it documented the unknown.

As you walk the land at Tippet Rise, the aesthetics of risk and conquest are further defined by tangible connections to early settlers who, like those of later generations, were seduced by challenges of the unknown. Small, decaying log cabins are almost-viable time capsules, connecting our present with the experiences of the men and women who preceded us. Architecture is imbued with the narrative of those who chose to be challenged by the land and harness it despite the risks. It is this timeless, universal attraction to the unknown that helps create our insatiable appetite for exploration.

The Satellite #5: Pioneer creates intimacy within the infinite largeness of a natural vista. It is planted within geologically carved natural bowls that serve to surround and protect both the sculpture and the viewer—purposefully sited to facilitate a human scale within the monumentality of nature—a private sanctuary that ensures a sense of intimacy and contemplation. As you stand within *Pioneer* and take in the encompassing vista, you are presented with contrasting landscapes: the intersection of surrounding slopes that visually meet the sky and the ultimate view of a majestic infinite panorama. These two contrasting landscapes represent the timeless obsession of an individual's quest for validation and one's role within a much greater galaxy.

STEPHEN TALASNIK

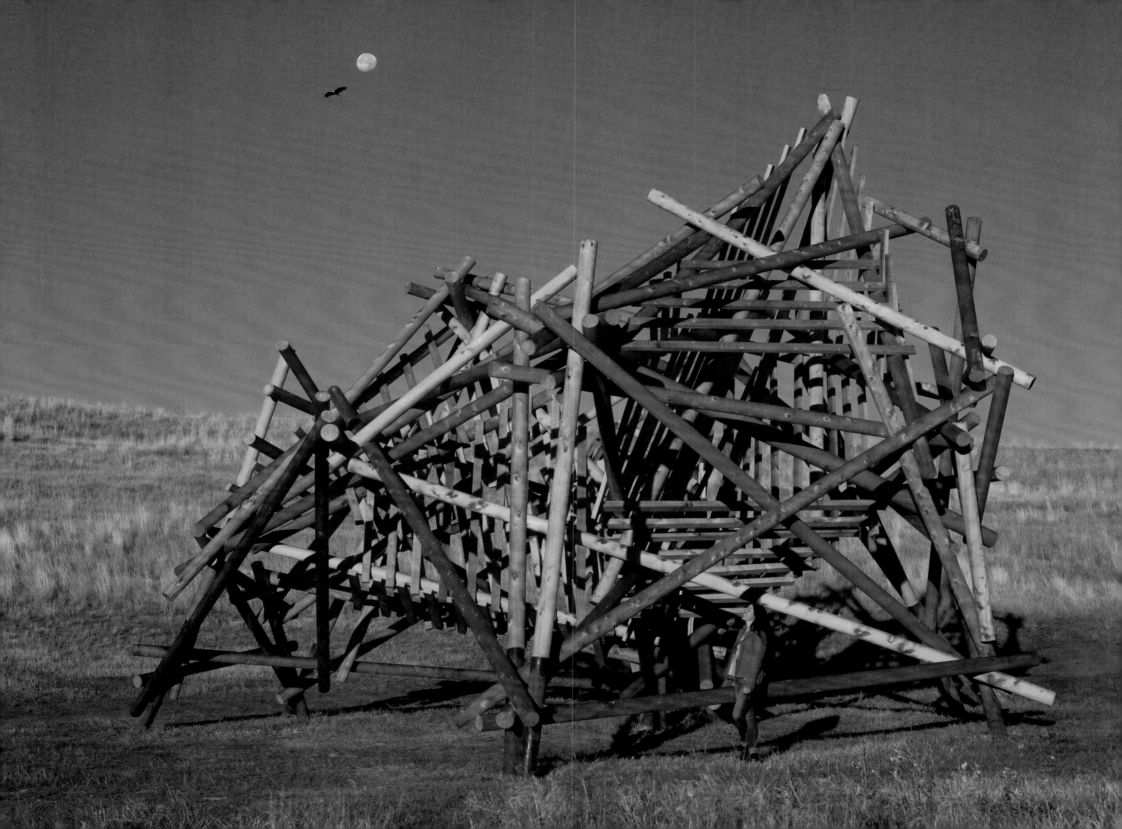

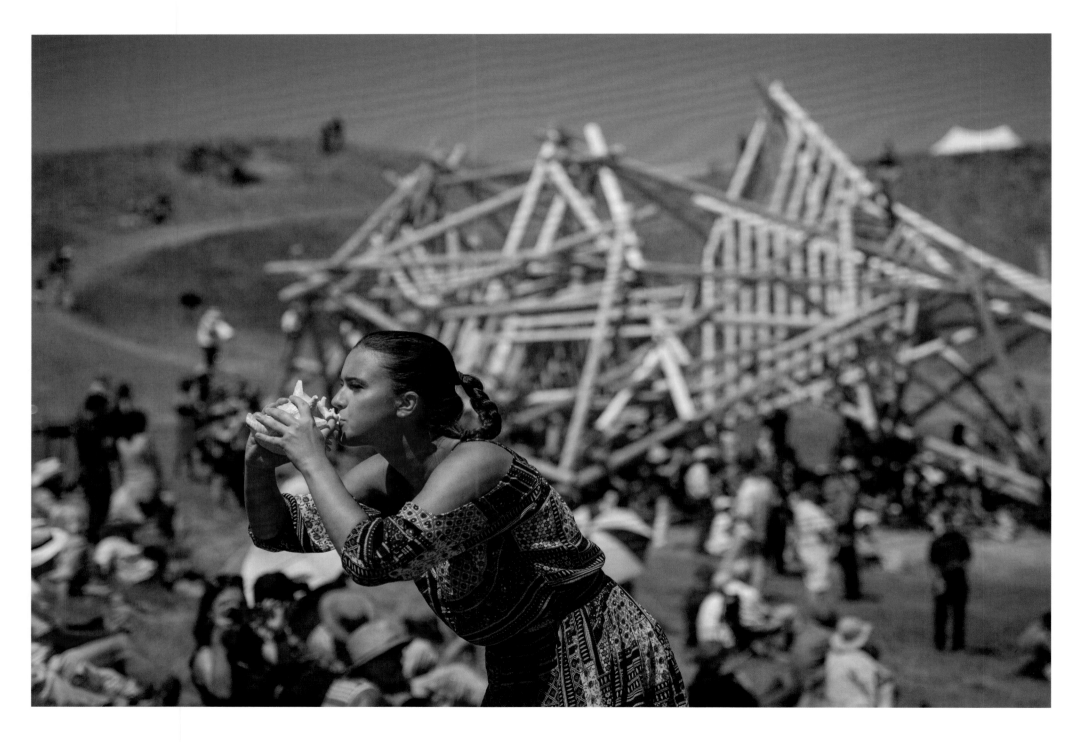

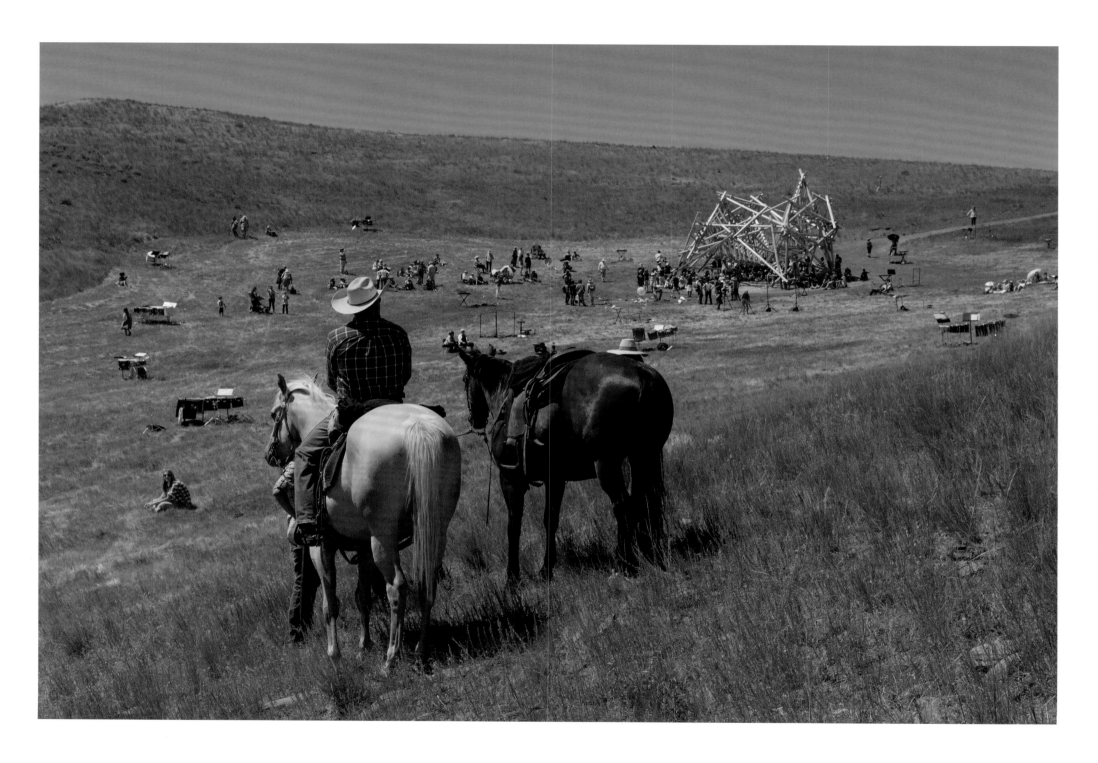

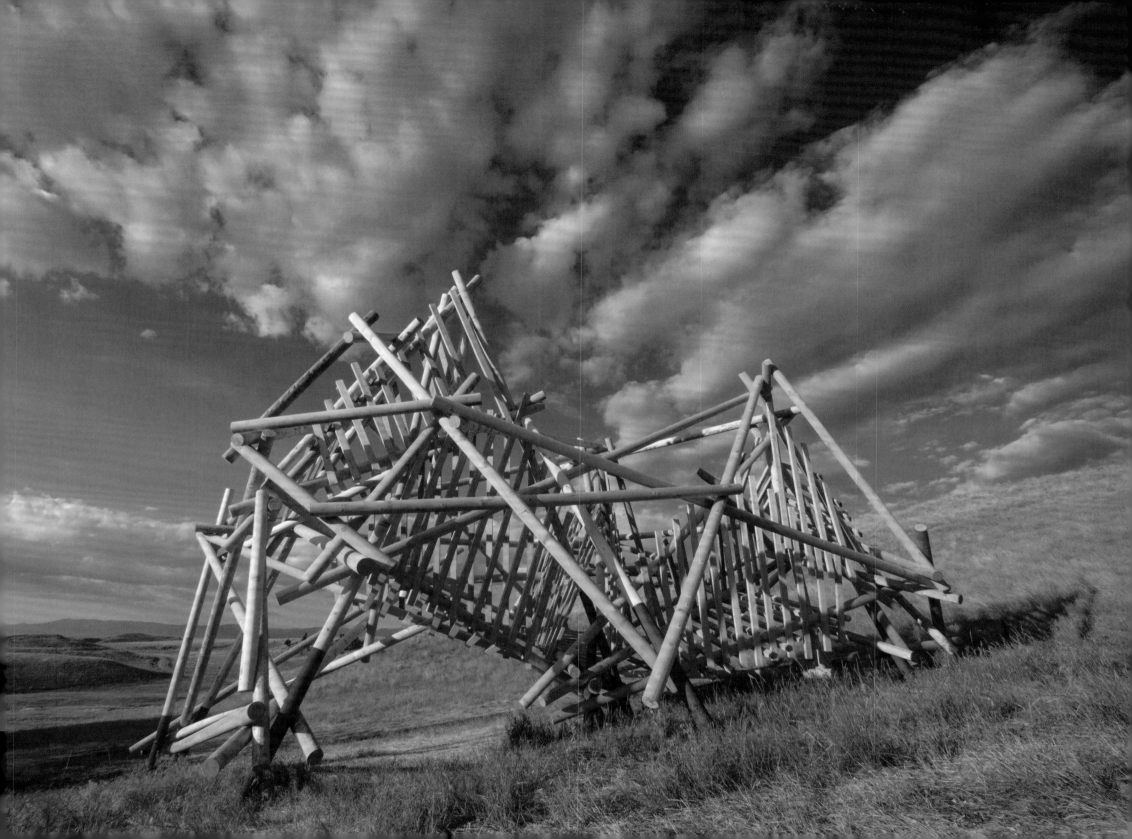

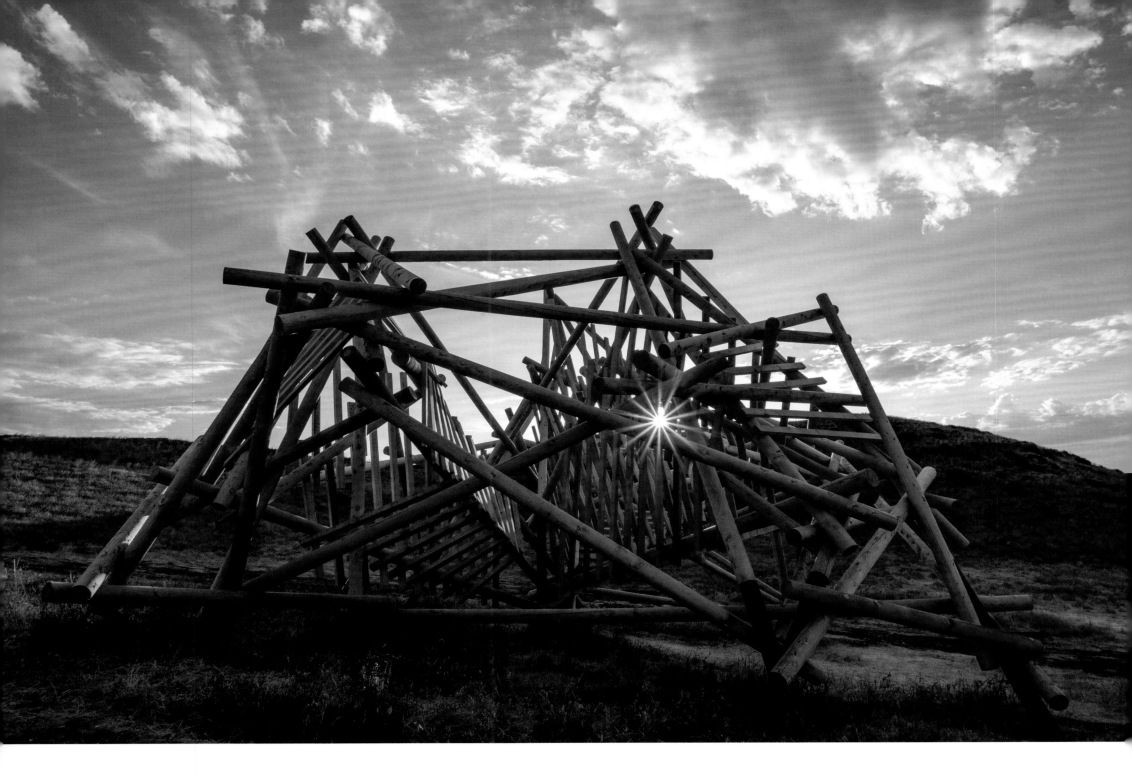

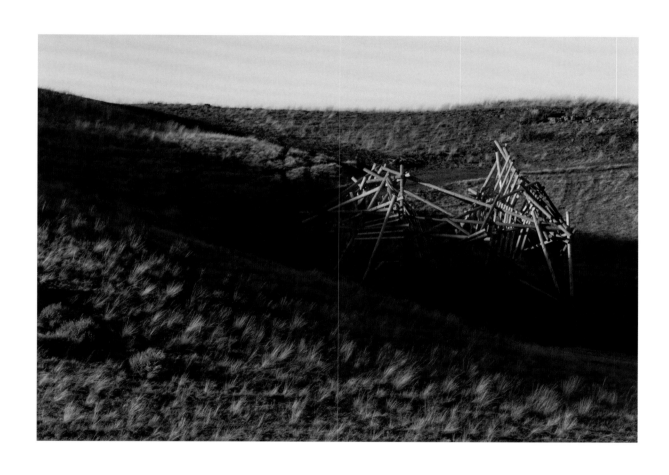

Kindling

To catch the fires of the world
We reassemble what is old,
What is slashed and flawed and hurled
Against the chaos of the cold,
And use it, wrecked and lost and burned,
As fuel on the broken ground,
That has all winter learned
To flourish in the summer's blowing sound.

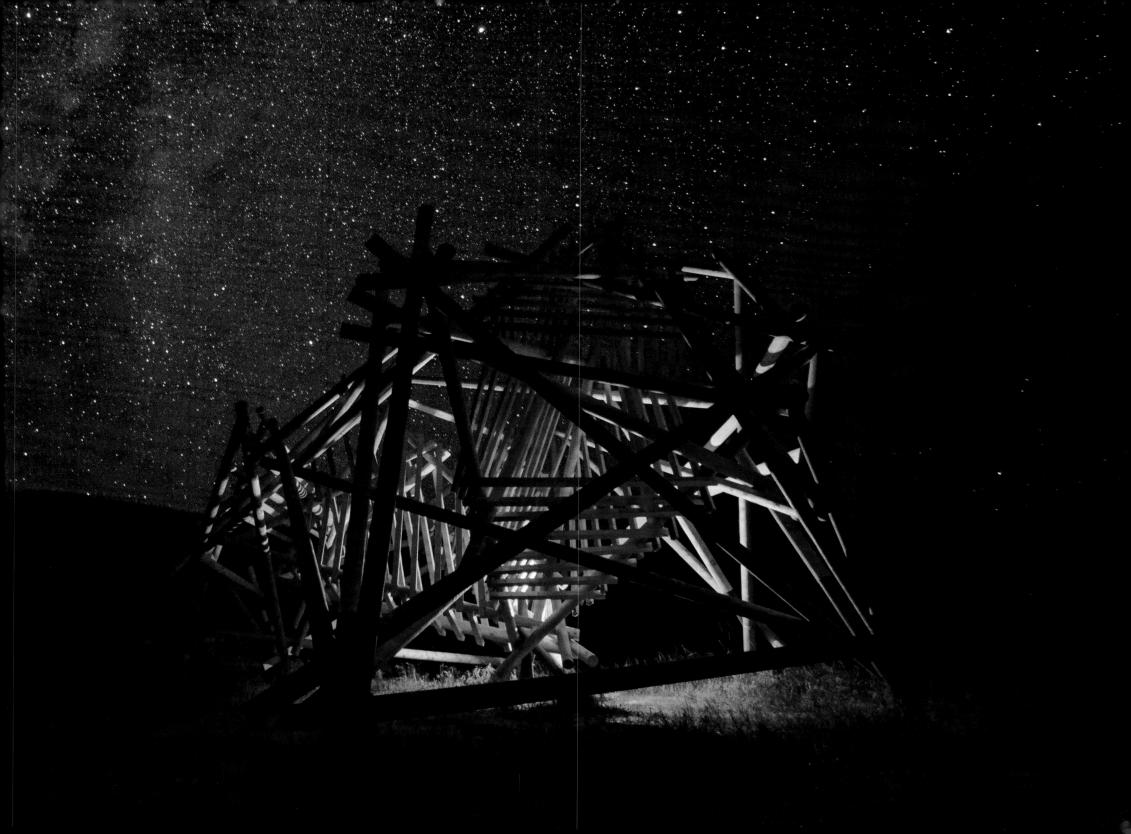

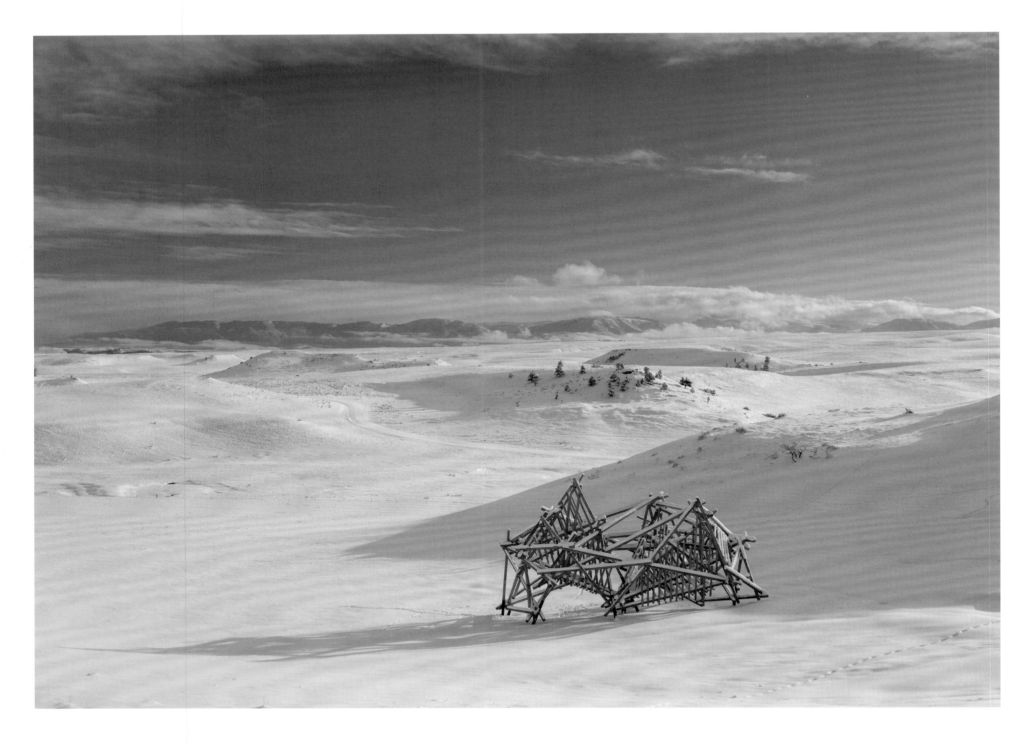

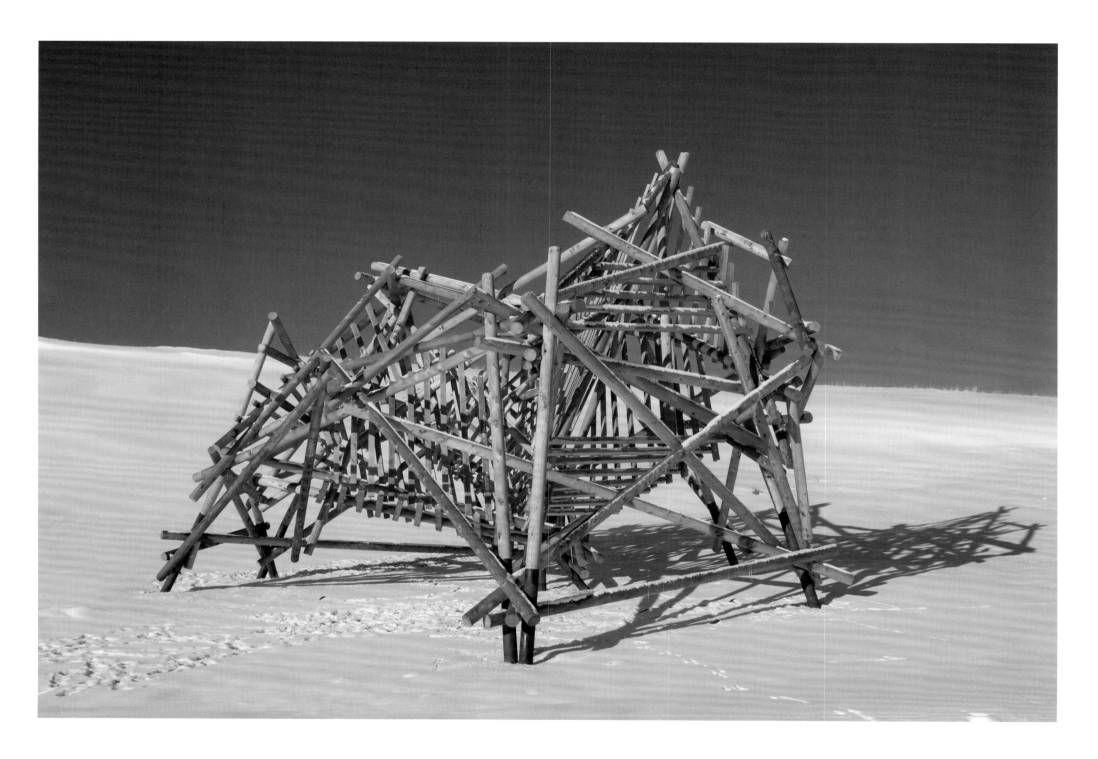

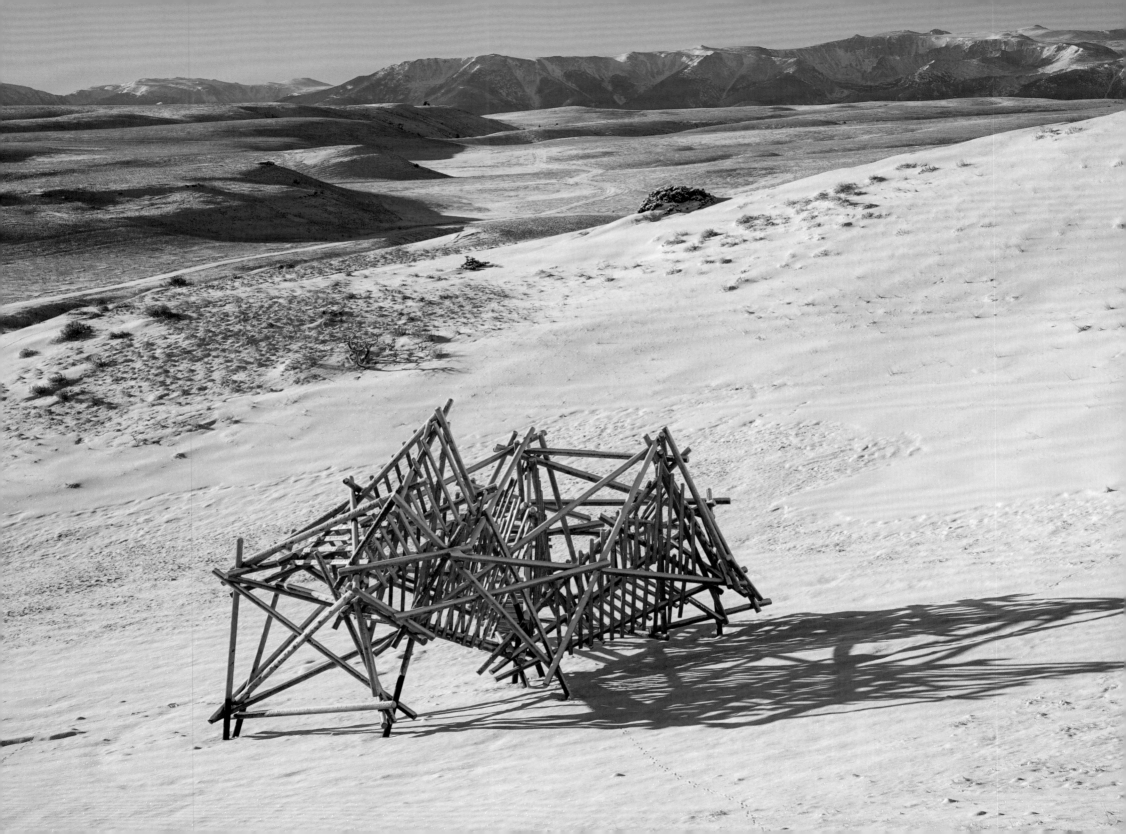

ENSAMBLE STUDIO
BEARTOOTH PORTAL

Beartooth Portal, 2016
Earth, rock, cement, grass, and rebar

The Space of Music

There are harmonic phenomena that record exactly how tones have been colonizing and dominating the greater ranges of space, from the octaves that start the sounds to the microtones in which they decay. And so, like tree rings, space is a linear history of the frequencies that parallel it. That is, the history of the universe can be written in sound as well as in physics.

We encounter gravity and use our own energy and observation to resist it; this resistance connects us to the universe. Music is the metaphoric way we resist the pragmatic world.

Architecture and music intercede with these forces and energies in antagonistic ways and in total symmetry but never coincide, since they operate with different densities. The substance of sound and the gravity of matter create the connections that make music and architecture understand each other, and accompany and merge their forces and energies into one space, that of our spirituality.

ANTÓN GARCÍA-ABRIL AND DÉBORA MESA, ENSAMBLE STUDIO

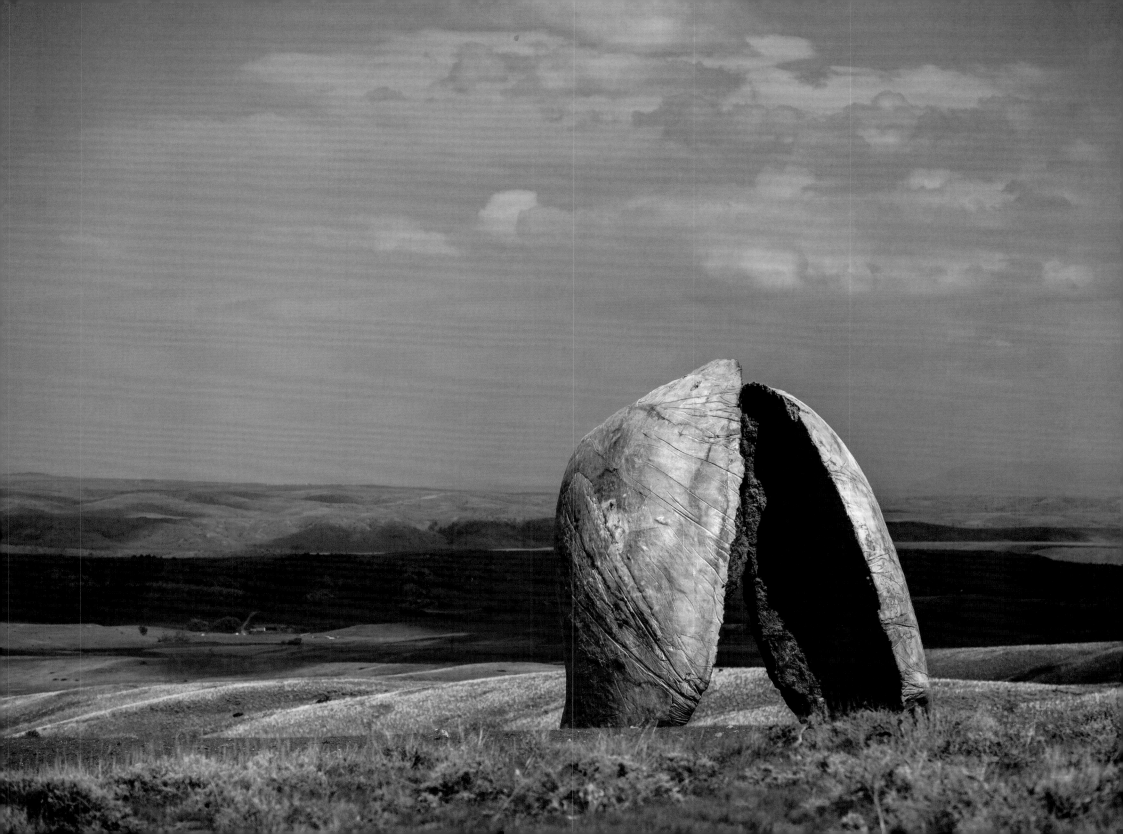

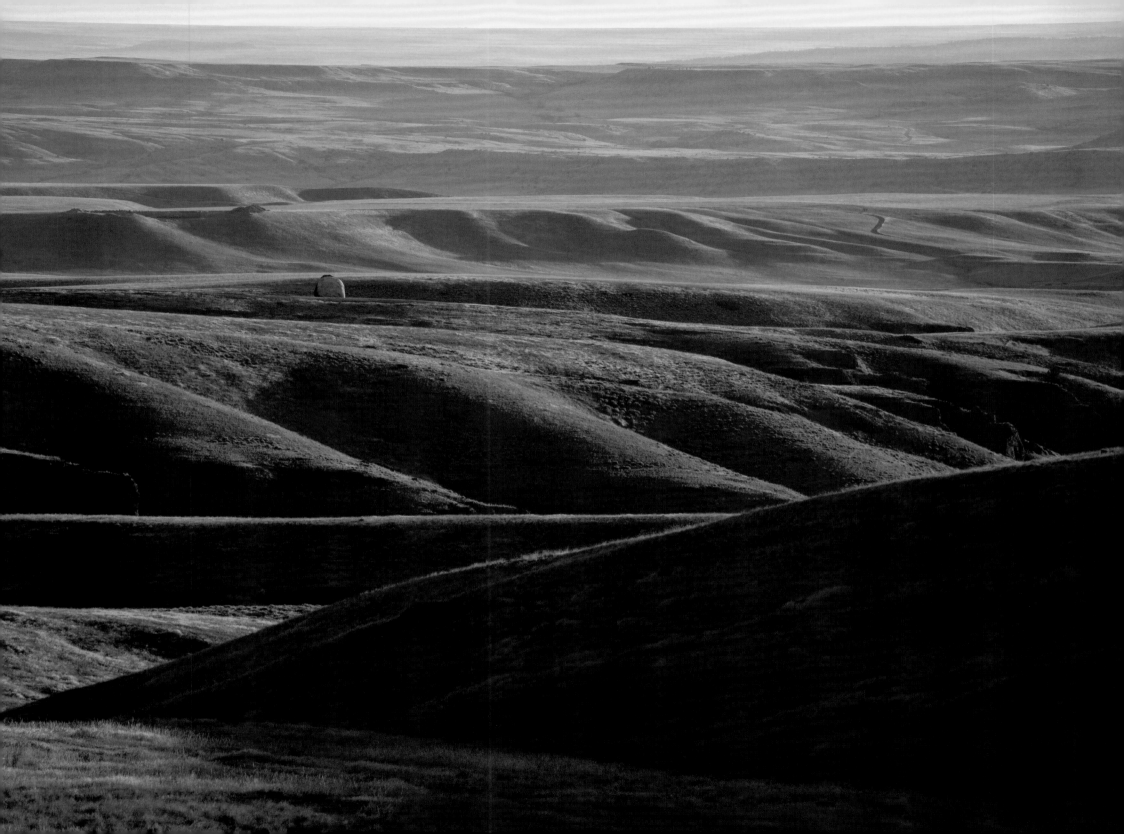

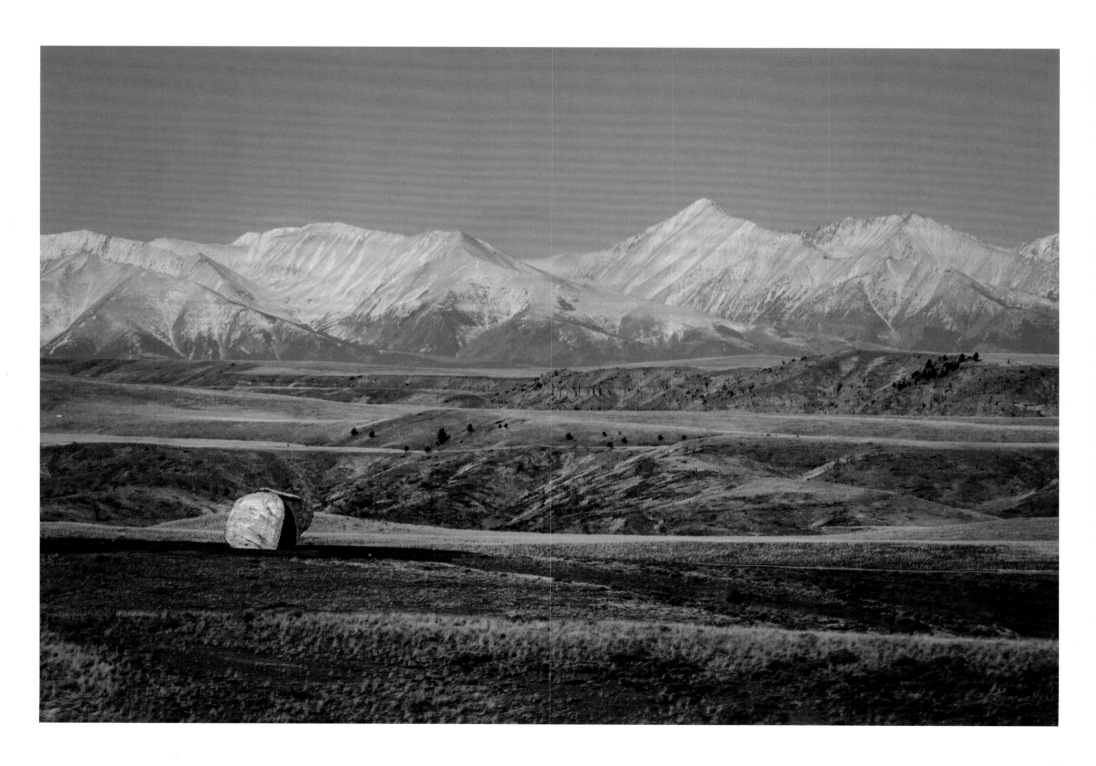

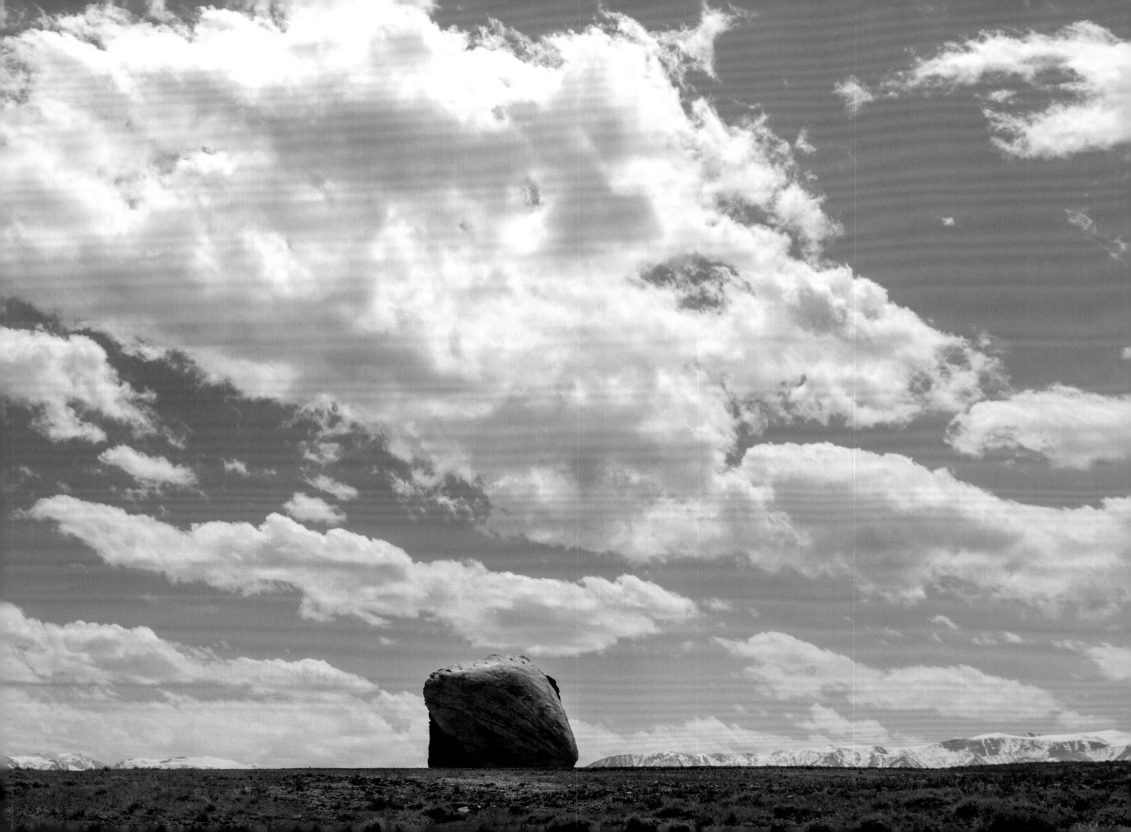

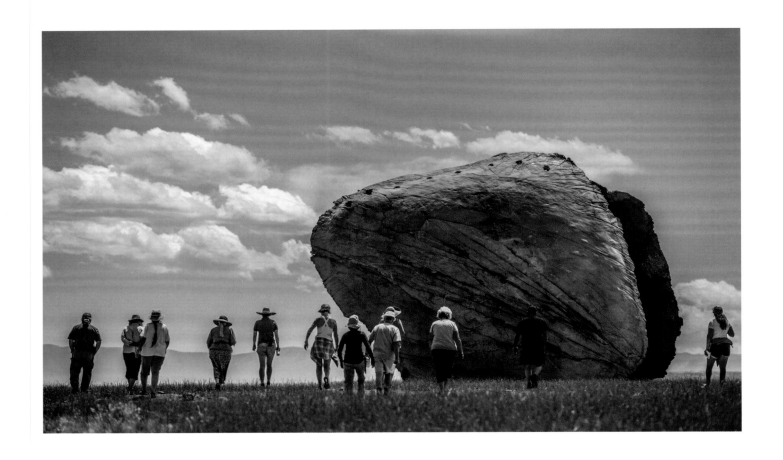

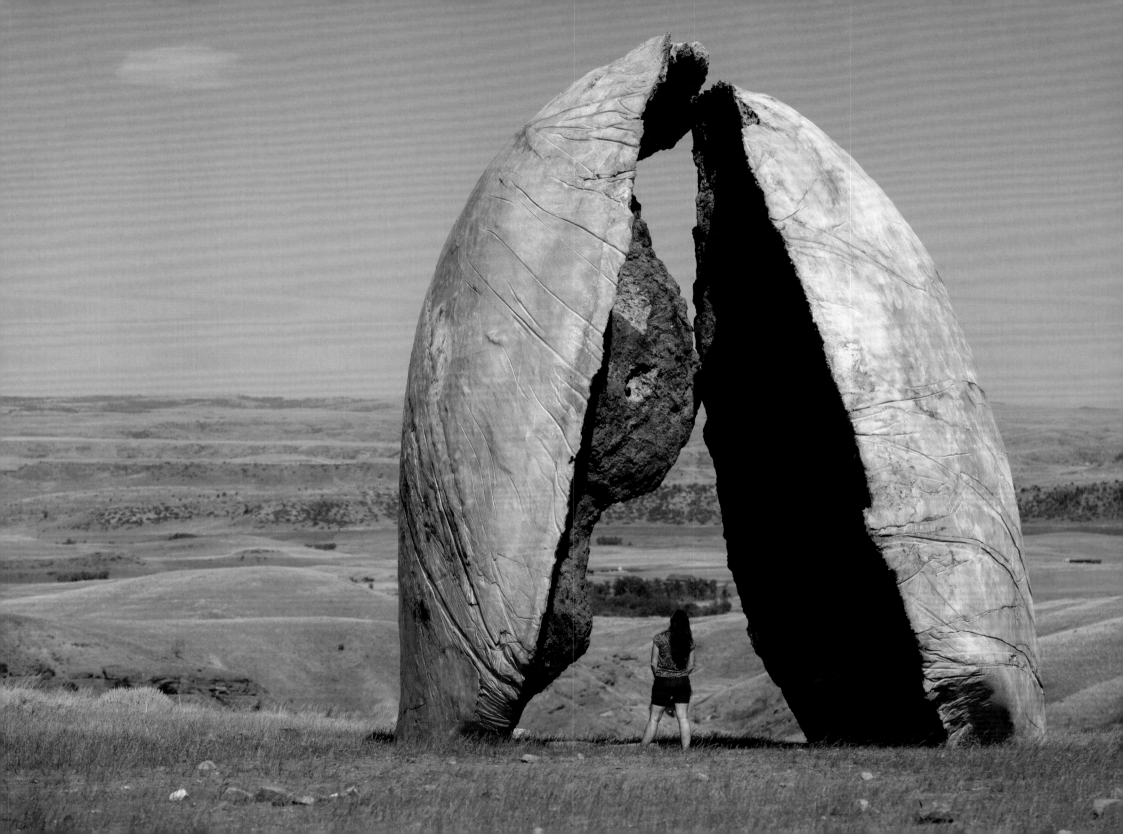

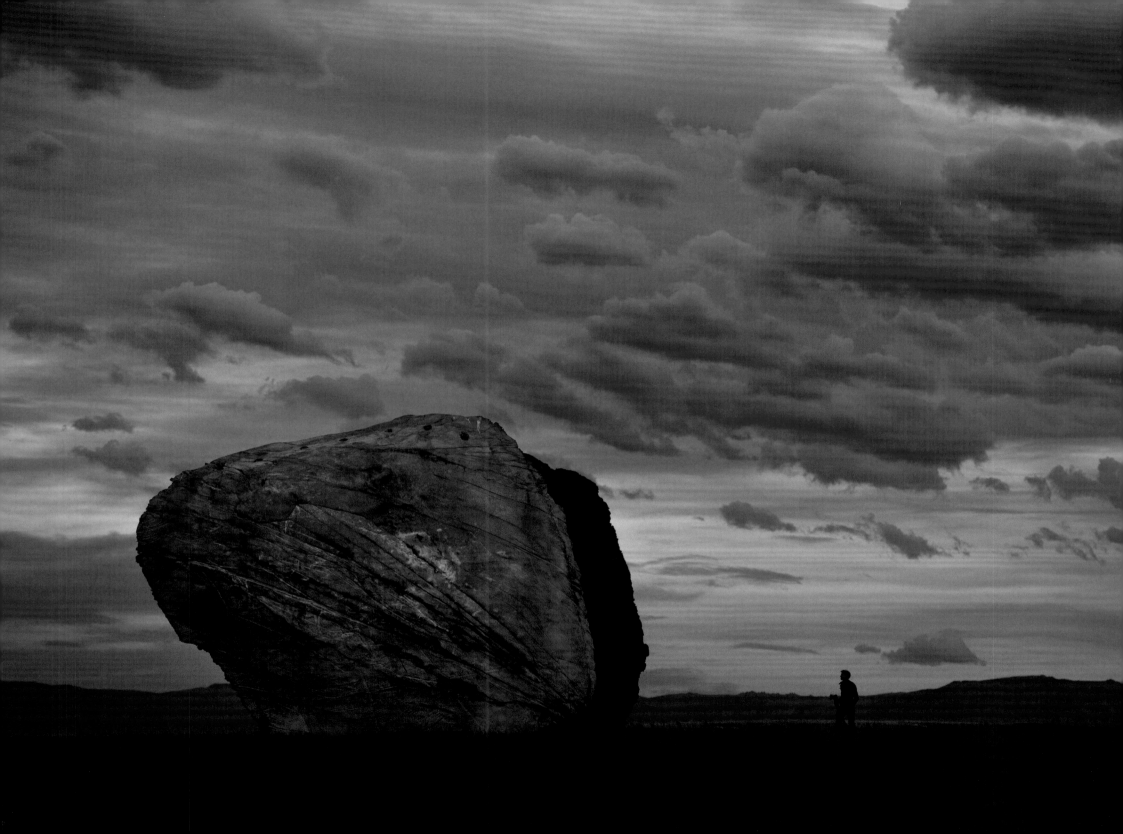

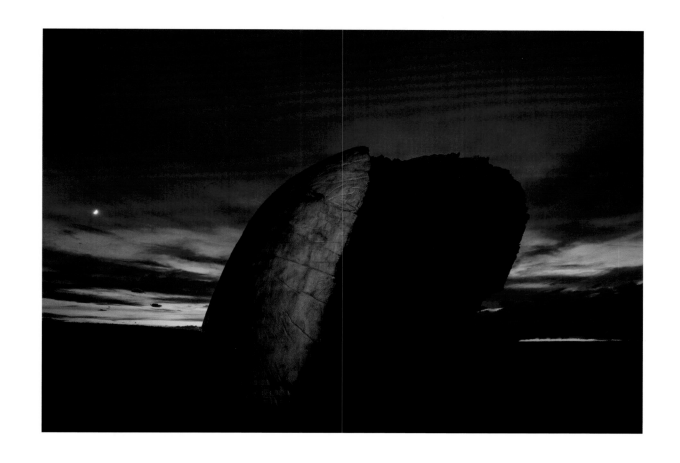

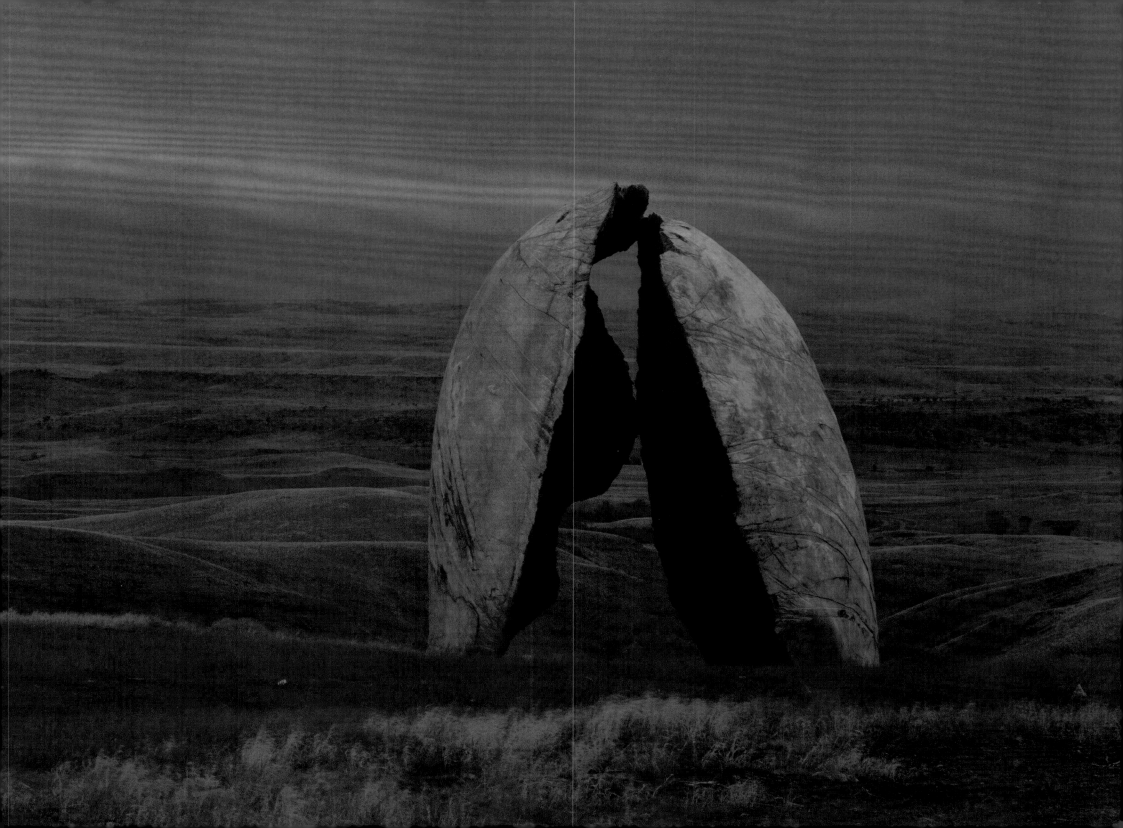

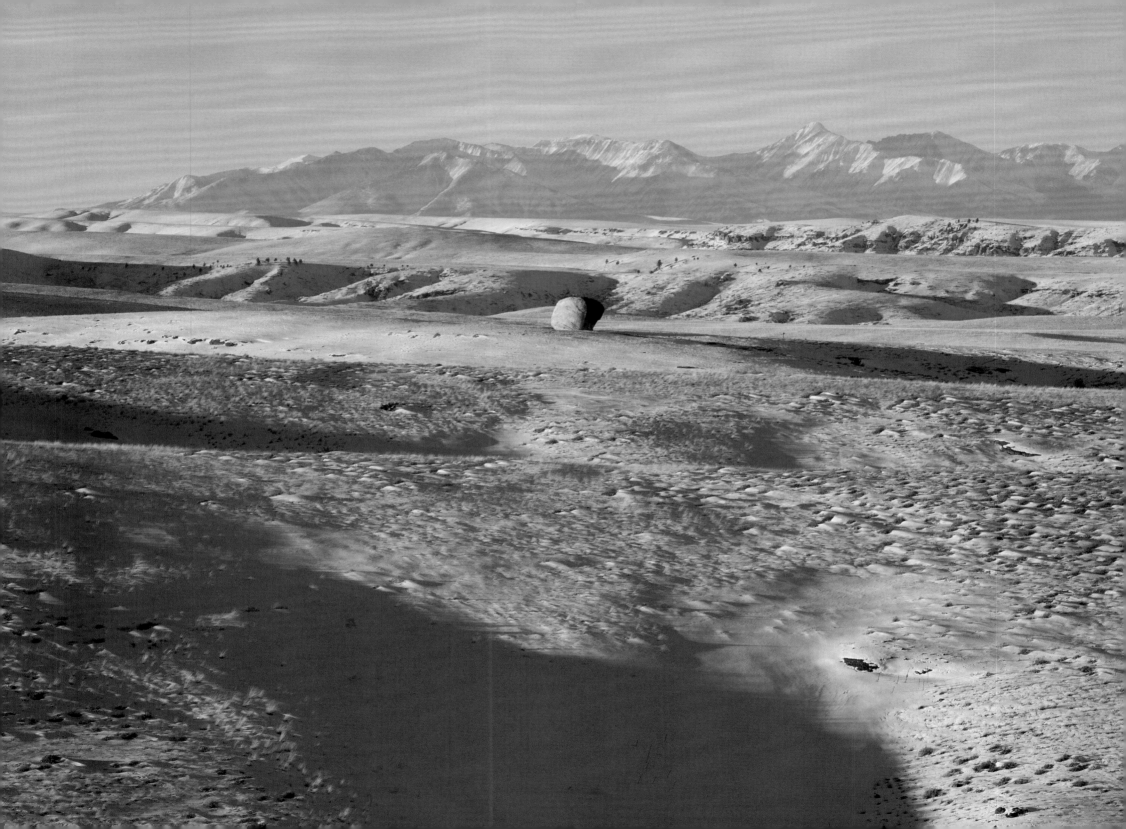

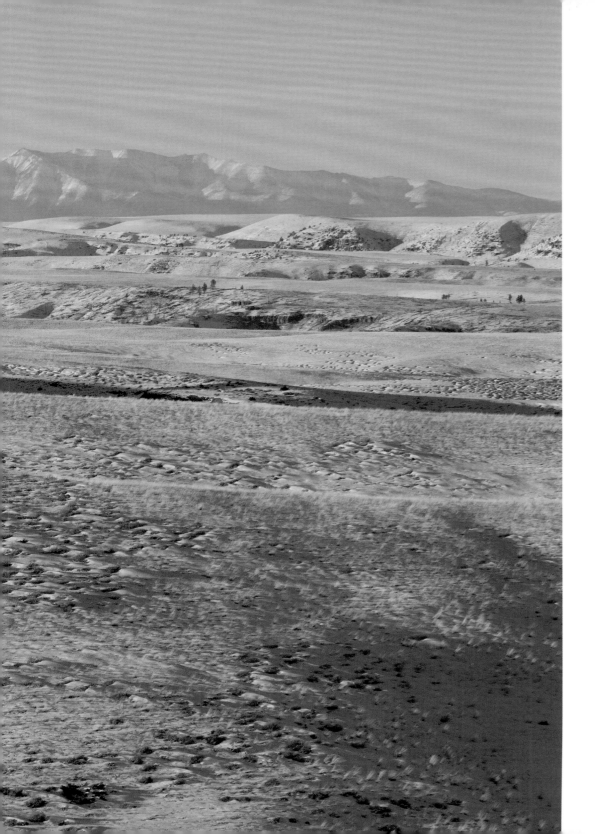

Common Sense

Bent on finding patterns
In the holes punched
Through snow by water's
Typing, random wells

Of ink that seem to swell
More by style than link,
A stream might care
For something in the air

The opposite of gravity,
Which might imply that every
River wants the sky.

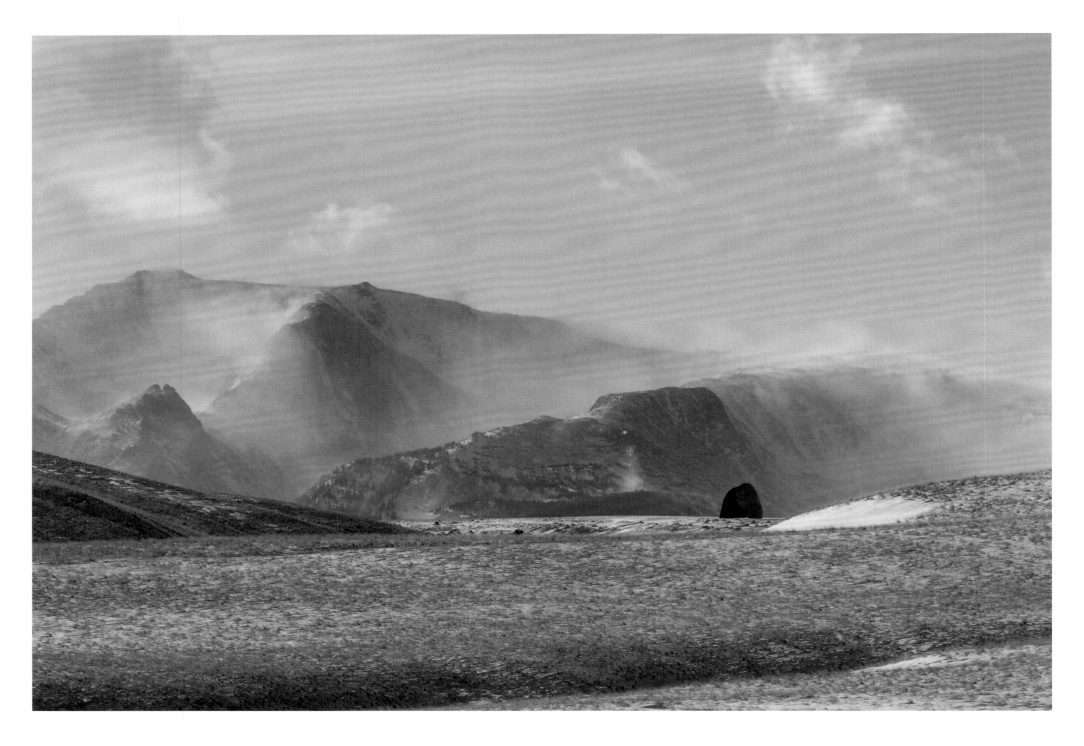

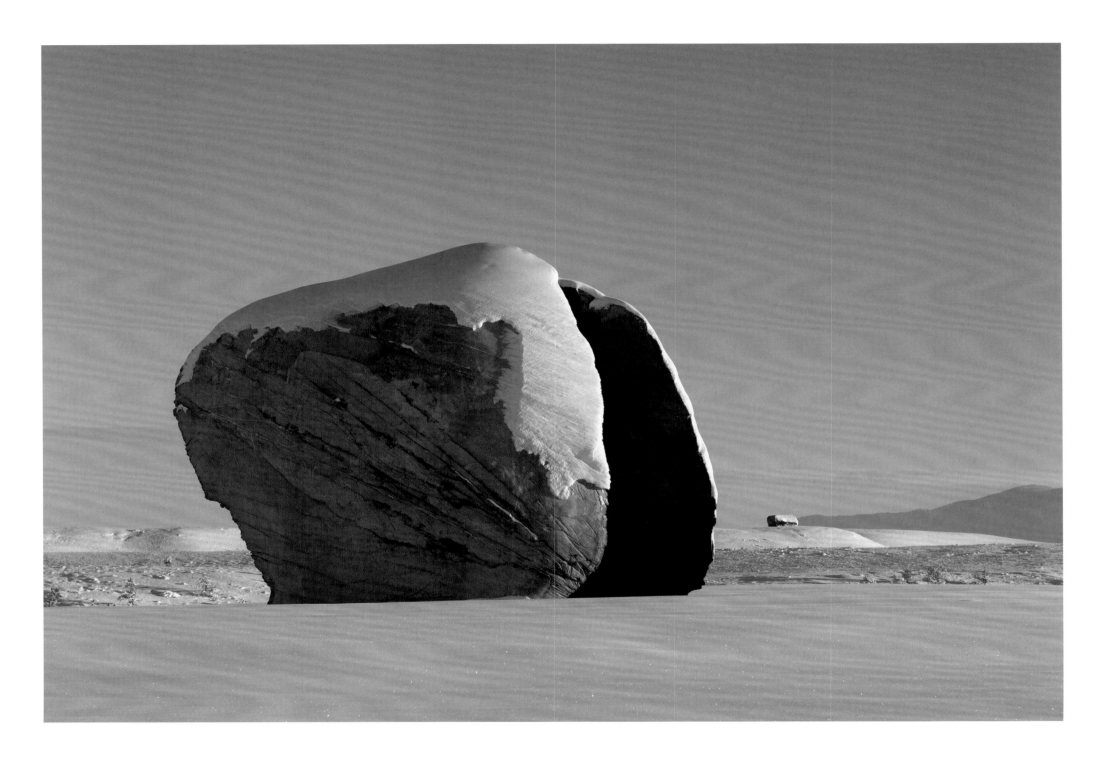

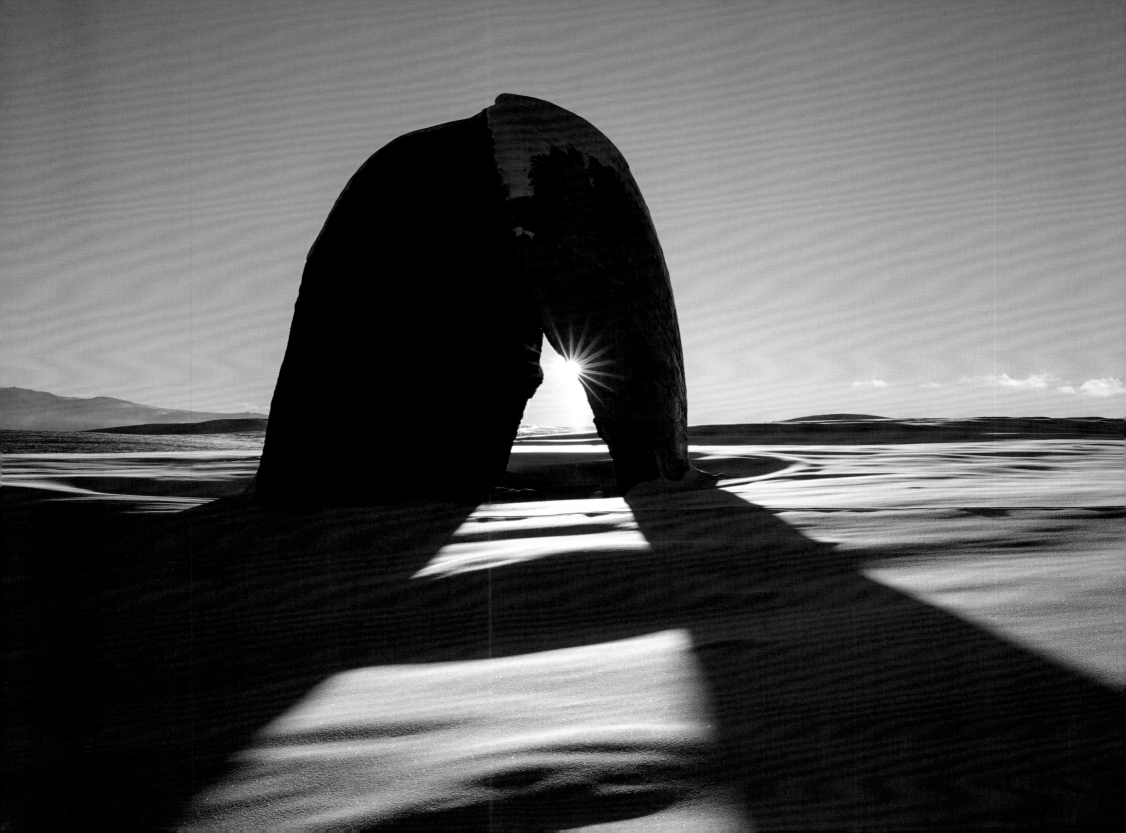

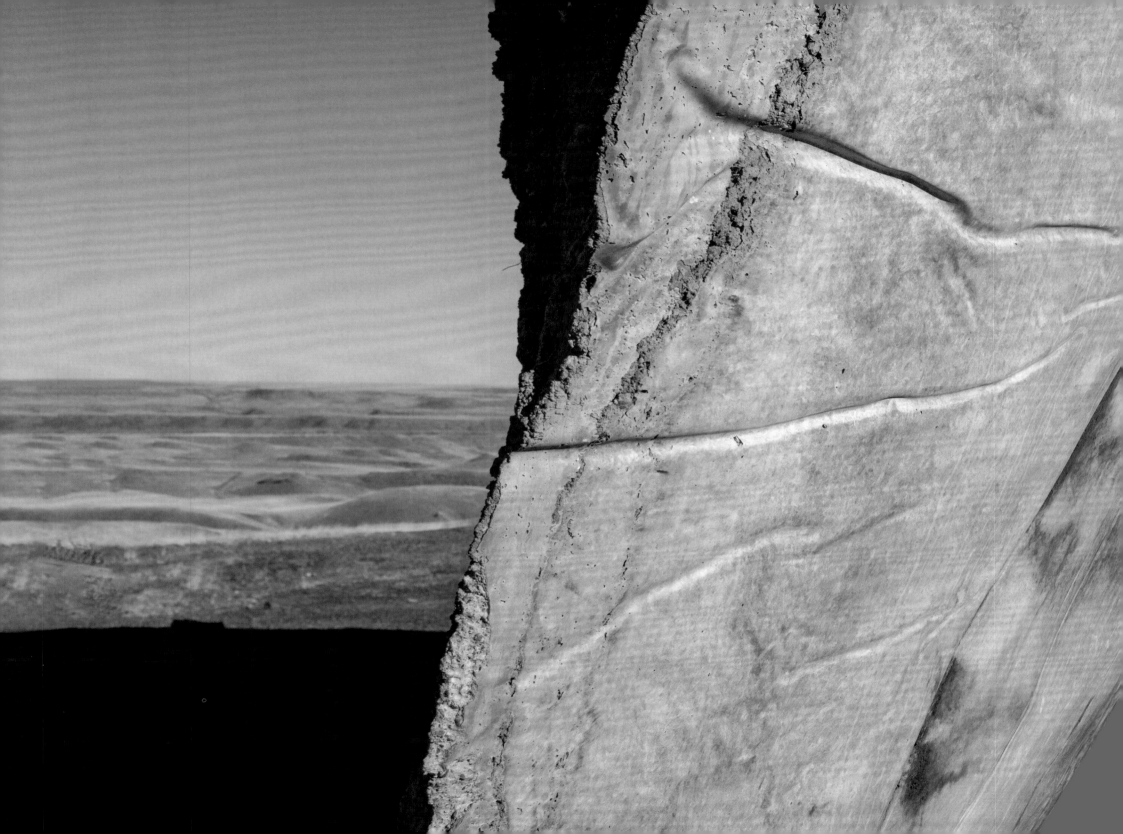

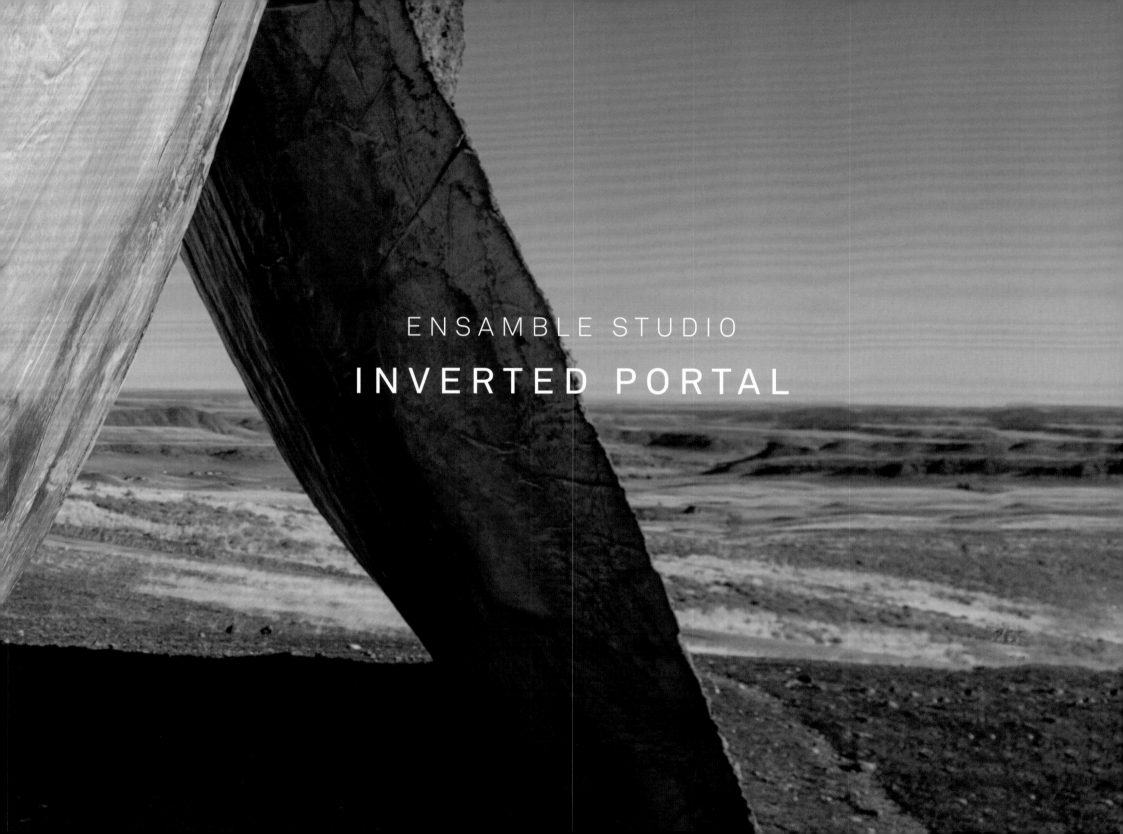

ENSAMBLE STUDIO

INVERTED PORTAL

Inverted Portal, 2016

Earth, rock, cement, grass, and rebar

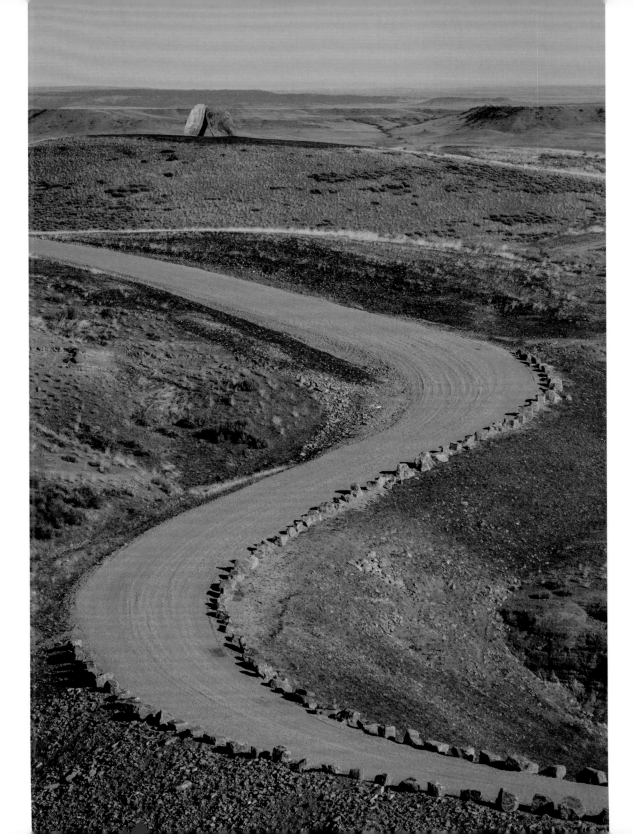

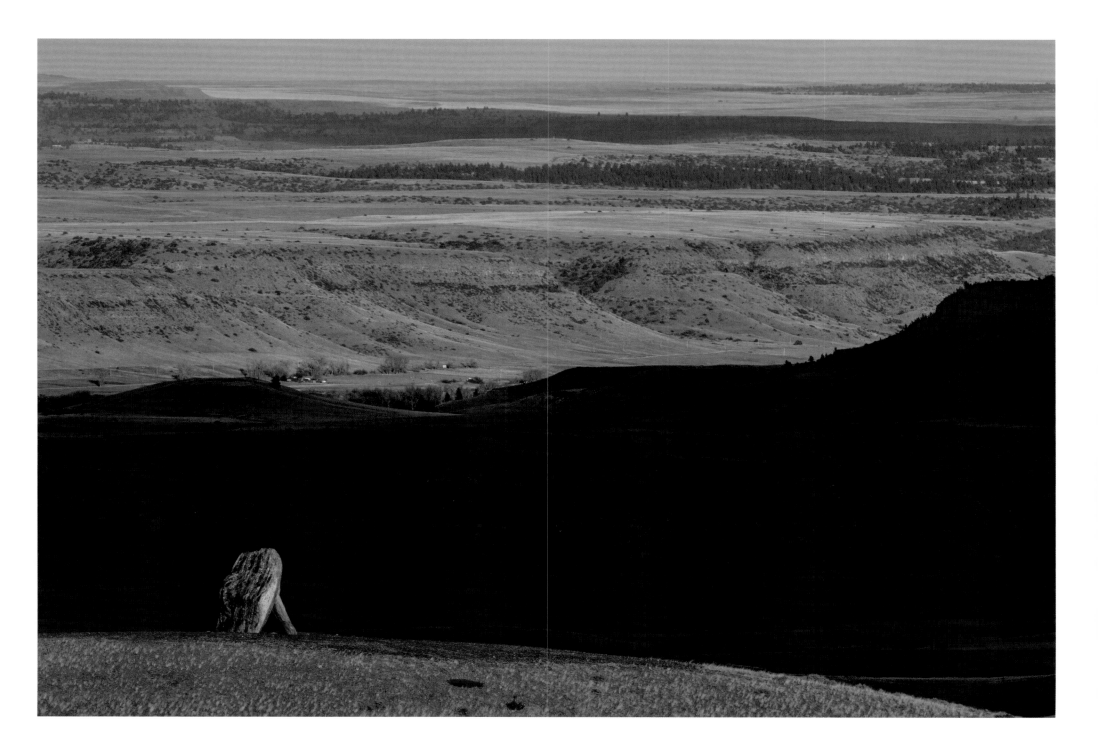

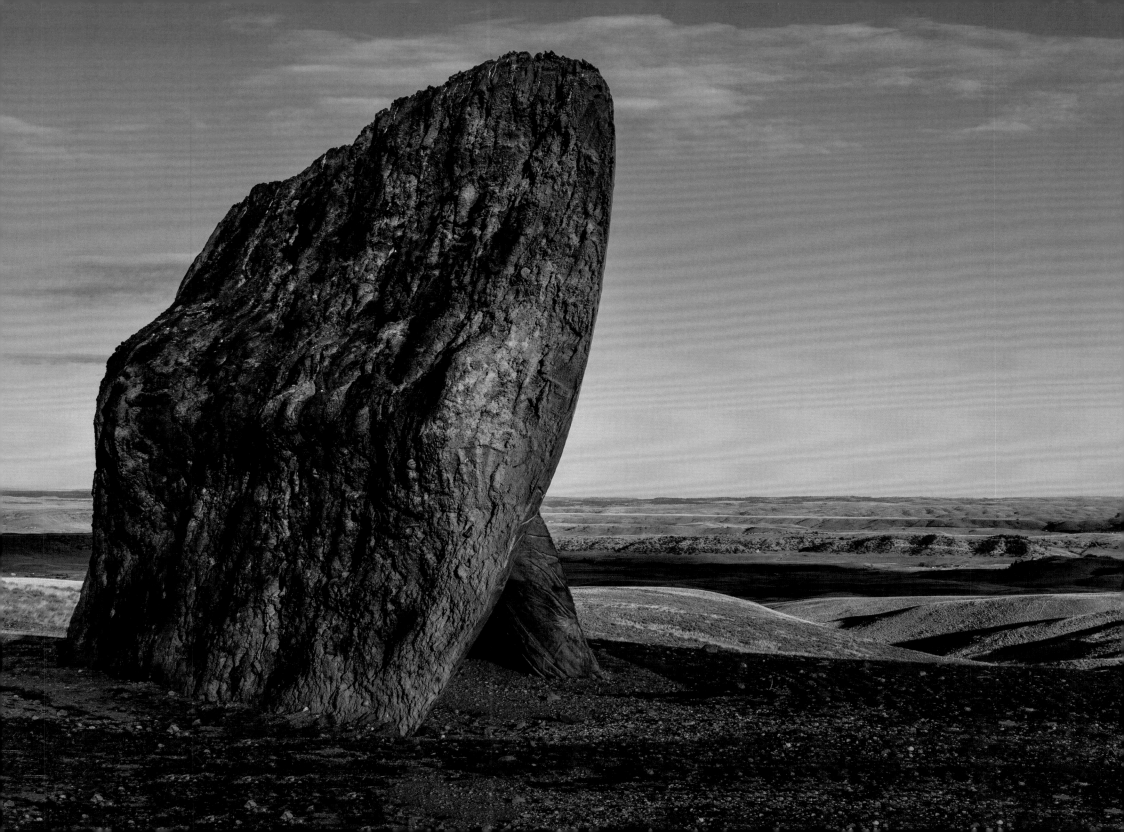

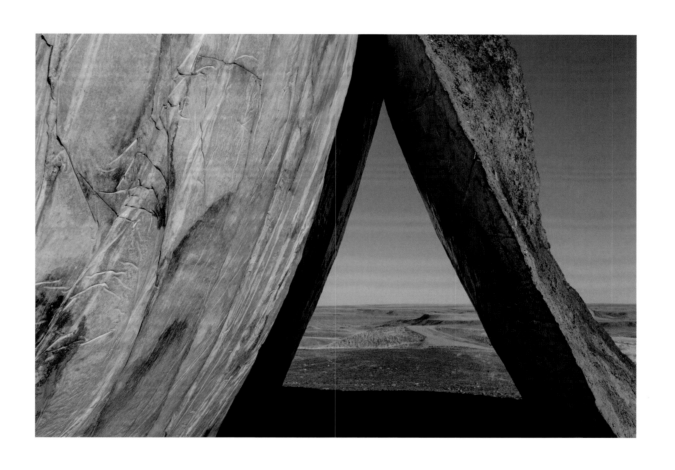

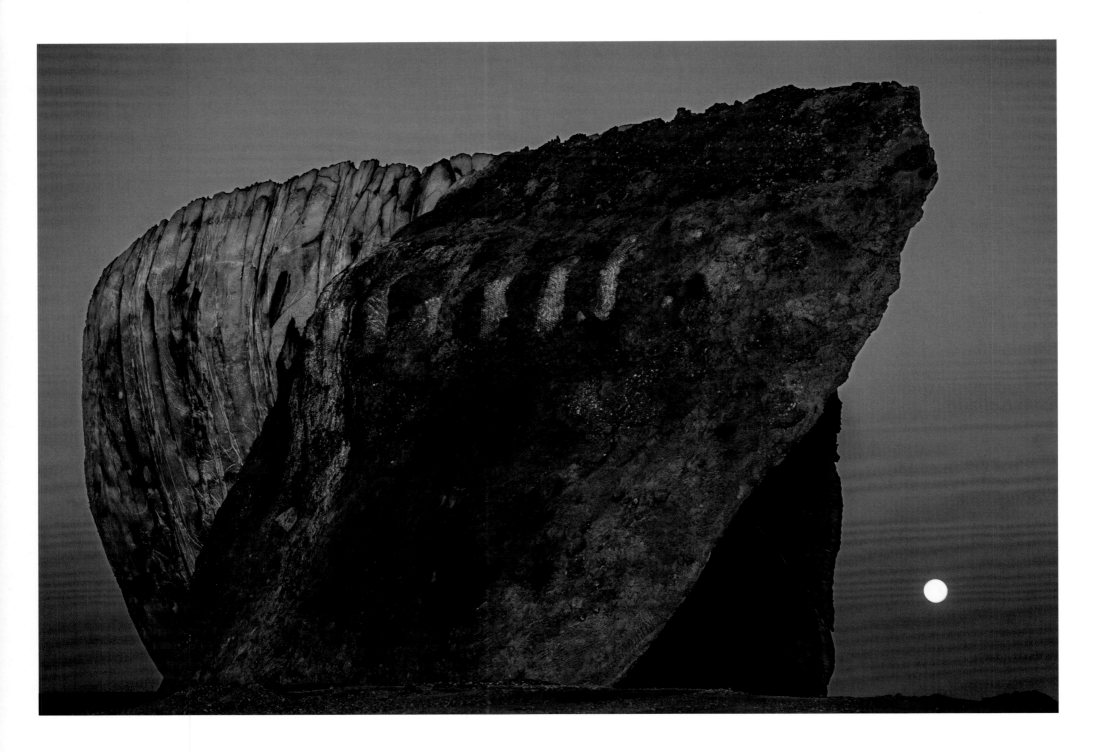

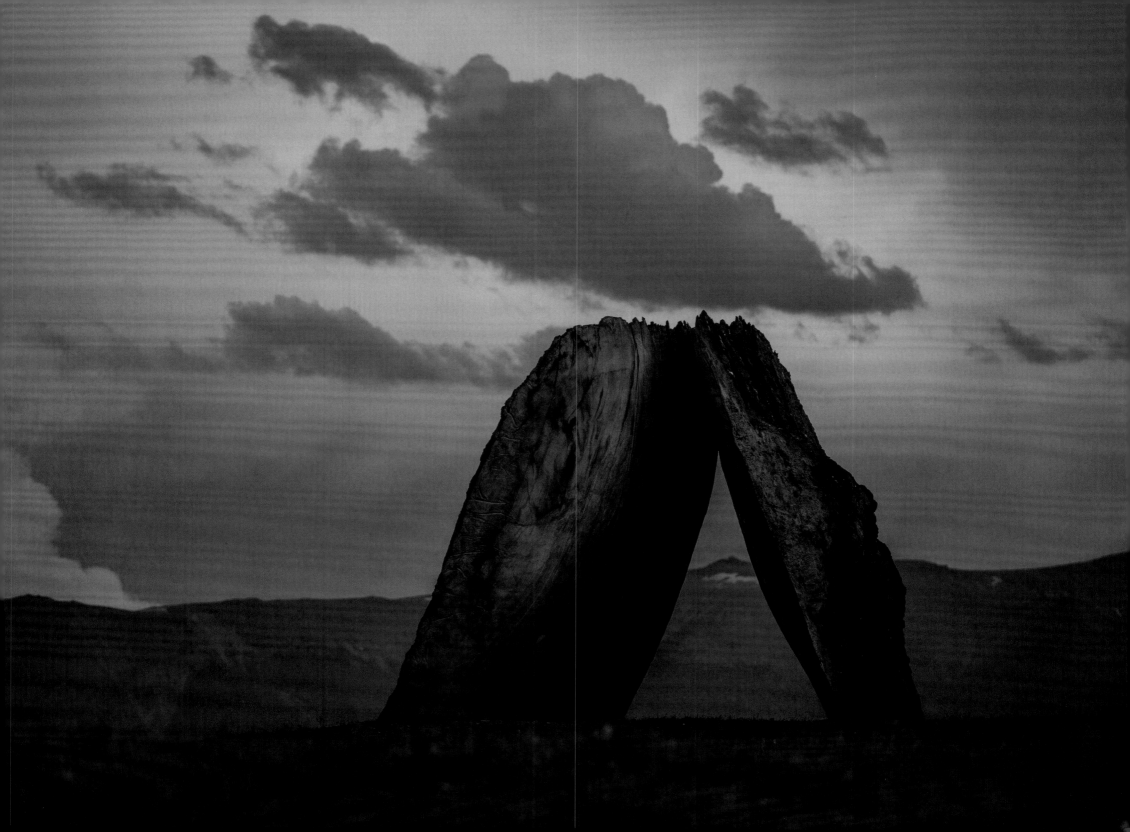

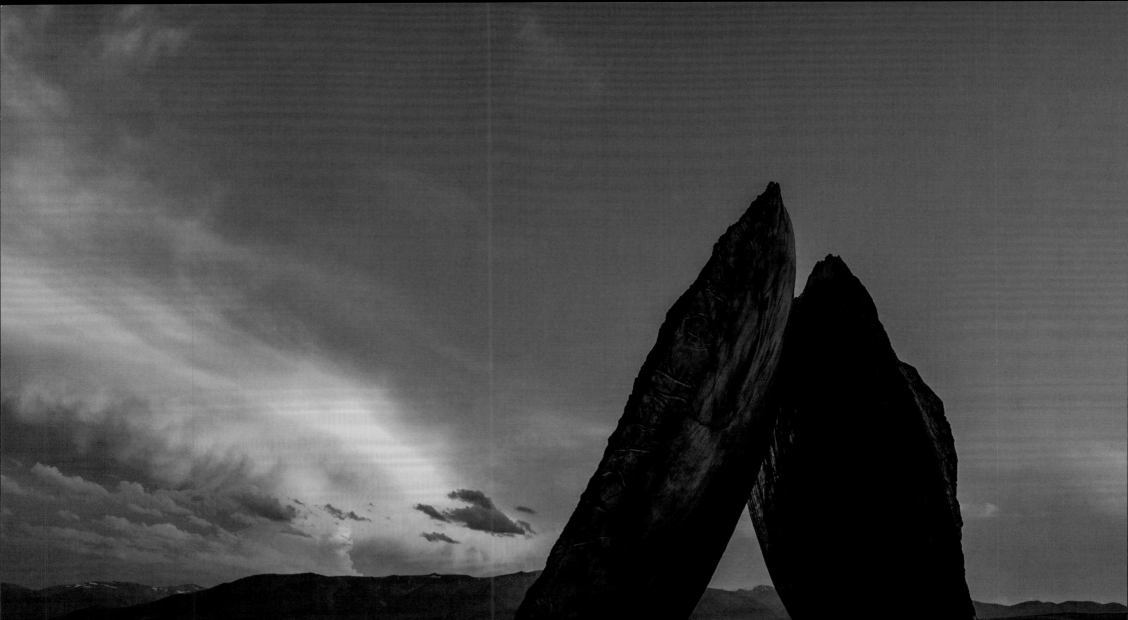

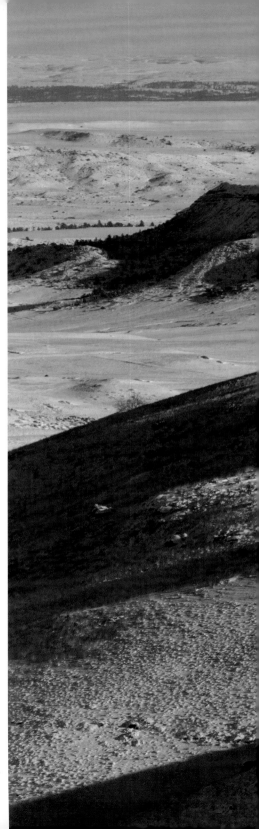

Hilltops

Here we are for one last night
To hold the heavens off
With copses at the ends
Of our planet's curving trough,
Stars surrounding bends
At the edges of the eye's
Reflected light,
Only wind and river in the sky,
Blurred by bursts of growing night,
The way the countryside
Was bathed in moonlit white
So many years ago,
Frozen now in icy pearls

To chiaroscuro,
Long gone worlds
Making here, before we sleep,
Cosseted by aspen, star,
And cloud, the endless meadow
Of dark matter far
Beyond our souvenirs—
Childhood, silence, summer sweep
One last minute on the lawn,
Before the real world disappears
Again at dawn.

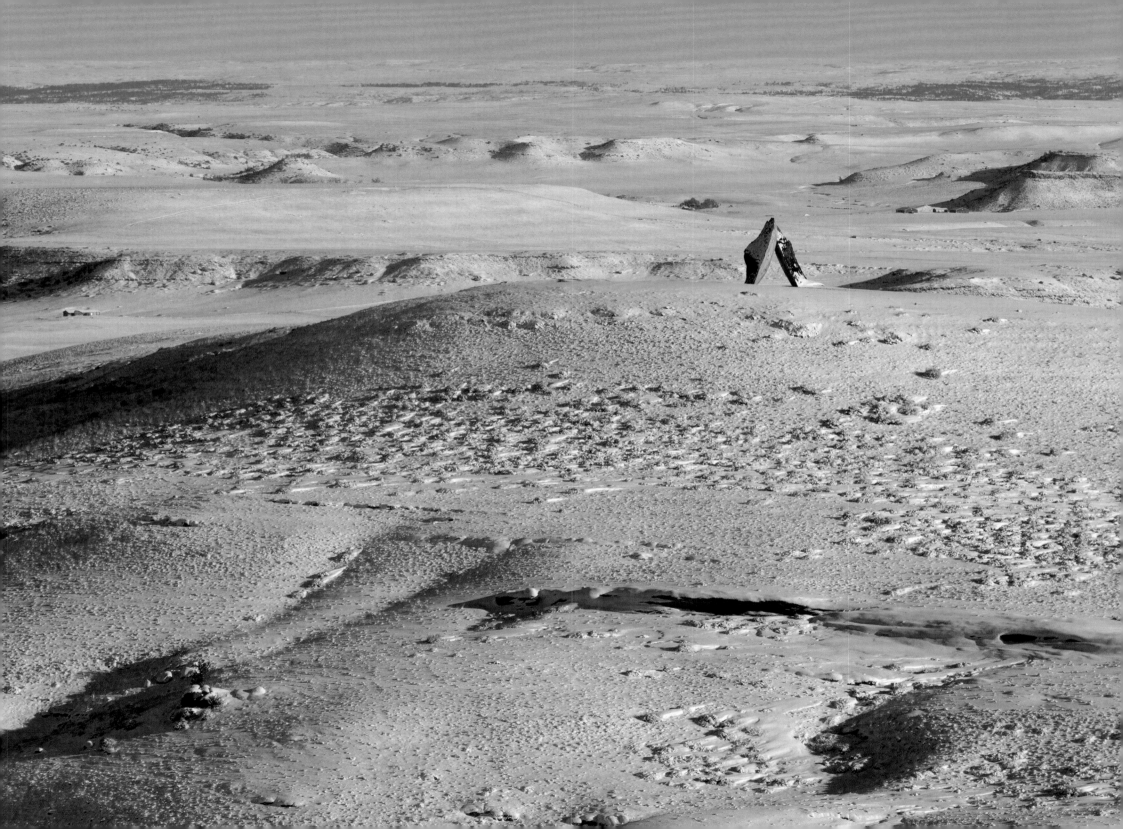

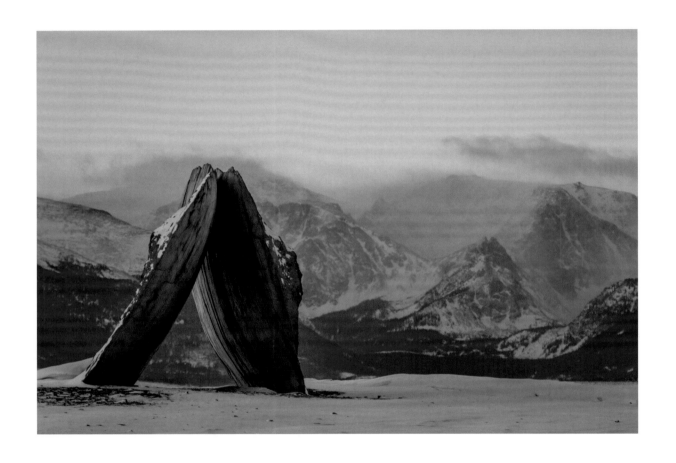

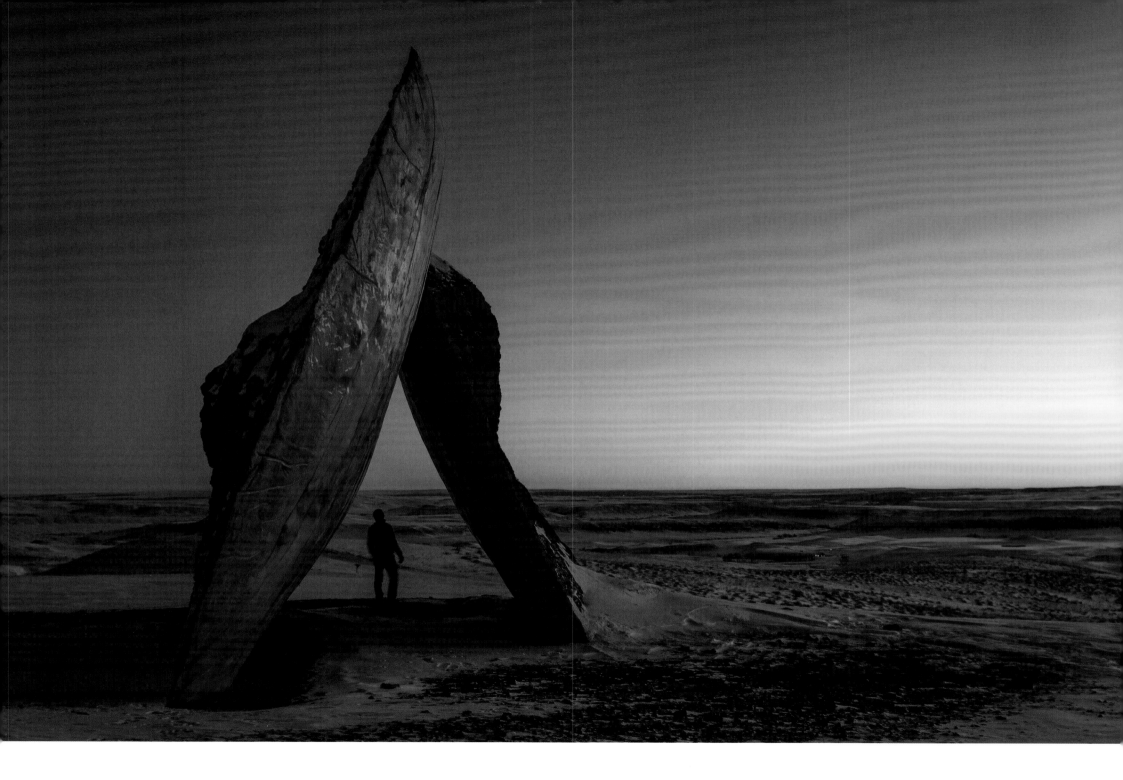

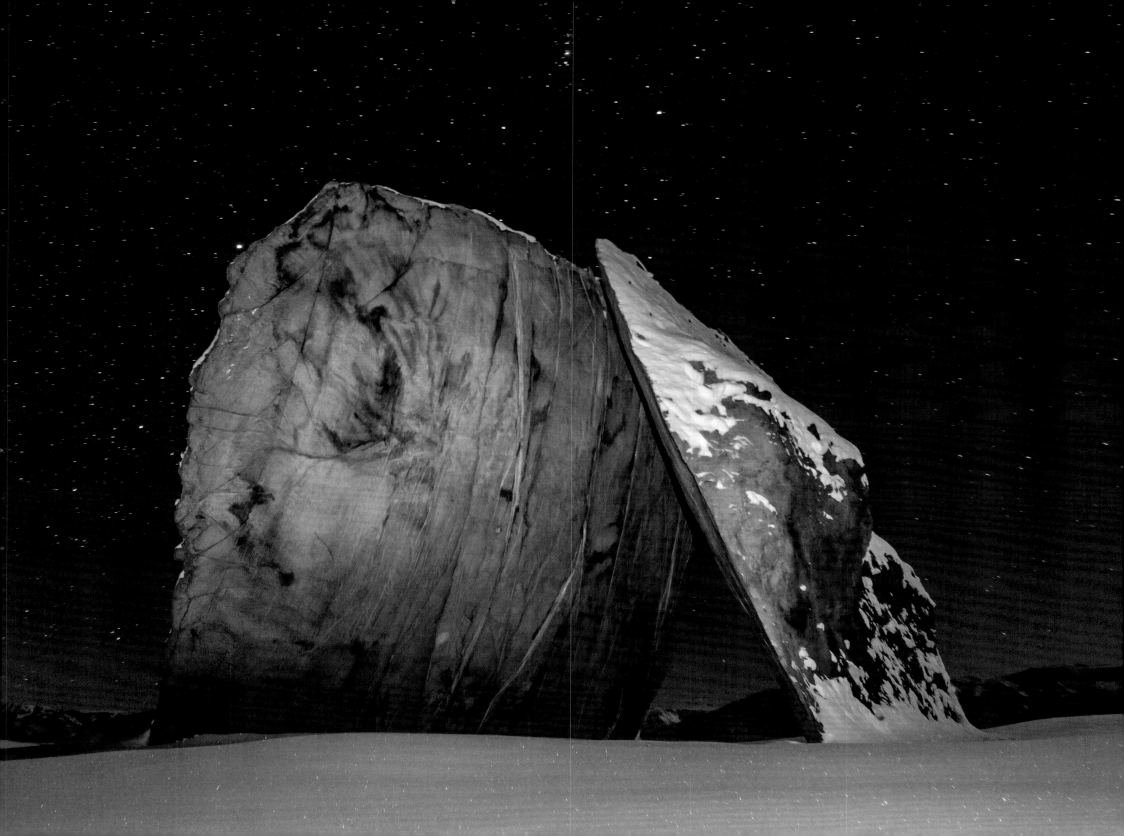

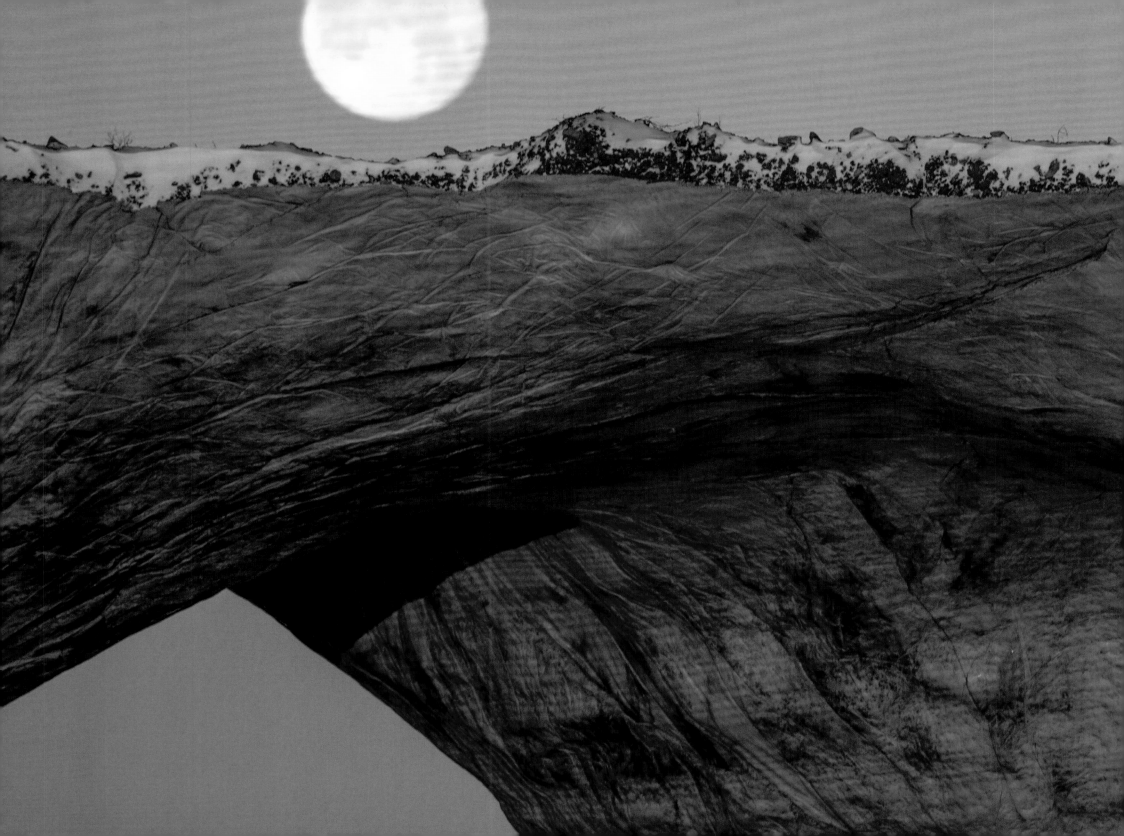

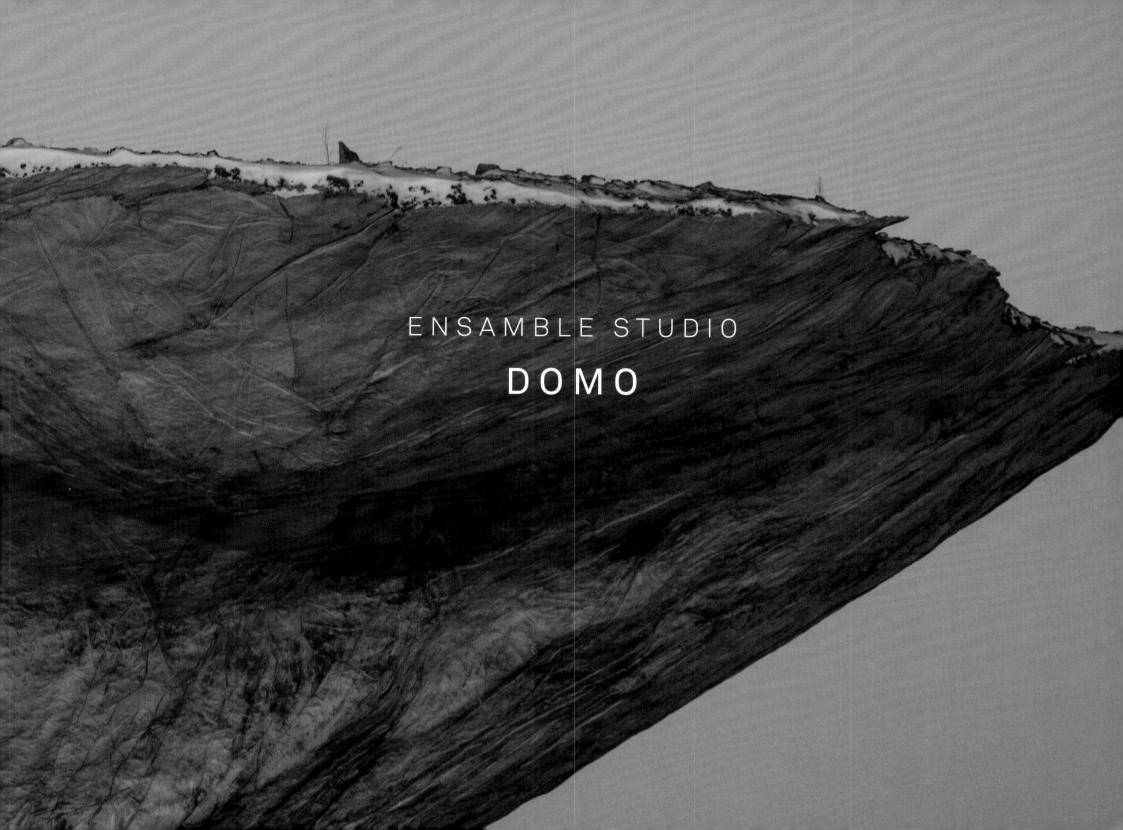

ENSAMBLE STUDIO

DOMO

Domo, 2016
Earth, rock, cement, grass, and rebar

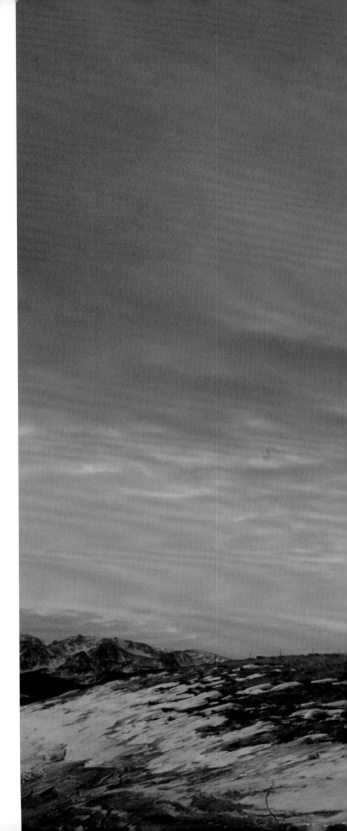

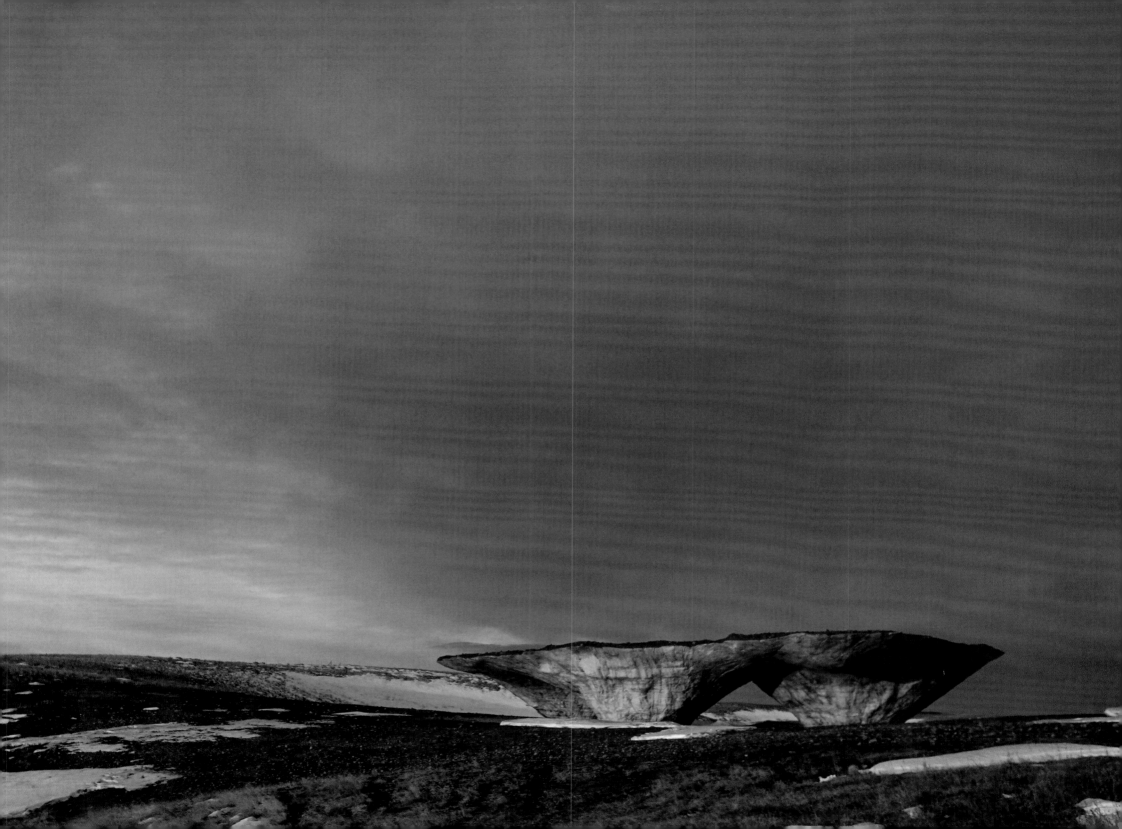

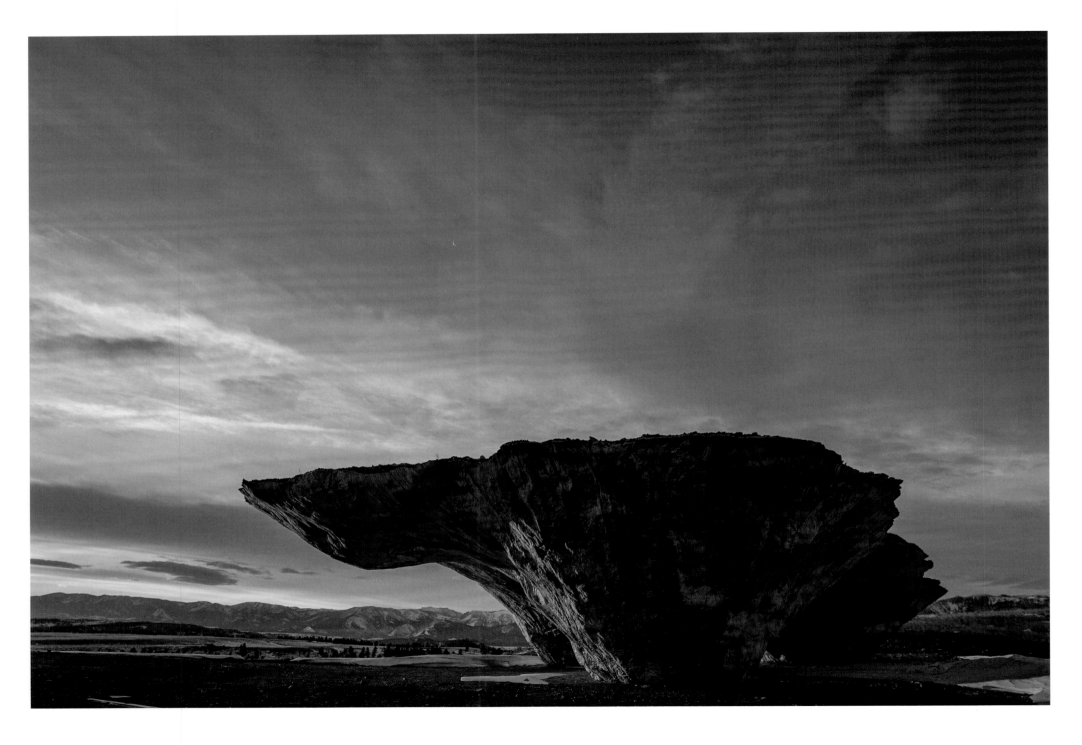

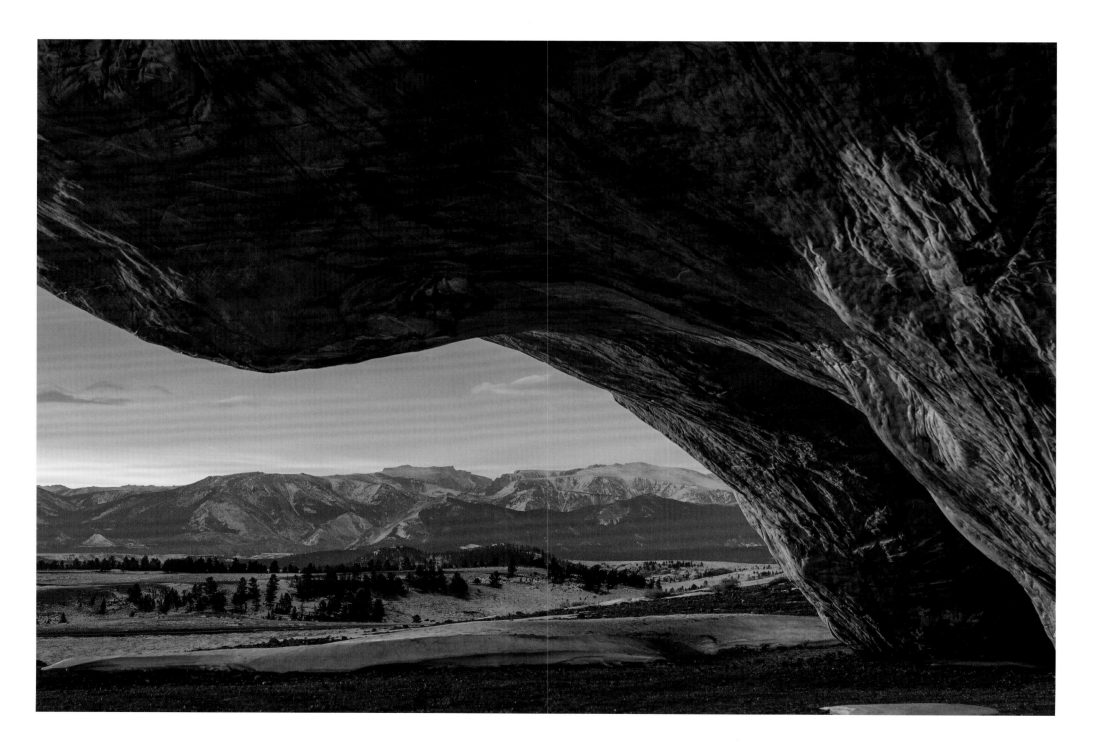

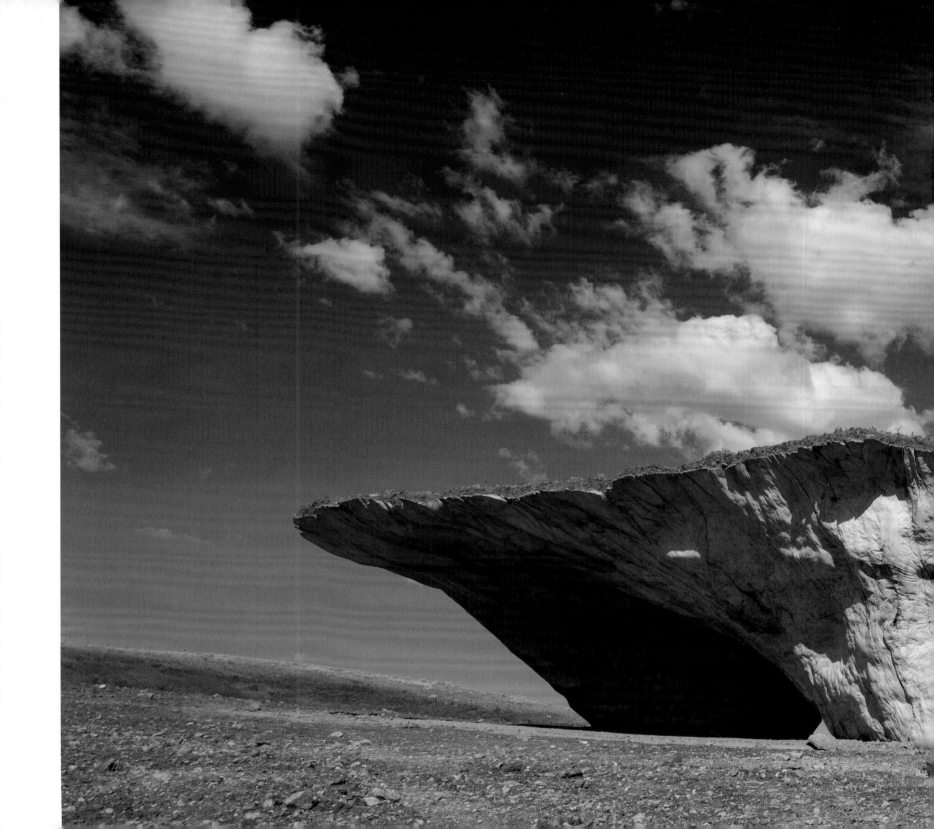

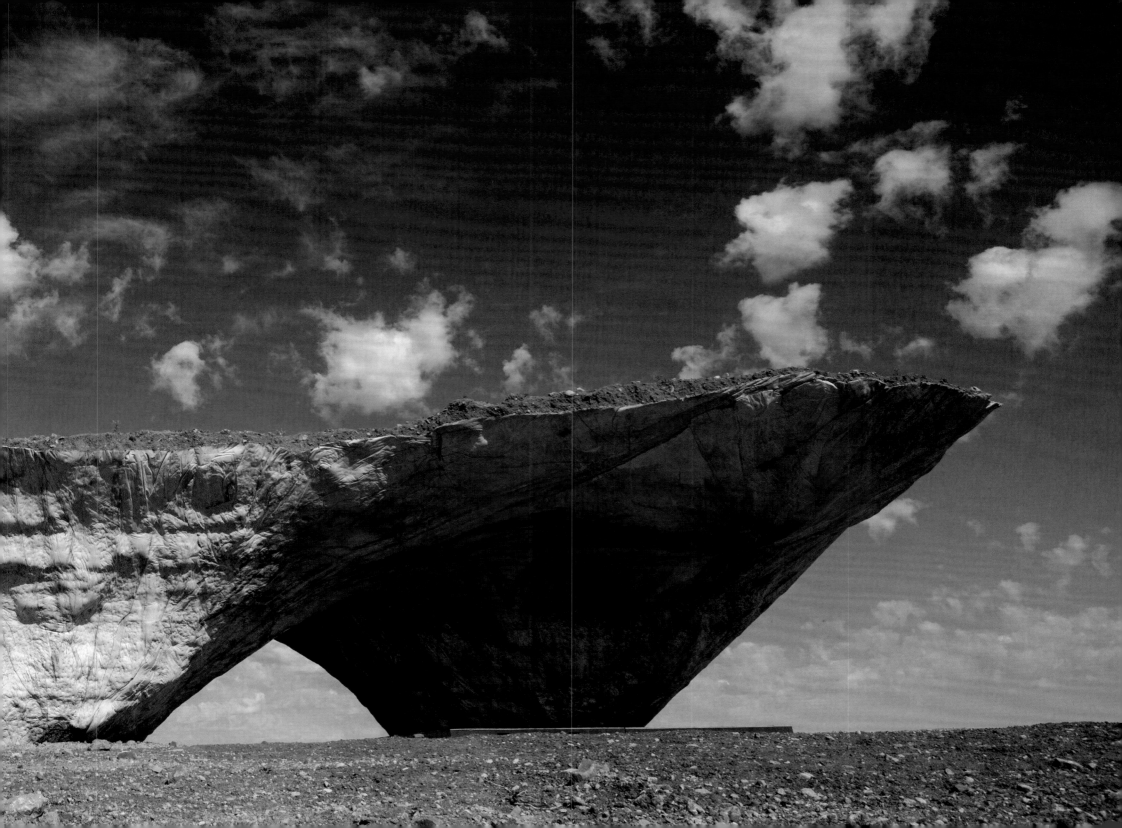

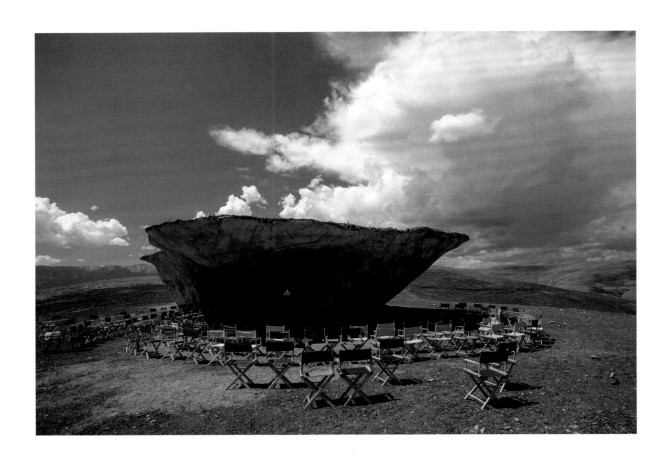

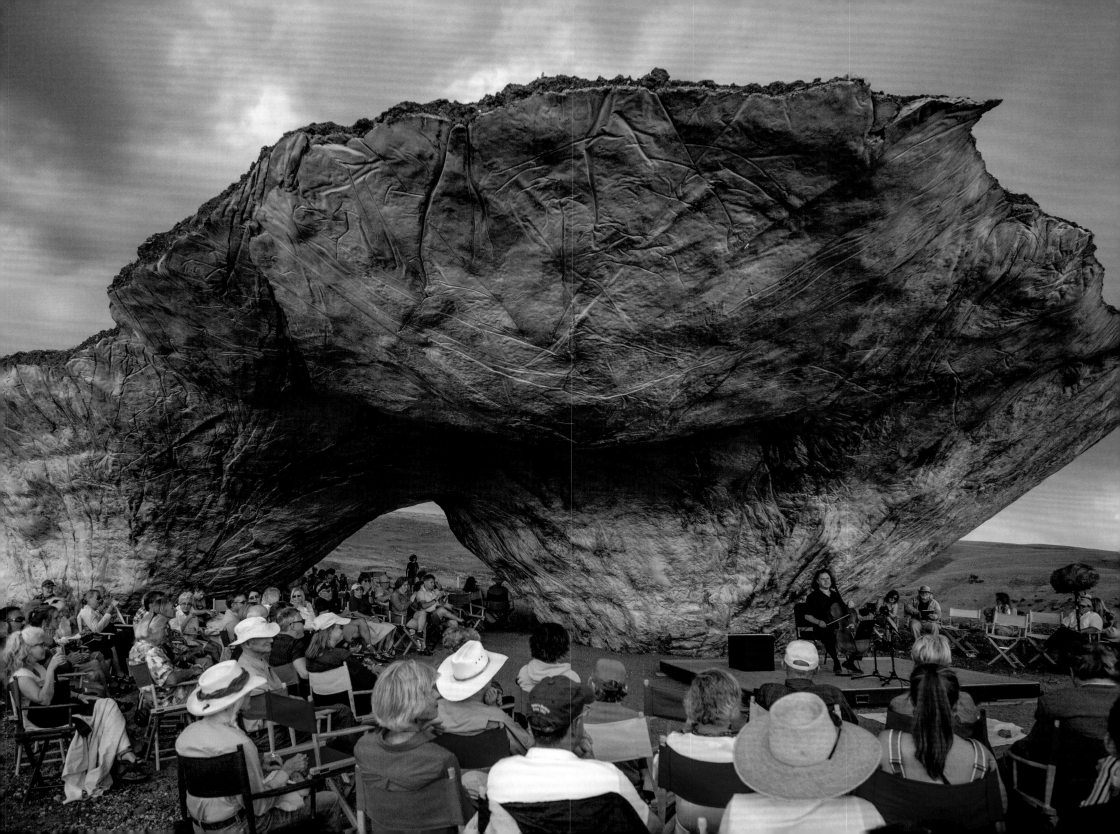

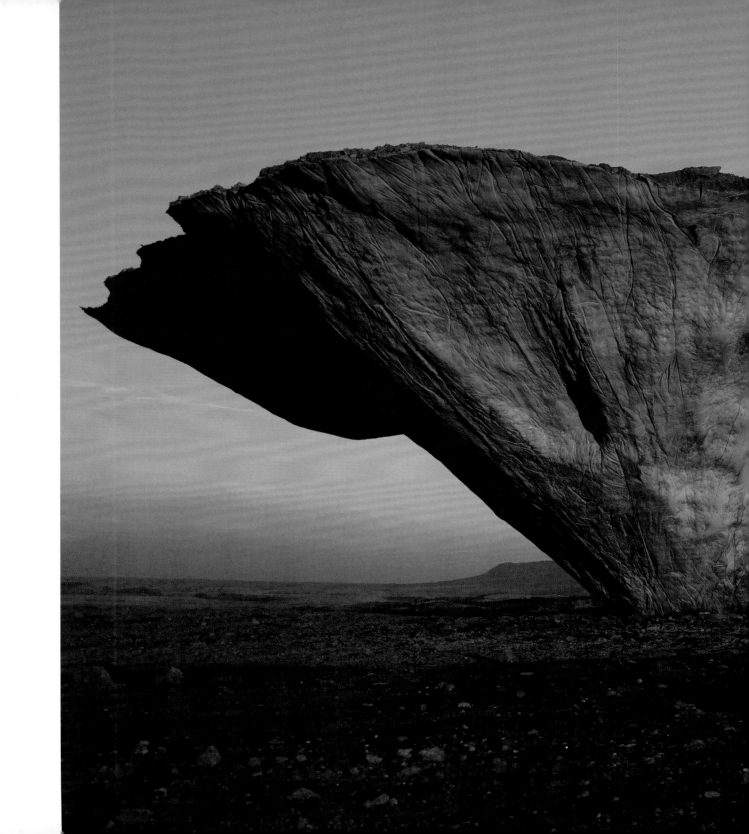

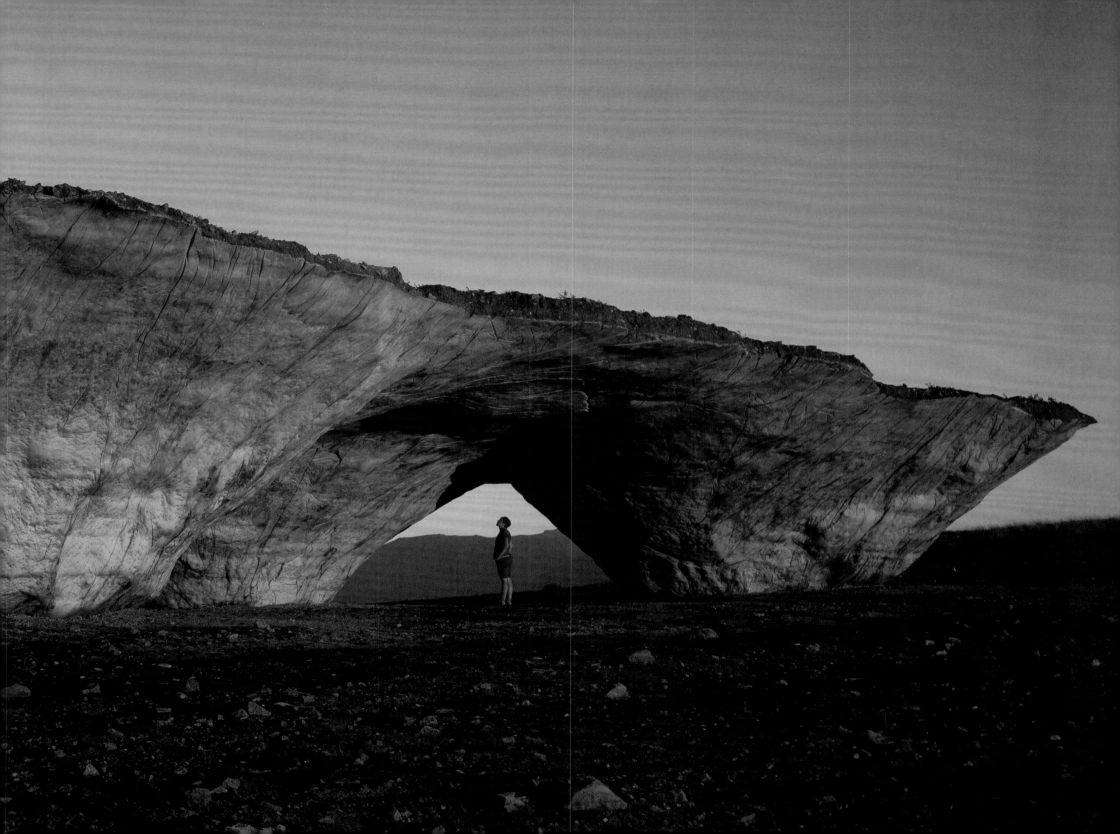

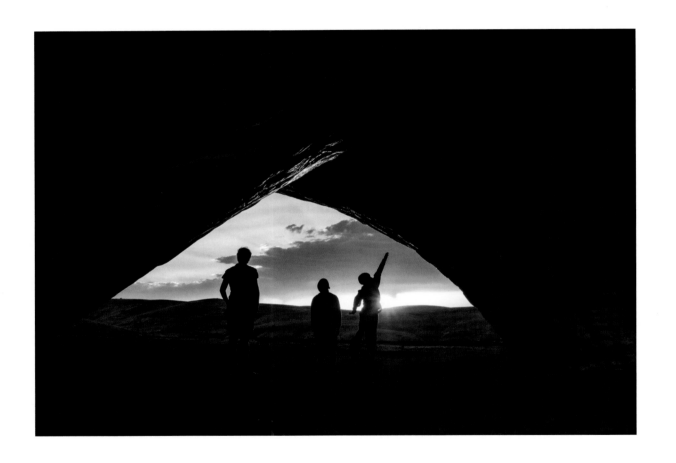

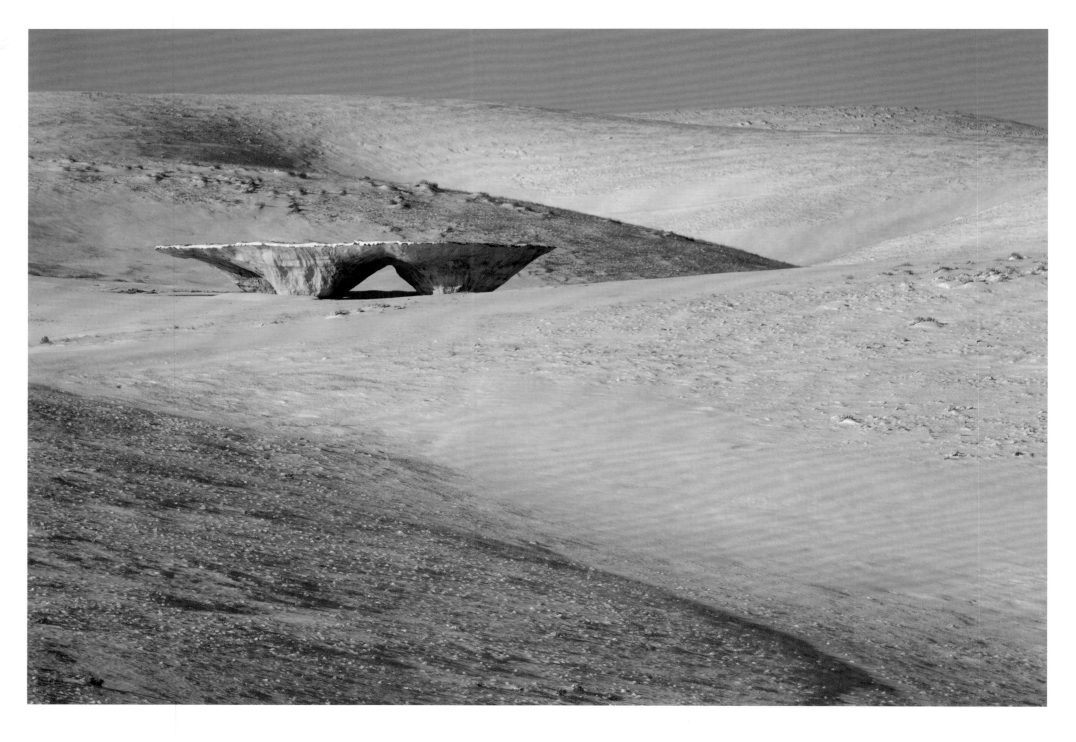

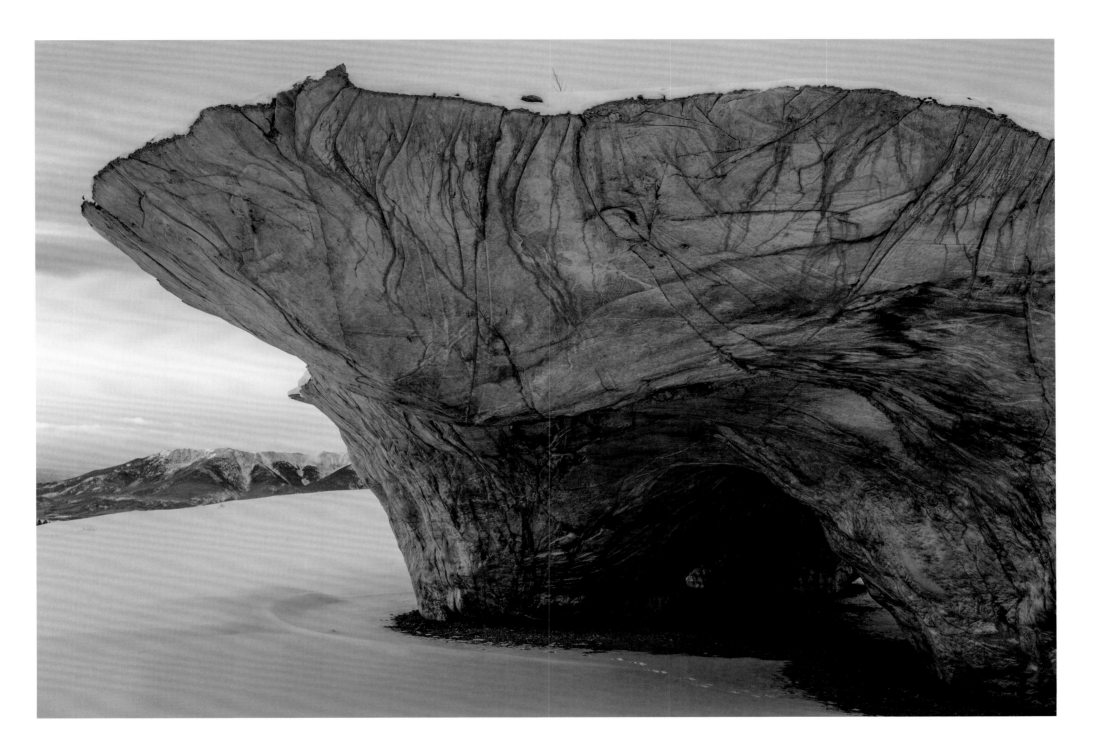

Piano Maker

Gnarls and boles, whatever woodwork words
Can turn or blur to use, to glue, to growth
Of board or bed, I know: I use their surds
And darkened boughs like fingers, so that both

Our hands are heard together on the keyboard
Bark; no sounds but branches rise
To leaf through breezes in the scattered cord
Of sheaves and limbs, inking in the dyes,

The ivories of silence on the evening's rose
And shade; twisting up the wires of a day's
Old sun and funneling the body's splay
Of music into crowns of maple, and god knows,

I wind up nature's miniature keys
To play out, on a bed of vines,
The tune of my own trees.

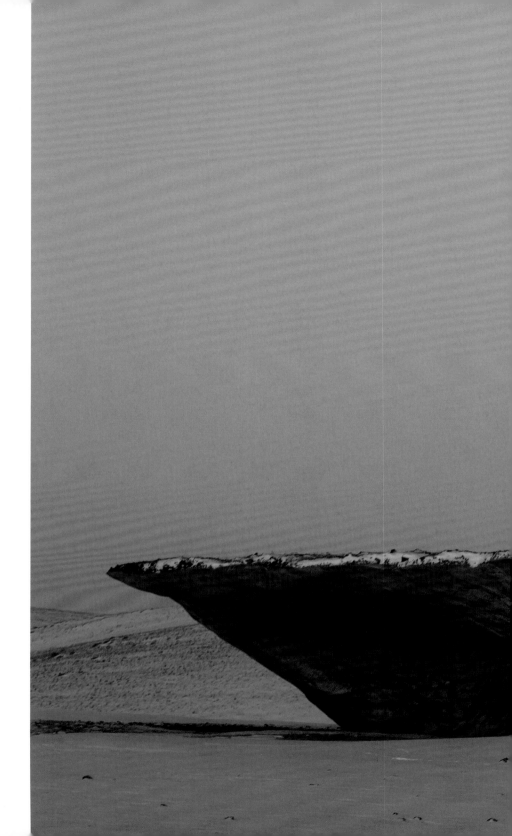

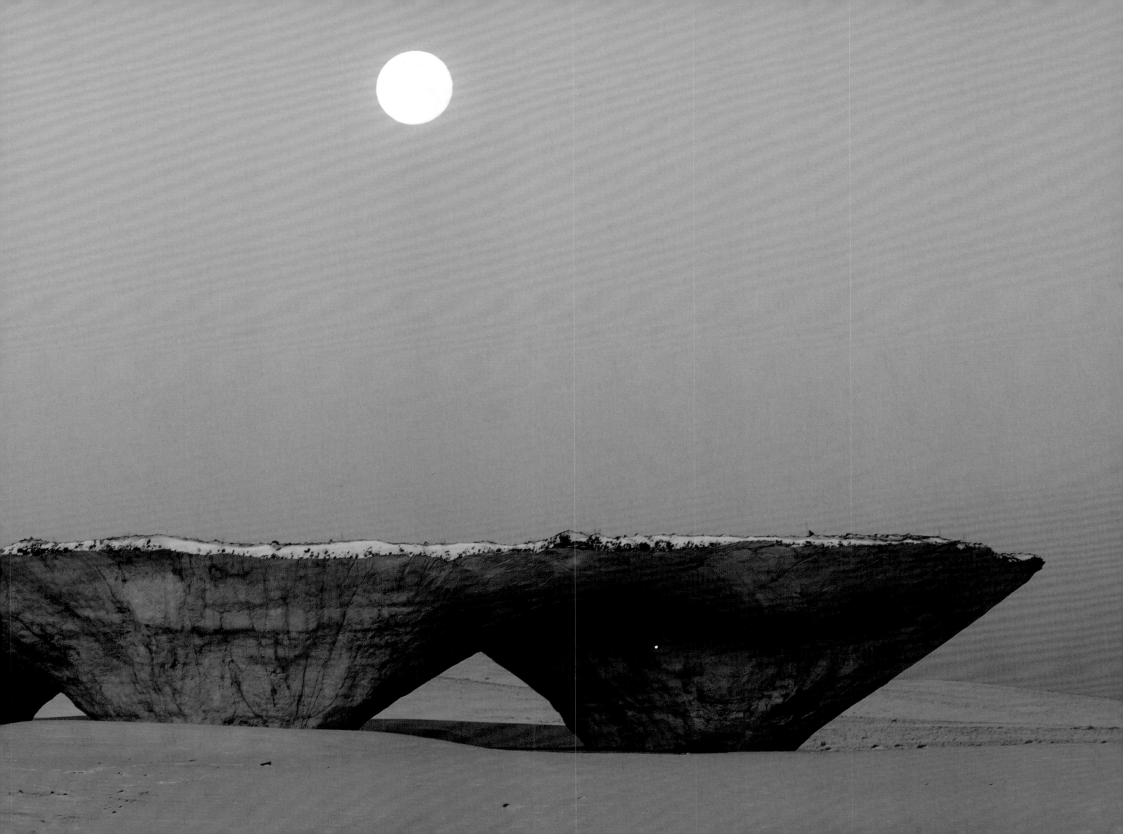

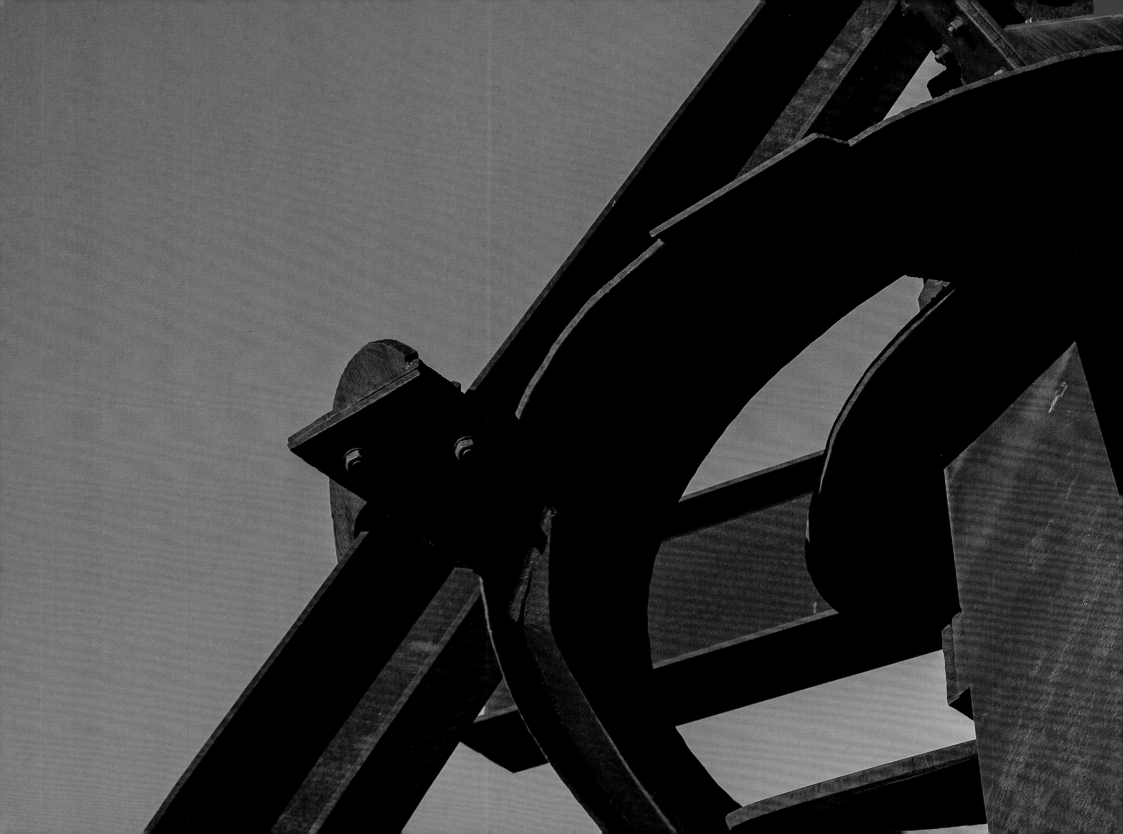

MARK DI SUVERO

BEETHOVEN'S QUARTET

Beethoven's Quartet, 2003
Steel and stainless steel

Mountains, Music, and Art

Beauty is in the spirit. And the spirit of Beethoven is madness. A deaf composer. How do
we know what he was hearing? All we know is the madness that was Beethoven's *Symphony
No. 9*. It grabs you by the hair and just throws you over a mountain. It is unbelievable.
And his quartets are so wonderful because they are like his own private notebooks.

The first time I heard Bach's *Mass in B Minor*, it changed my life. When art changes
your life, it's another step. It's a step higher. It's the wings of the spirit. It's what we work
for. When you hear music like that, it is a whole completeness of spirit.

The materials I work with also have spirits of their own. Wood is living. And iron
is what allows us to live. Blood is like iron, carrying oxygen. I like scrap an awful lot. Steel is
very recent, not more than a couple of thousand years old. When people are working
with stone, they are working with things that are millions of years old. Steel has a different
type of capacity and structure, which is what draws me like a magnet.

Steel wants to bend, but do not try to bend it with your hands. It wants to frame.
It wants to be wide and expansive. It wants space. It wants to be open.

The mountains of Tippet Rise are the ultimate paradigms of space, of mass. They occupy
with solidity. But to be open about it requires a different kind of thinking. It is more like
thinking among the trees.

MARK DI SUVERO

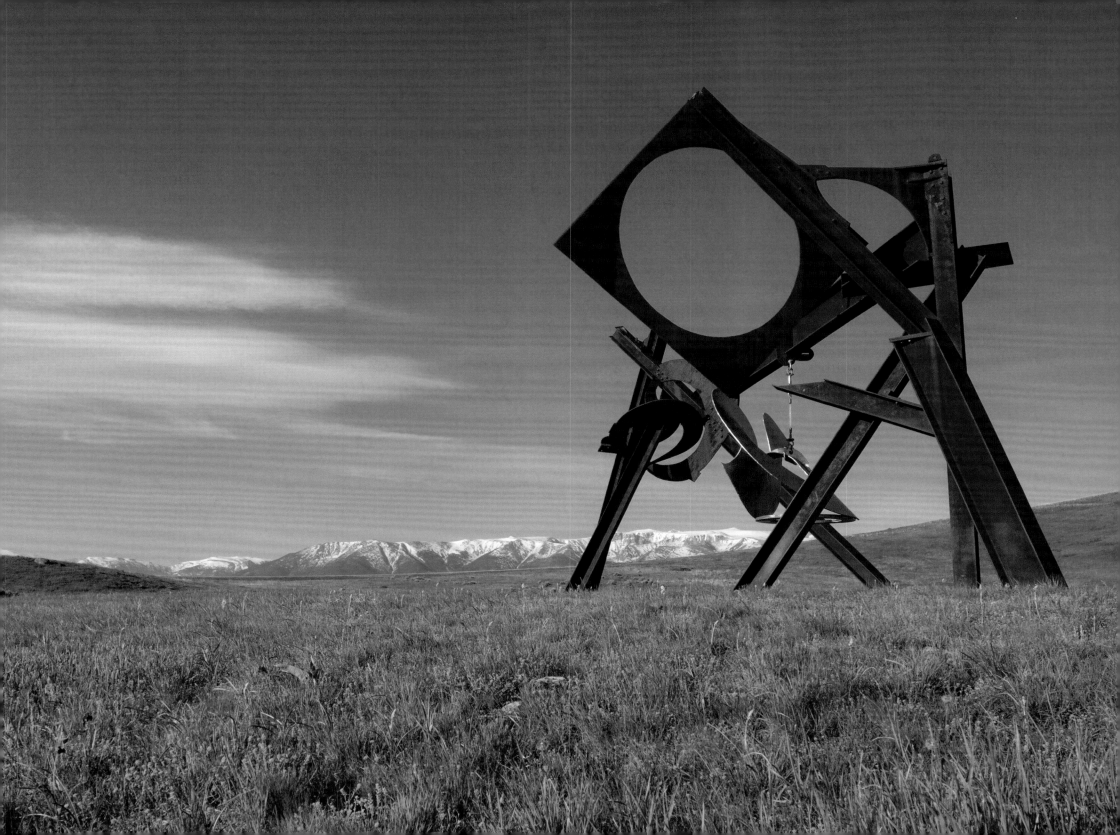

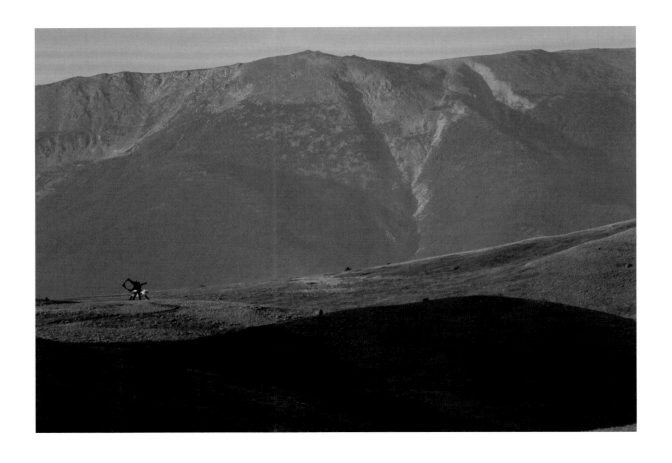

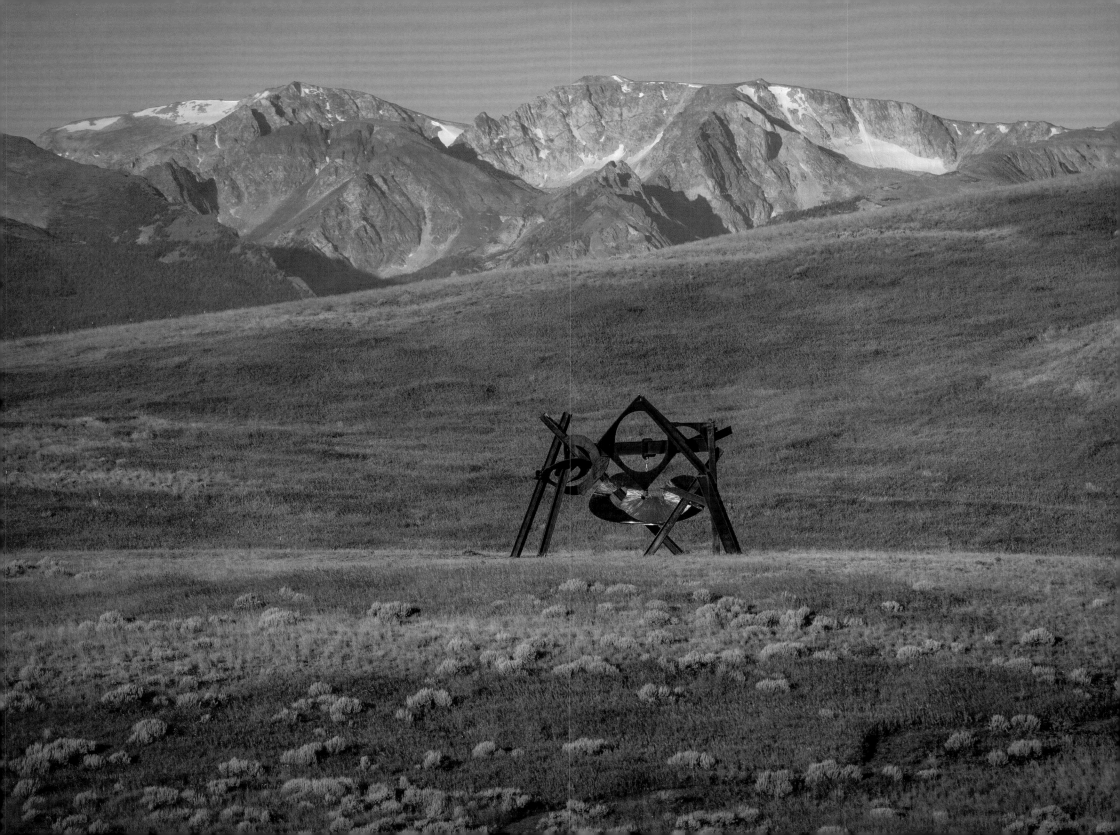

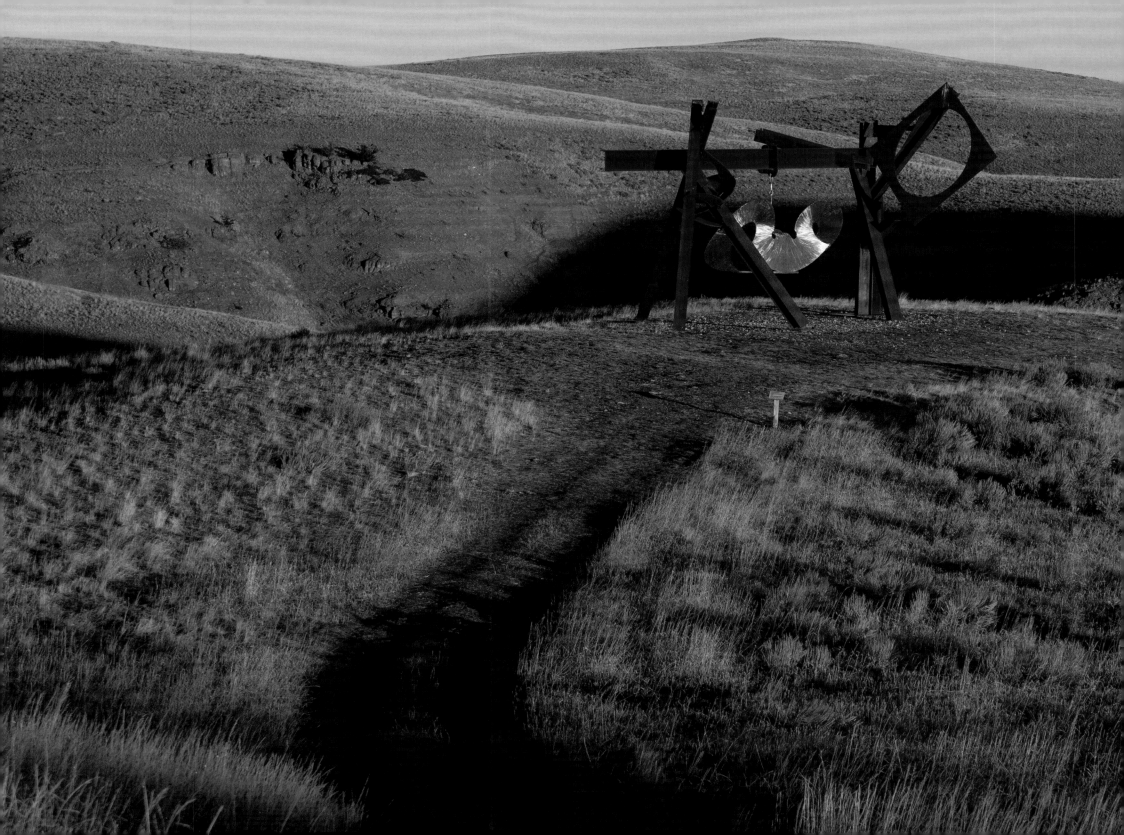

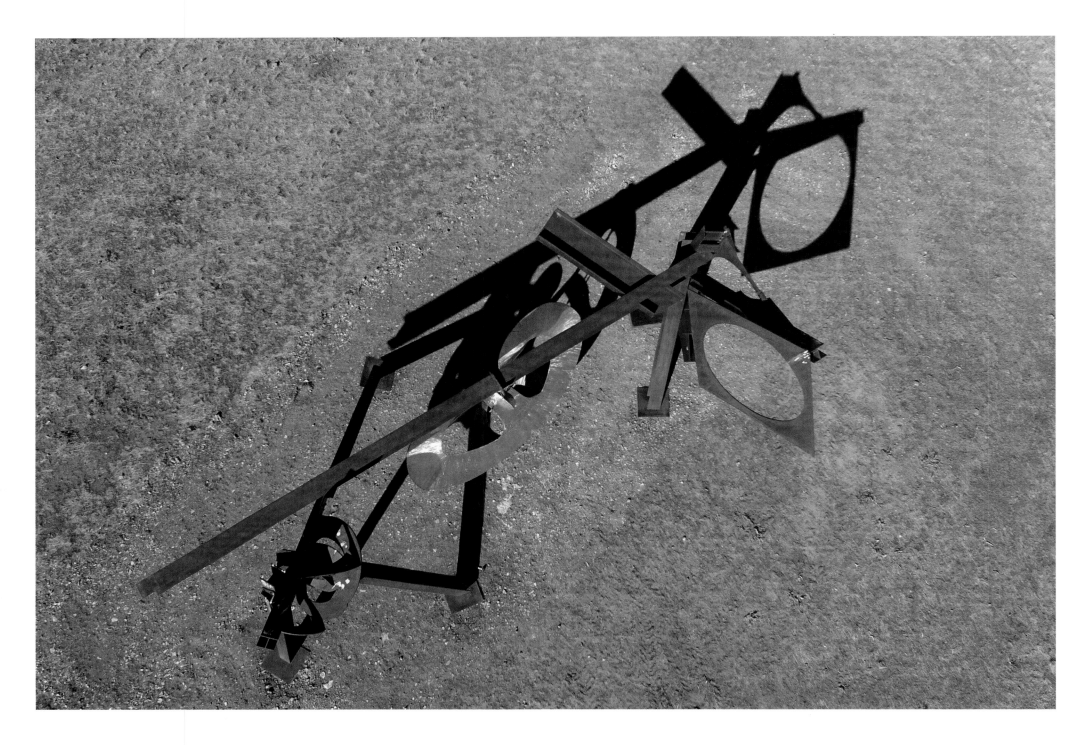

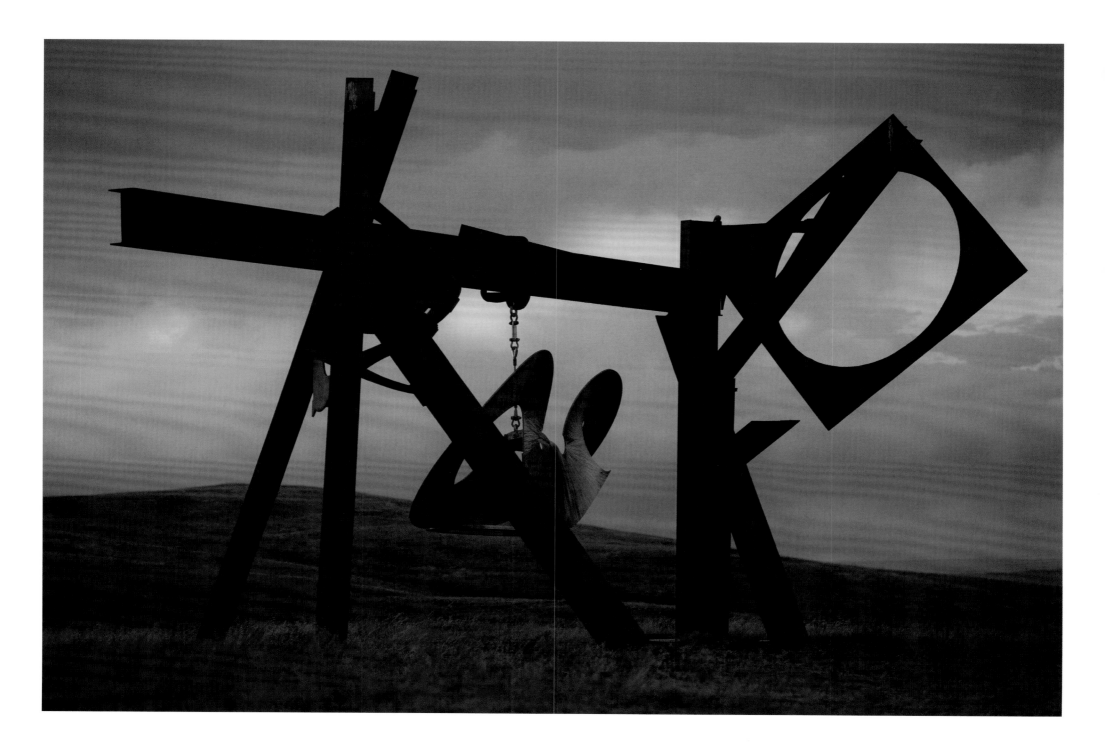

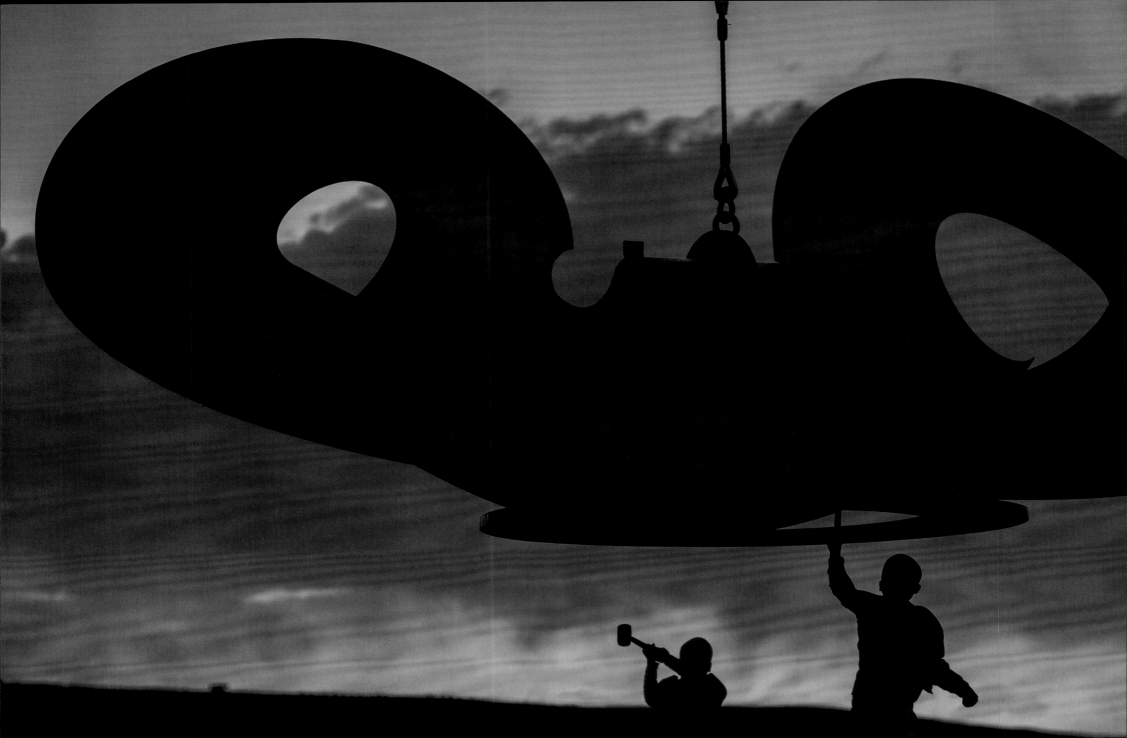

Endurance

The ruined heavens split
The rigging one last time,
Pushed by buckling in the planet
To coat the bay in rime,

To trace the slip
Of phosphorescent lights
As monstrous ripples ship
Around a sky of ice,

Sheets that splinter in the air
Like seas failing in the deep,
Broken worlds whose dying glare
Burns like fuses in our sleep,

Fireballs whose forked extremes
Spray us shipwrecked into dreams.

* Peter Halstead wrote "Endurance" for Mark di Suvero's sculpture
after its installation at Tippet Rise Art Center.

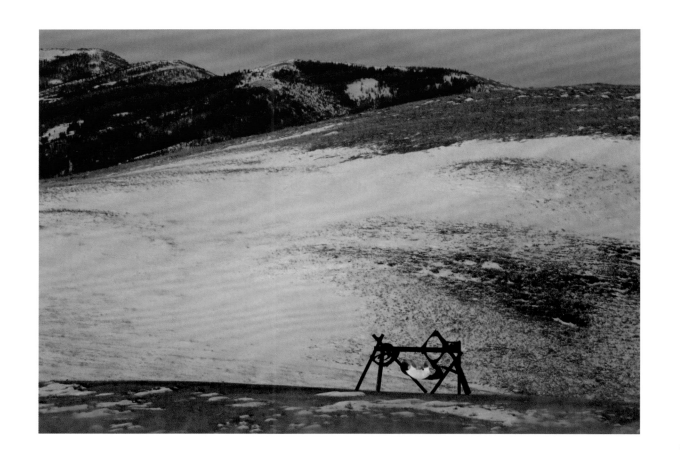

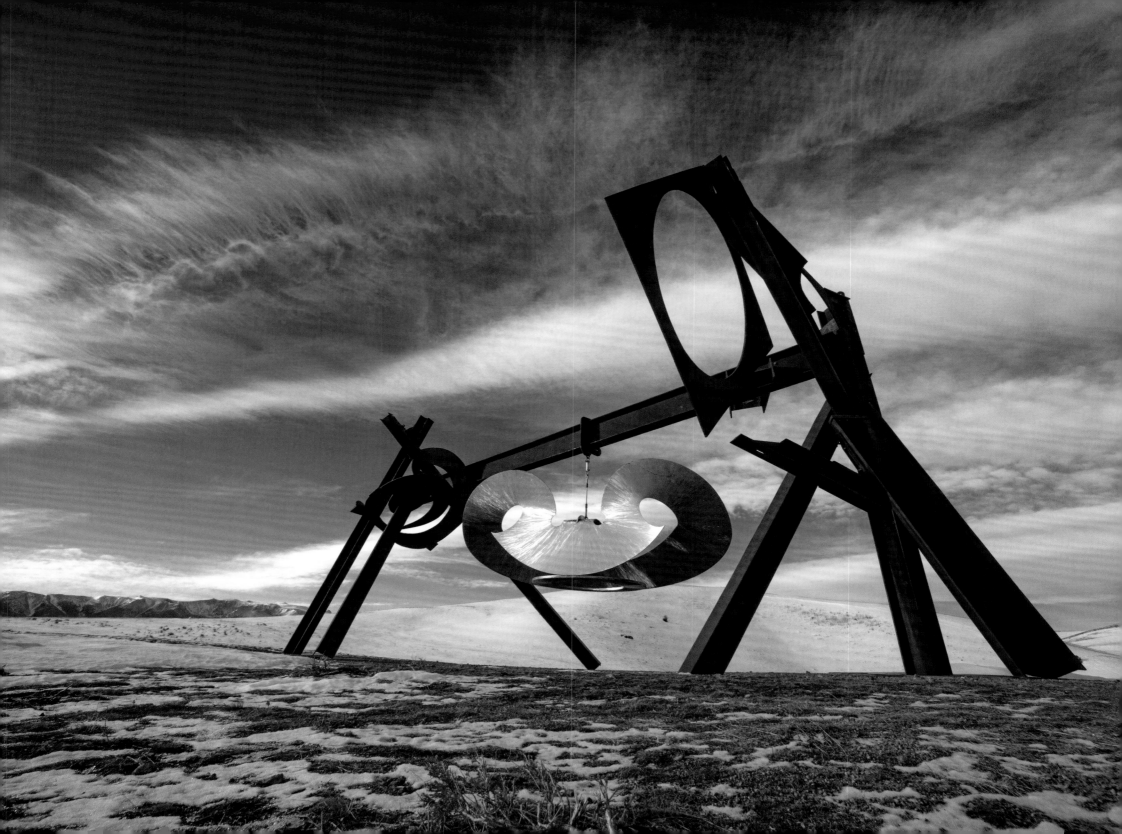

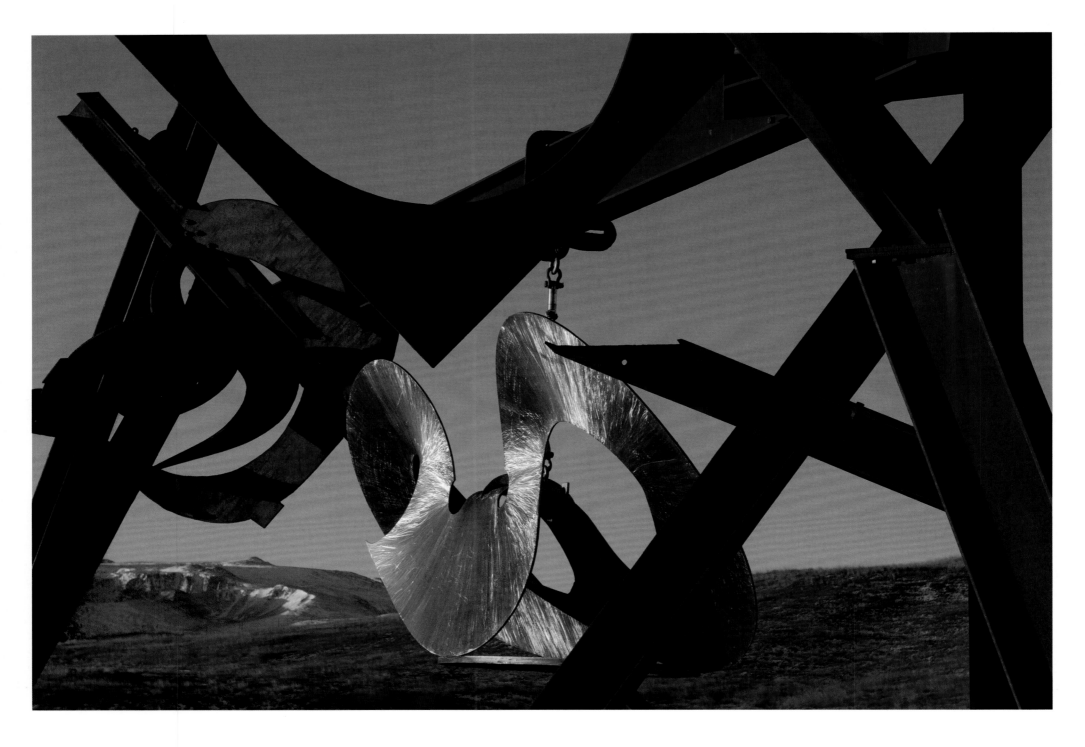

128

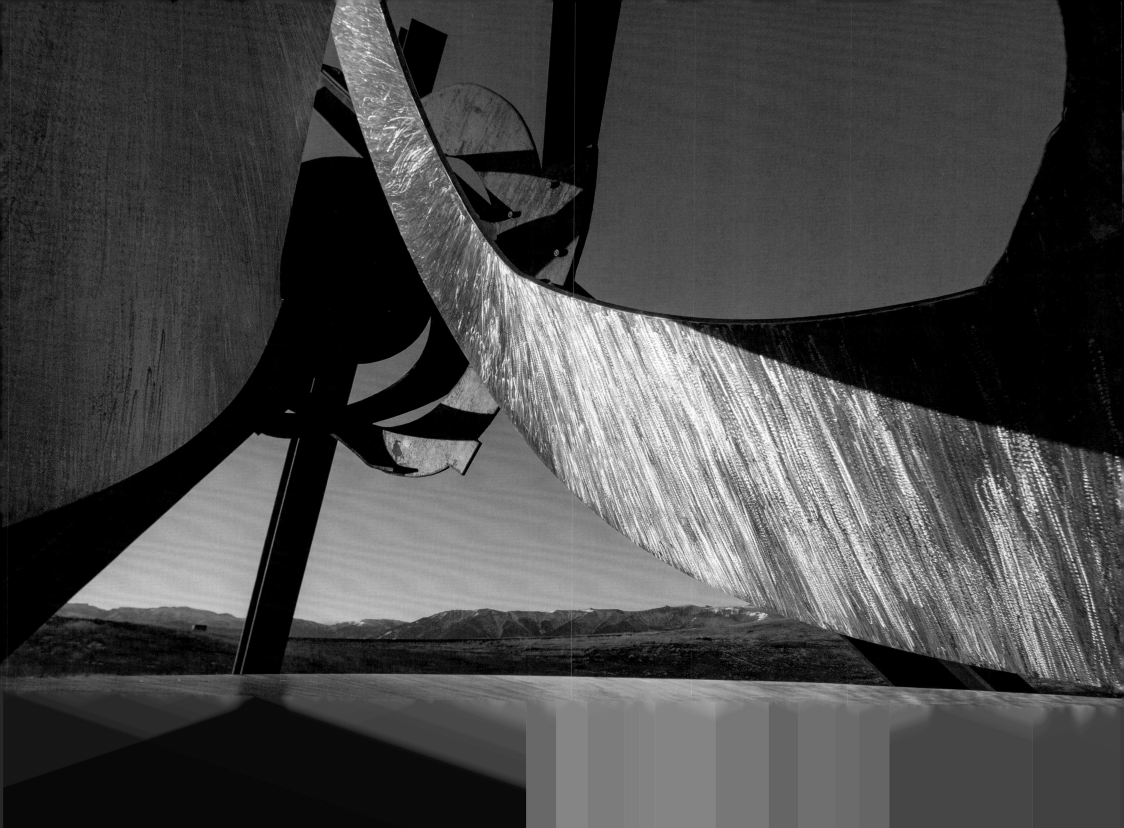

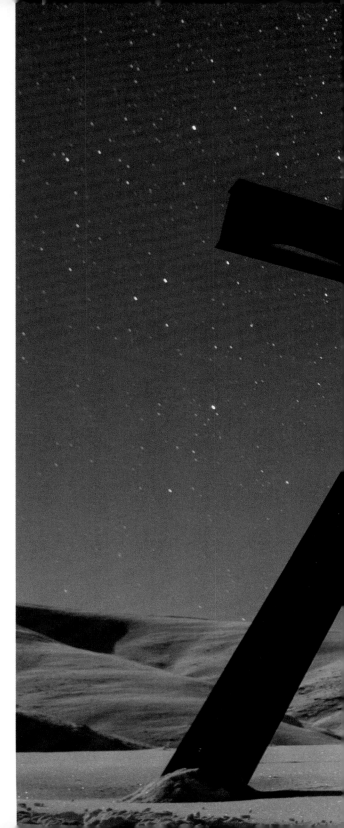

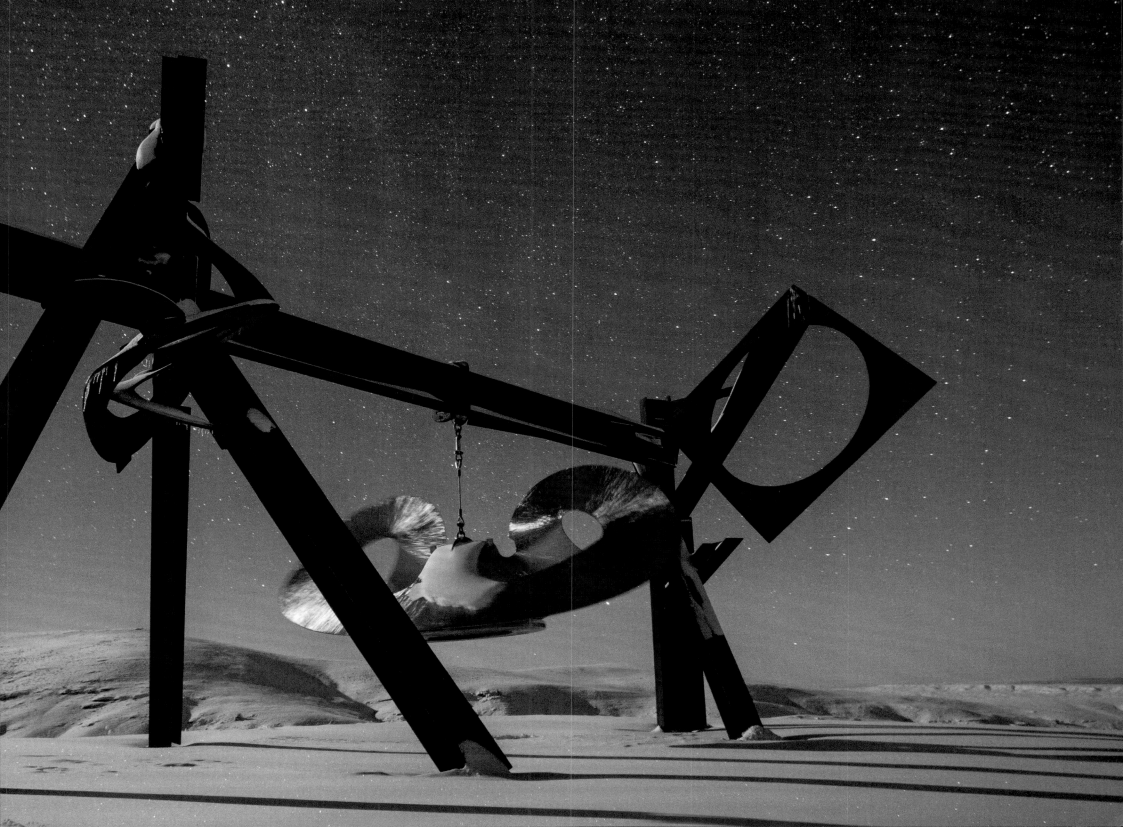

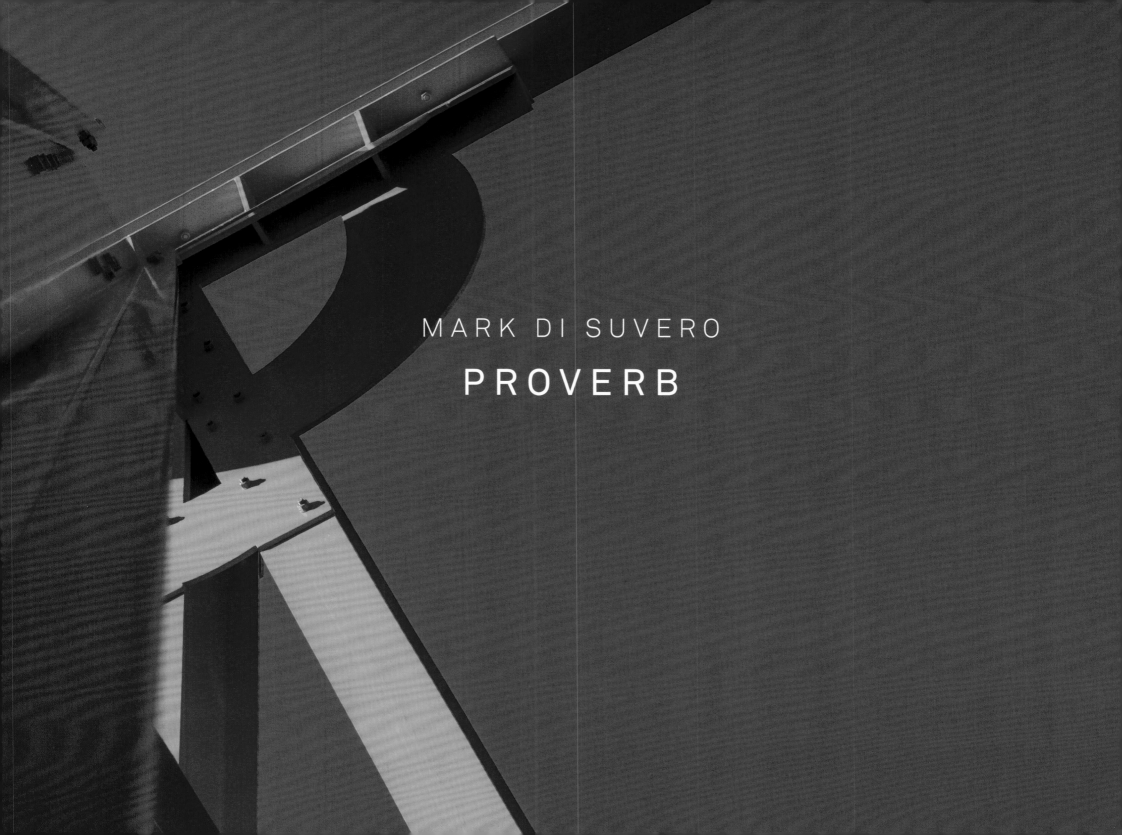

MARK DI SUVERO

PROVERB

Proverb, 2002
Steel and stainless steel

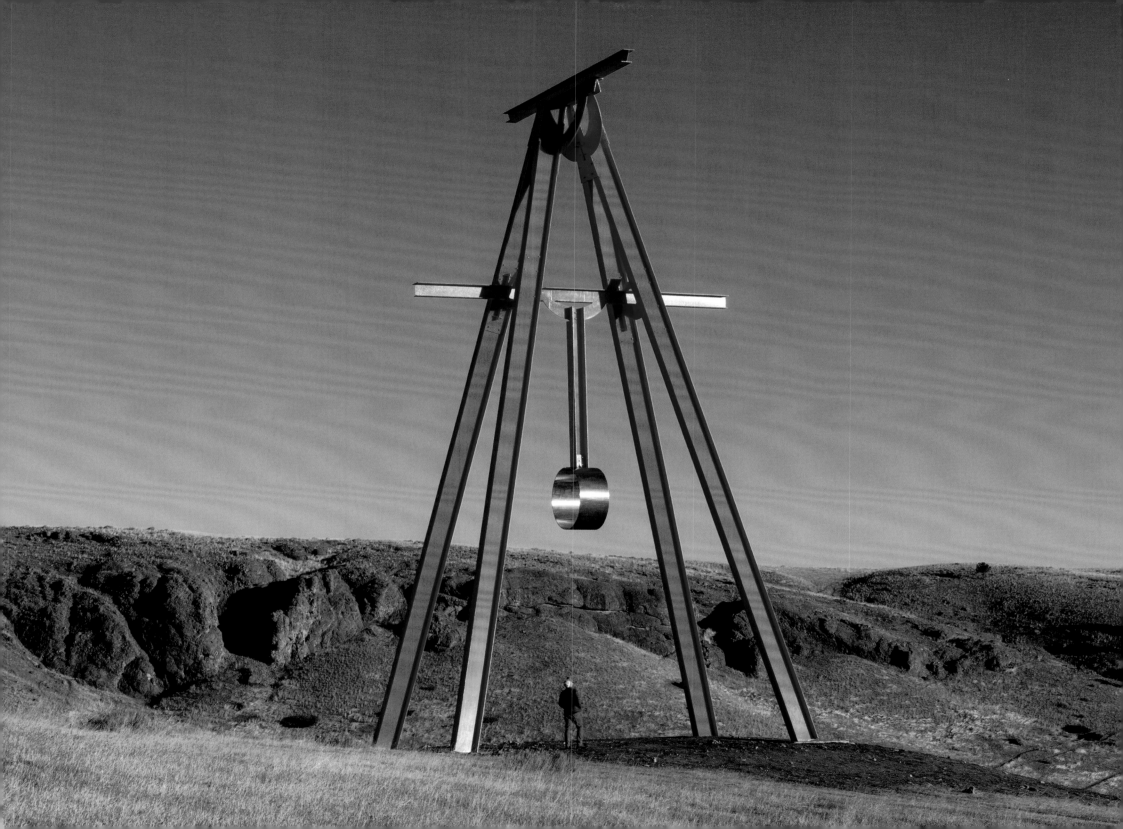

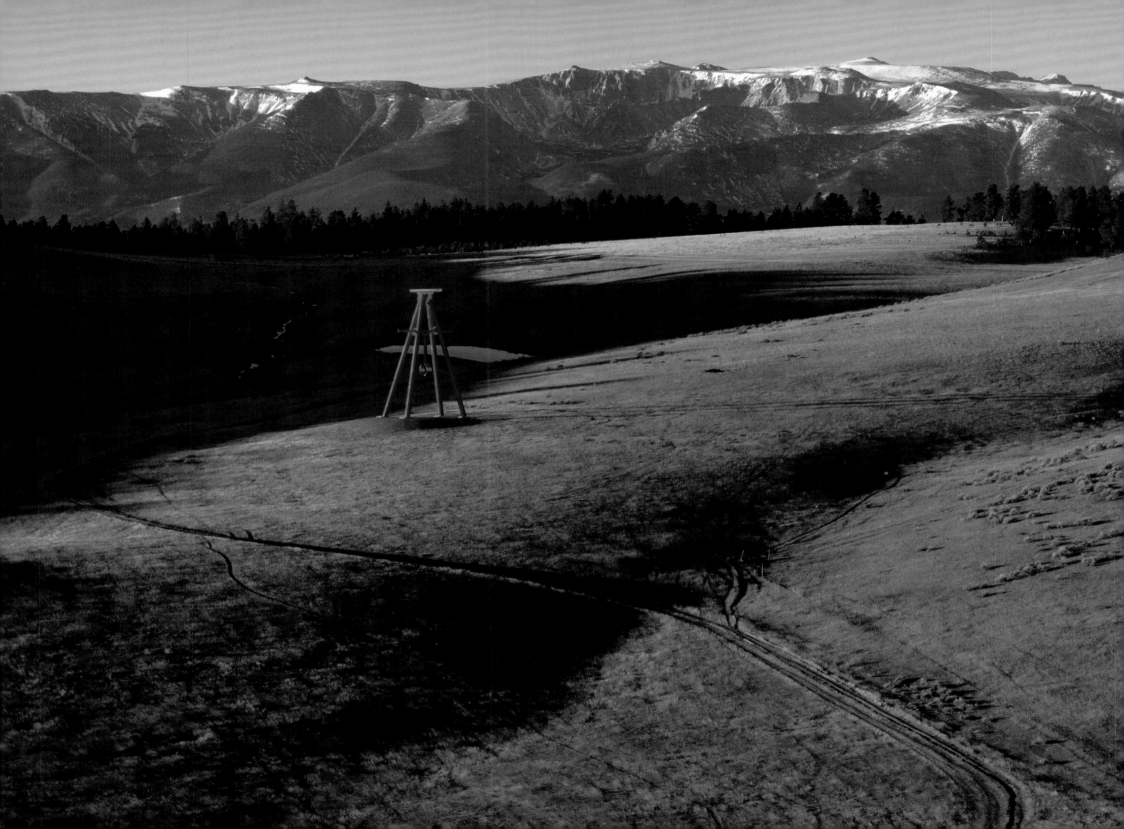

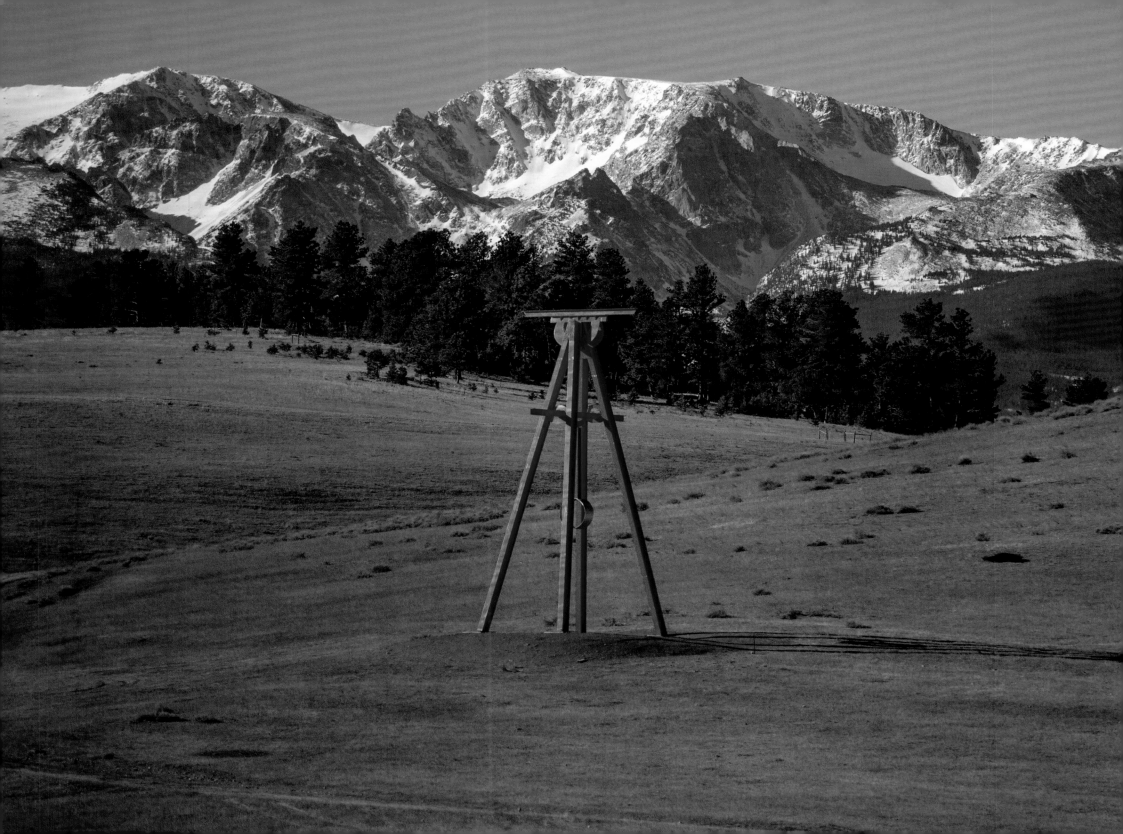

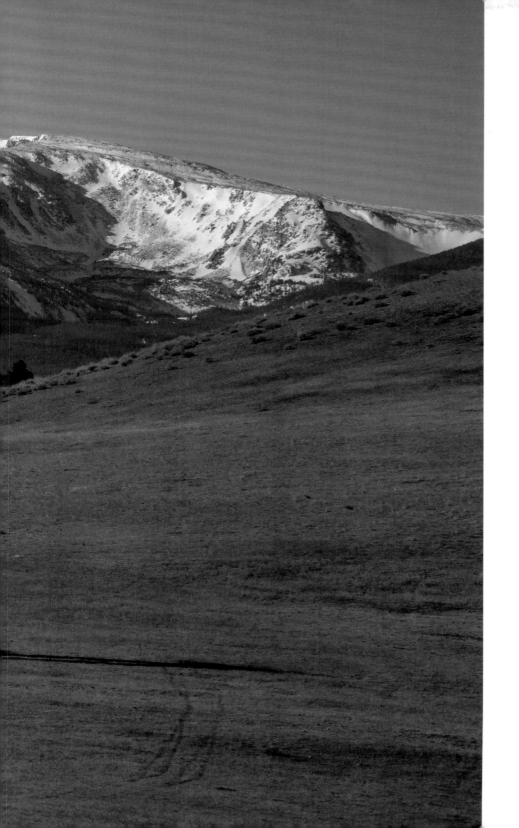

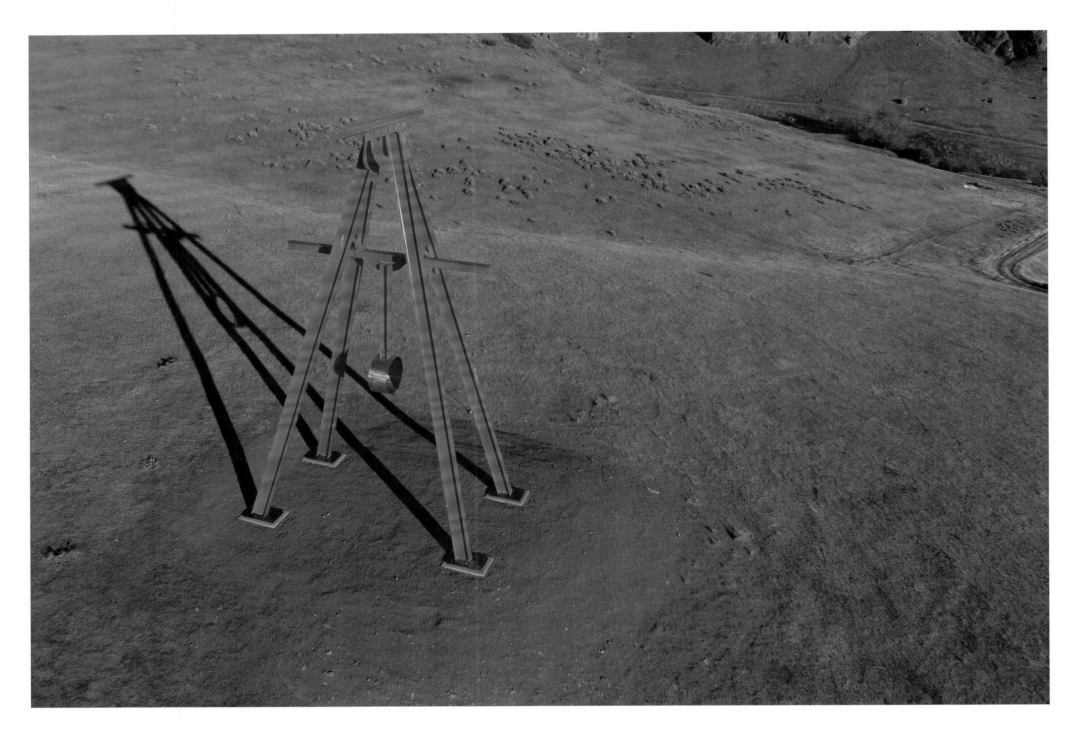

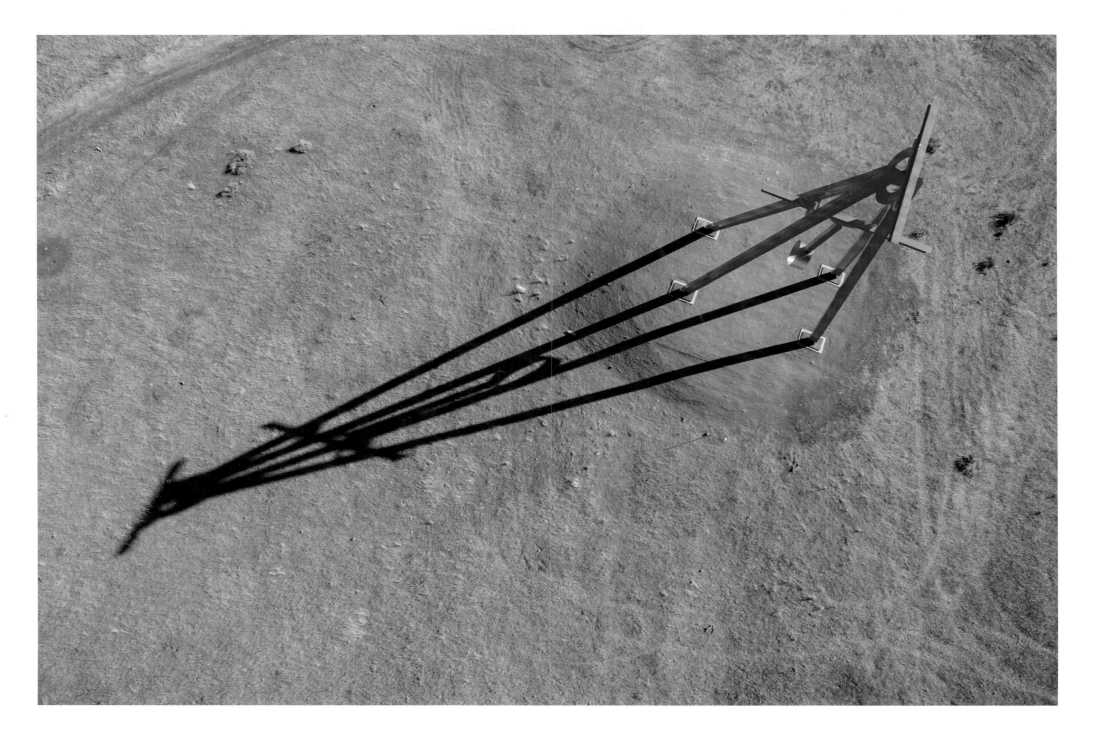

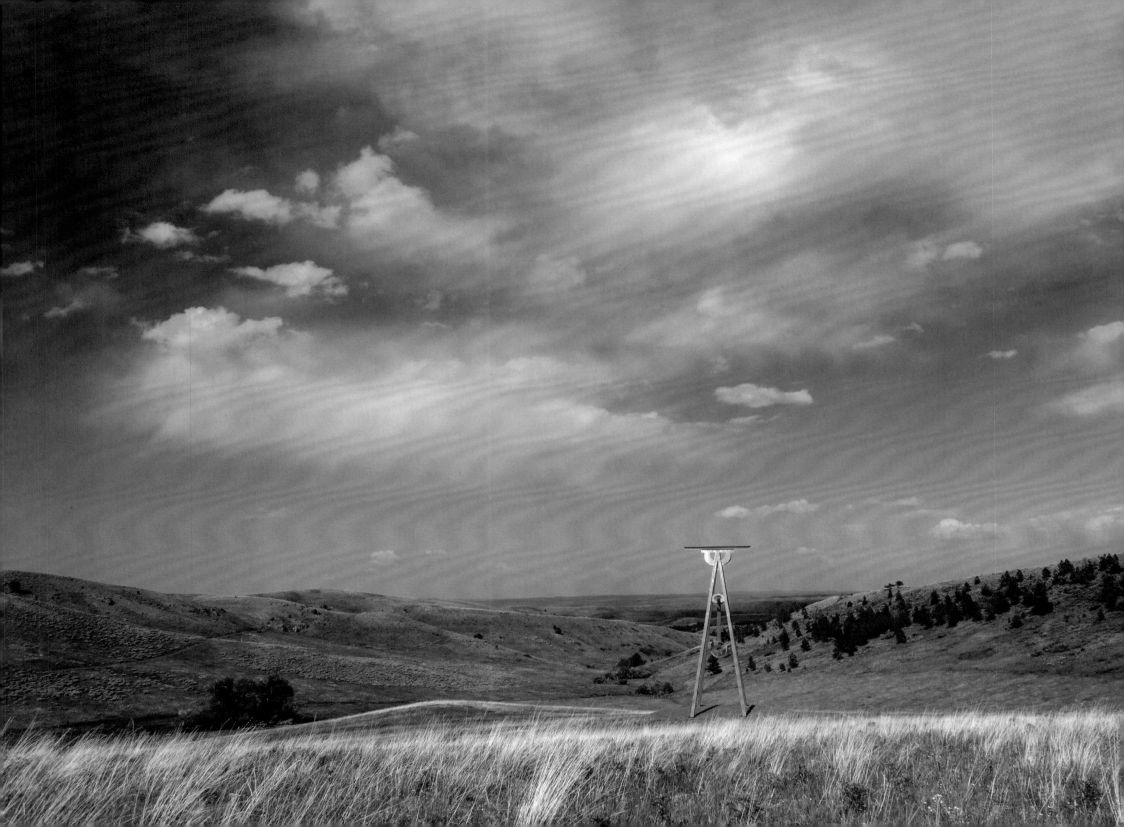

Proverb

I

You straight edges that turn the swells of sunlight flat;
Calipers that fold the pleats of landscape to a map;
Compasses that fix the endless world with sticks,
And metronomes that time our timeless songs with clicks,

II

Hourglasses that trap the tides
In a draining jar of sand,
And pendulums whose constant glides
Make the future secondhand,

Fill the gauges of our empty pond
With the astronomical embrace of time,
With notches on a magic wand
That mime the galaxies of rhyme,

The light years of a lover's face
With measureless degrees of grace.

* Peter Halstead wrote "Proverb" for Mark di Suvero's sculpture
after its installation at Tippet Rise Art Center.

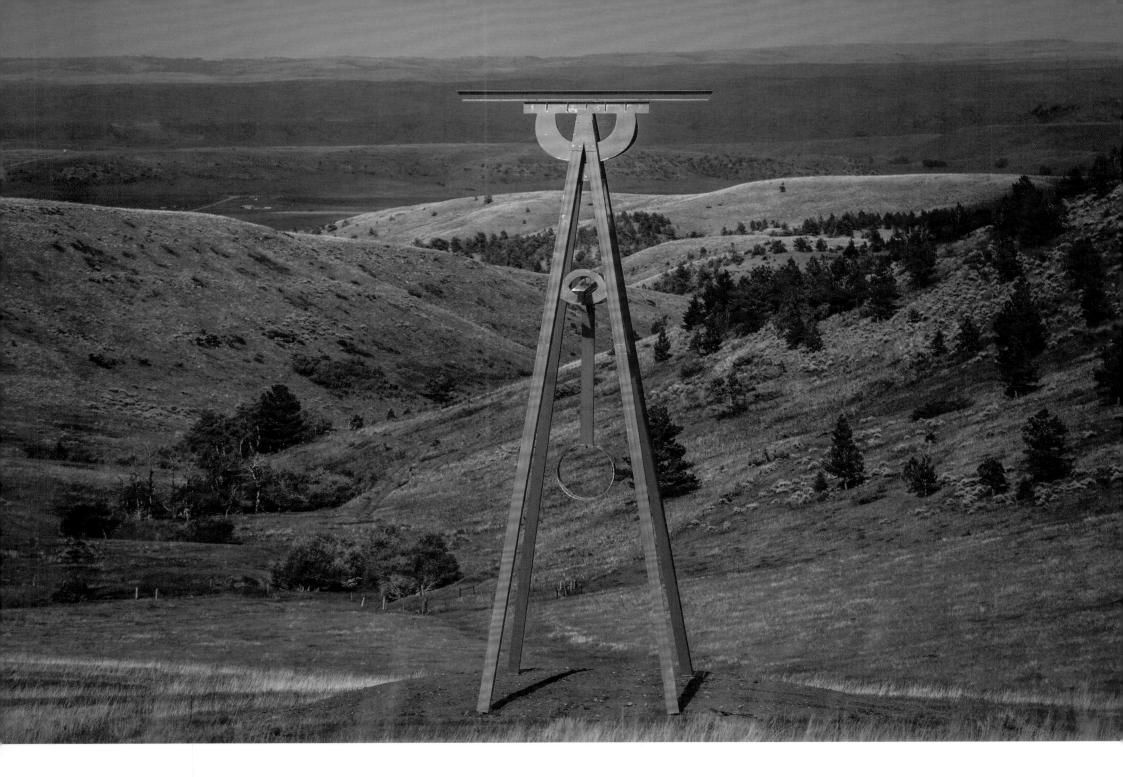

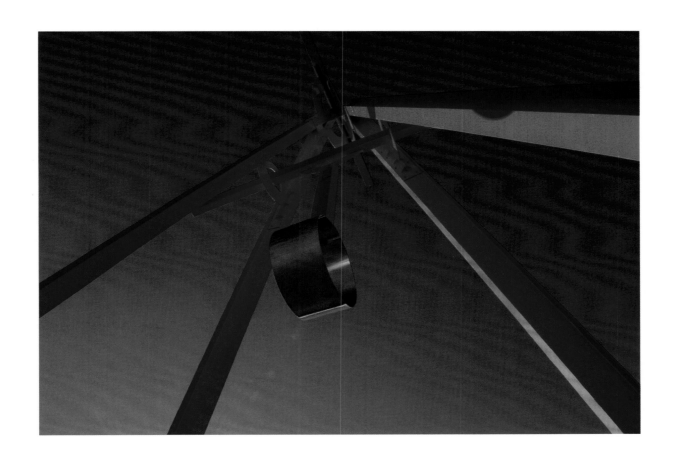

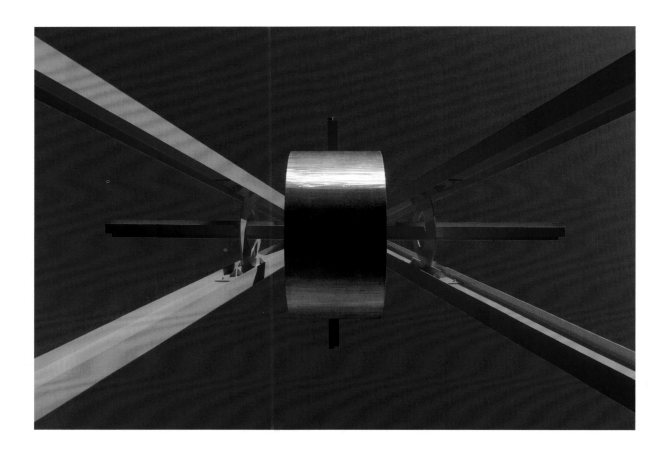

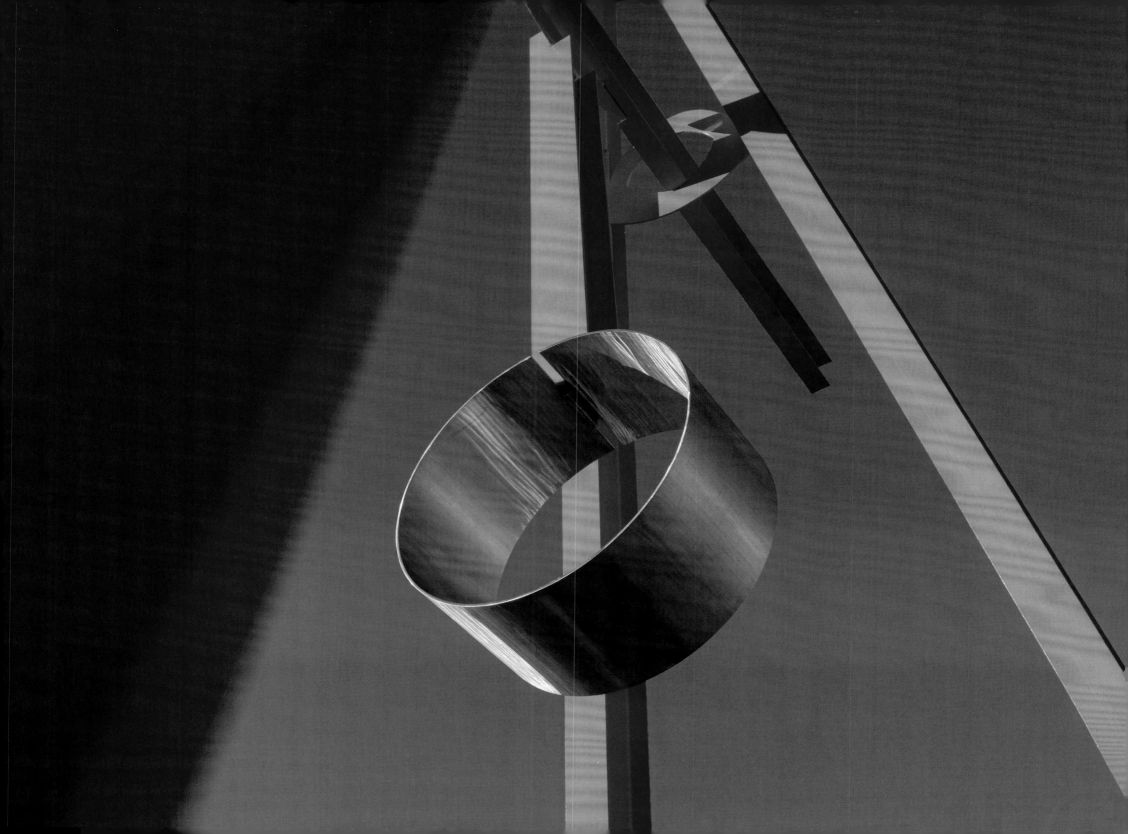

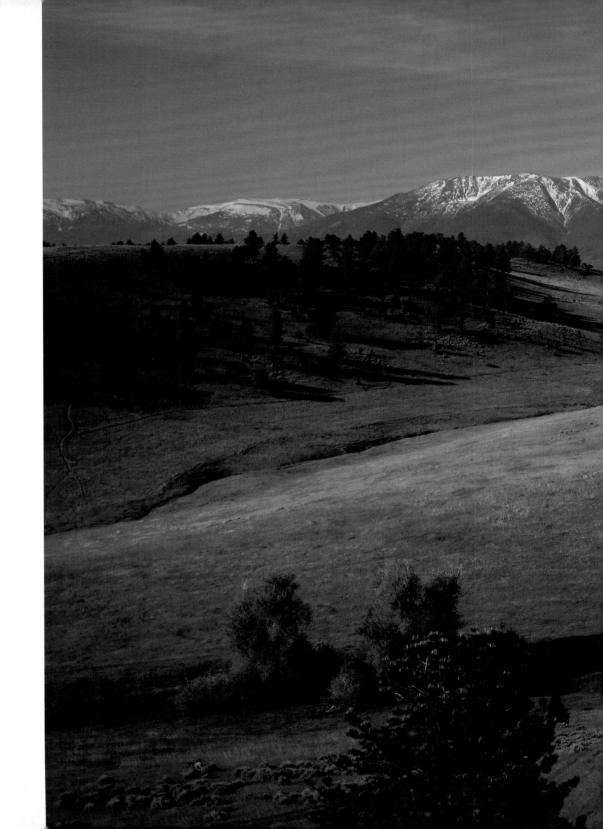

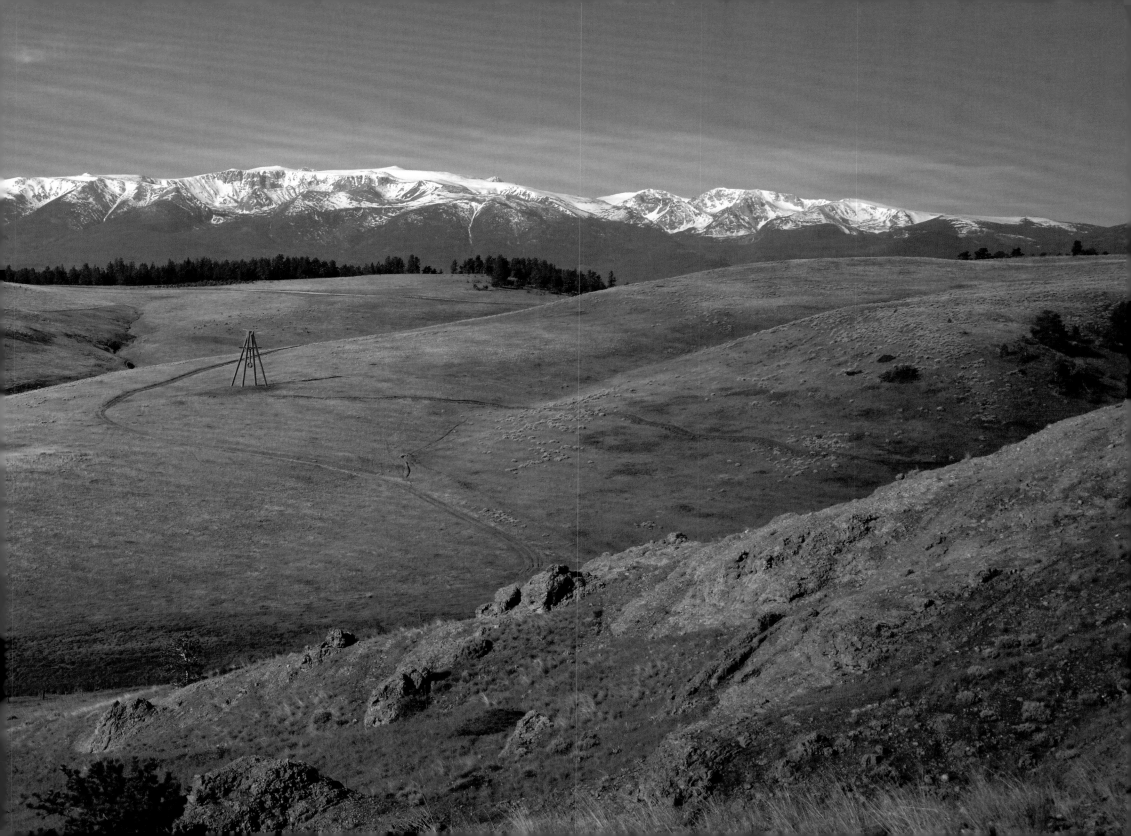

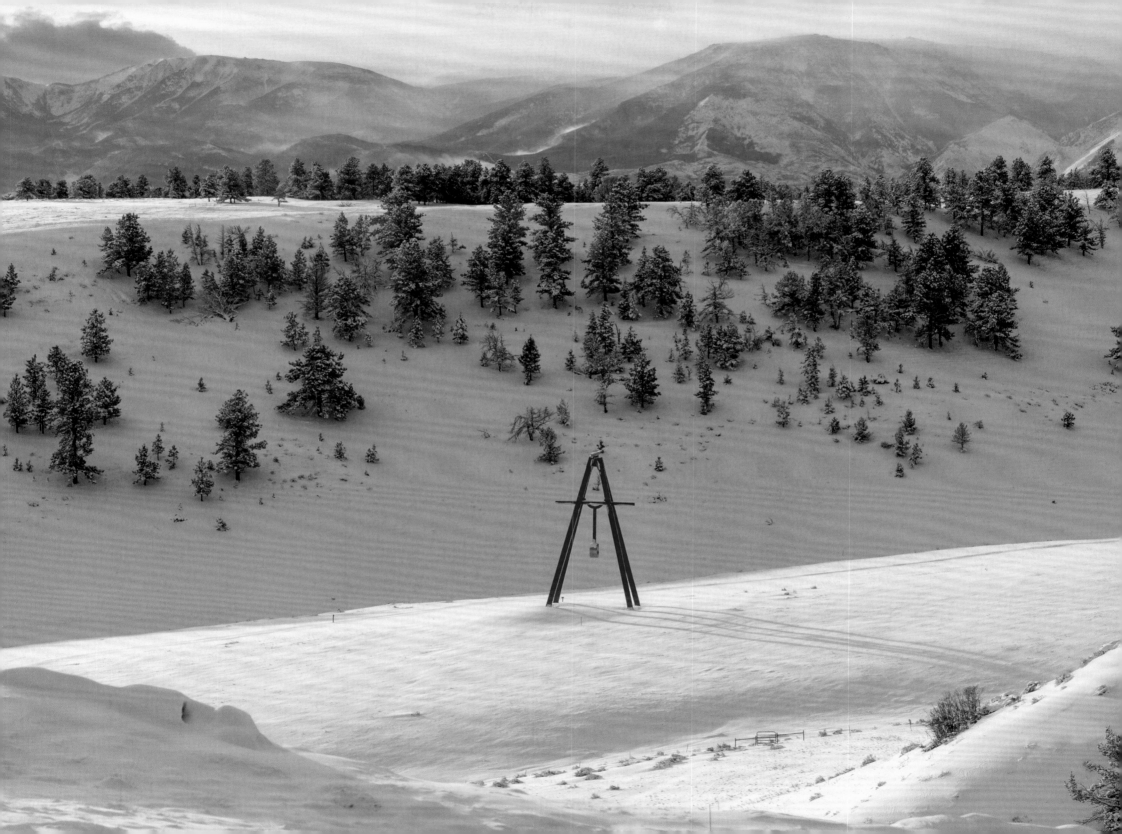

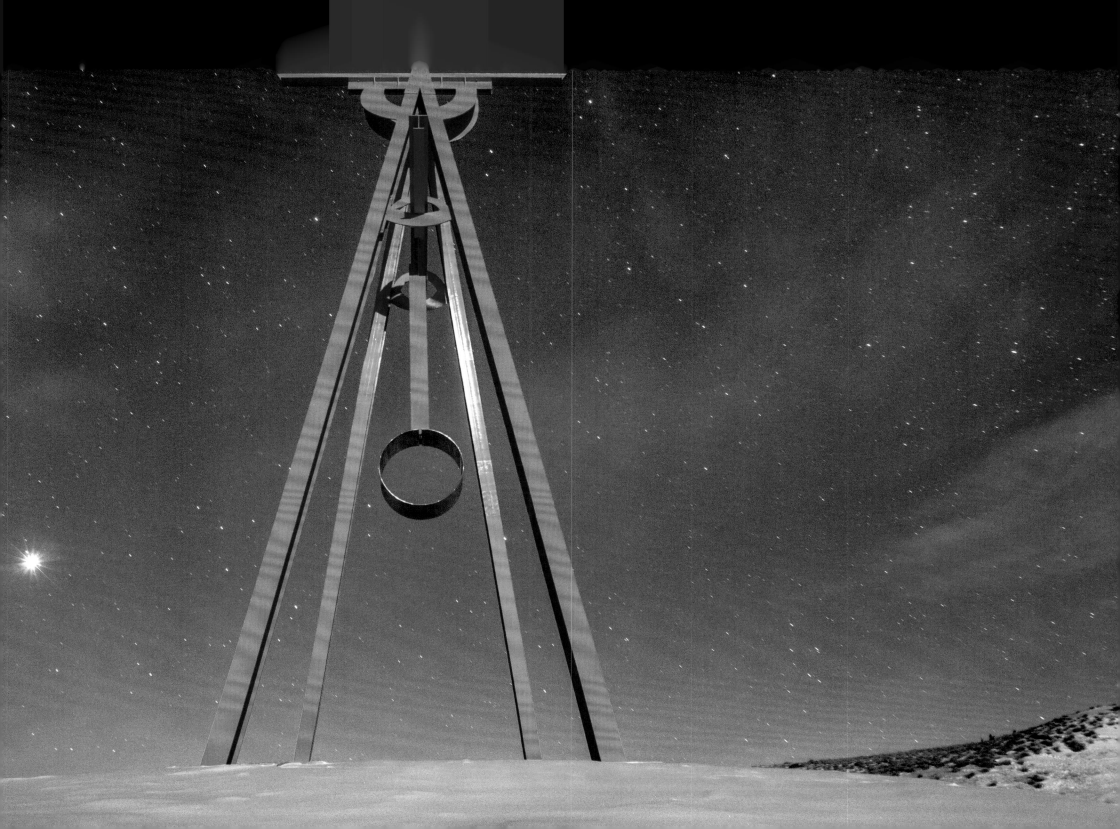

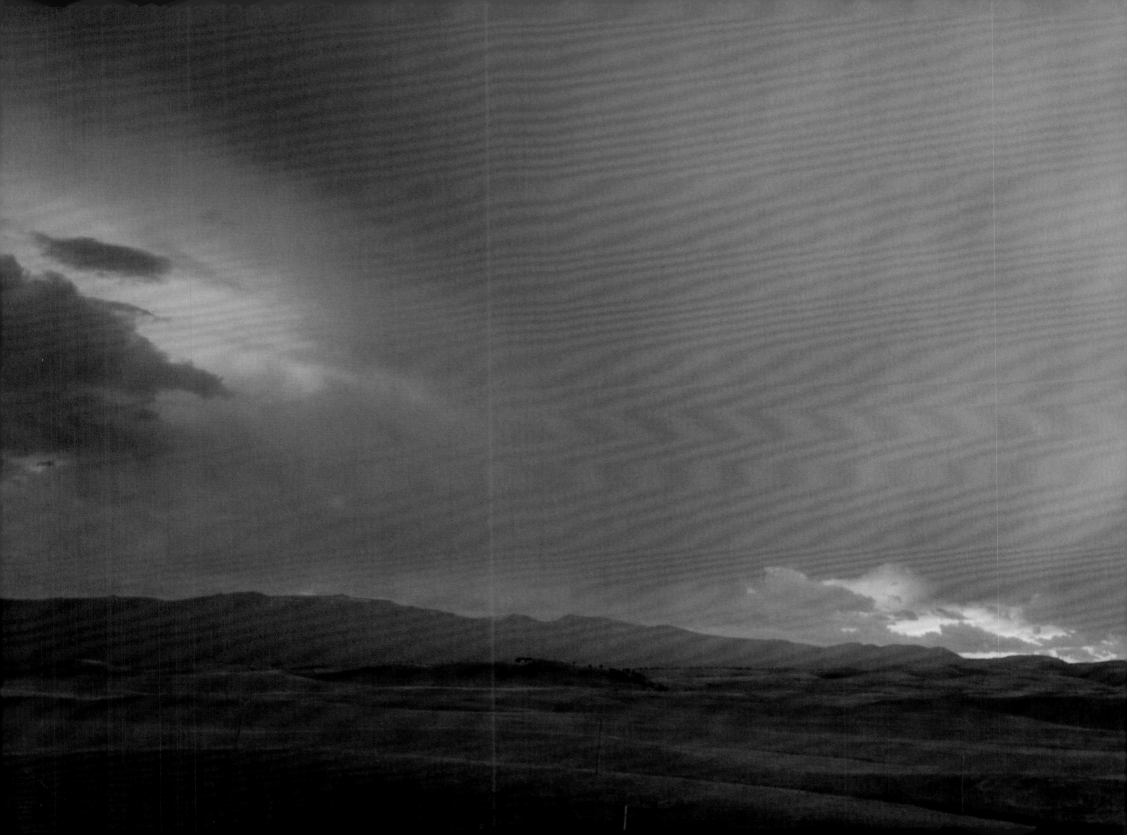

MEDITATIONS

ESSAYS BY **PETER HALSTEAD**

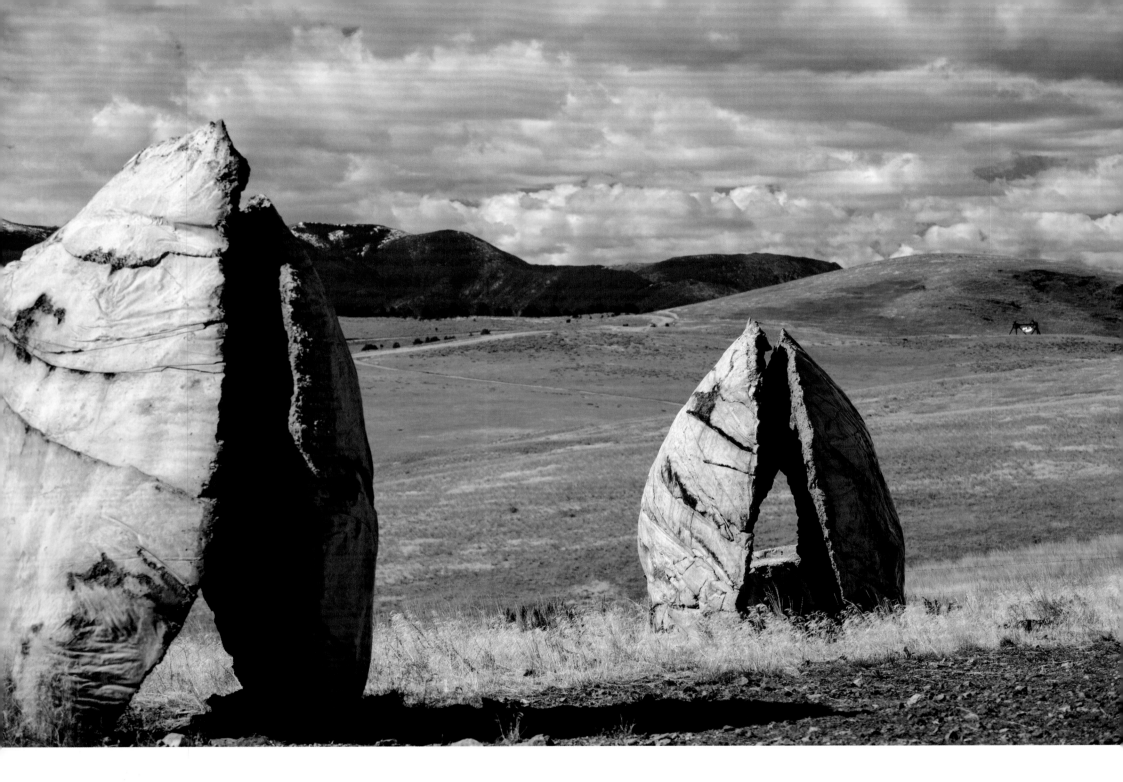

THE HUNT FOR TIPPET RISE

Scientific rationalism was not what many of the great philanthropists sought from their gifts. Most held to a belief that there was something higher, beyond science, upon which communities must draw. They generally believed in people; they believed that individuals, if exposed to education, to art and to music, to the sublimity of great landscapes, and to the complexity and beauty of the natural world, would blossom. These individuals would form a community of spirit and intellect, and would, through a sense of stewardship passed to them by their experiences, tithe themselves financially and intellectually to help the next generation.

—Robin W. Winks, *Laurance S. Rockefeller: Catalyst for Conservation*, 1997

Our parents and grandparents each had a disposition for helping humanity, which we inherited from them. Peter Halstead's great aunt, Welthy Fisher, founded World Education in 1951, which began by building "literacy villages" near Lucknow, India, to teach Indians how to drive tractors, grow long-grain rice, and speak Urdu. Since then, it has helped some five hundred thousand children and adults in over fifty countries in Asia. Cathy Halstead's grandfather Lewis S. Rosenstiel started the Rosenstiel Basic Medical Sciences Research Center at Brandeis University and the Rosenstiel School of Marine and Atmospheric Science at the University of Miami. The Sidney E. Frank Hall for Life Sciences at Brown University is named after Cathy's father.

We both grew up collecting small works of art and lots of books. Cathy's mother, Tippet, had some beautiful mobiles from Alexander Calder's studio. She had helped the careers of a few artists living in France on the Riviera, where Cathy's family used to spend the summer, and was involved in the kinetic art movement in Paris. One of her protégés was Israeli artist Yaacov Agam, who participated in the birth of the kinetic movement at the Denise René Gallery in Paris, along with Jean Tinguely, Alexander Calder, Le Corbusier, and Sonia Delauney, among others.

Cathy has always painted and has had gallery representation and shows in Chicago, Los Angeles, New York City, and Haifa, Israel. Peter has two volumes of piano music out on Albany Records: *Pianist Lost: Excesses and Excuses* (2010) and *Pianist Lost: Sunken Cathedrals* (2013). Forthcoming volumes will be available from the Adrian Brinkerhoff Foundation.

We did not end up under the Beartooth Mountains by chance. We have always been moved by mountains, and have done much skiing in New England, the West, and the Alps over the years. We have lived on a ranch outside Vail, Colorado, for several decades. Peter was in the Himalayas in the 1960s and the '80s and began climbing in the Alps in the 1980s. He recently played a concert on a mountaintop forty miles into the Chugach Mountains in Alaska, having flown a seven-foot Steinway grand piano in by helicopter. Parts of the concert are on pianistlost.com and adrianbrinkerhofffoundation.org.

One of the many inspirations for Tippet Rise was James Levine's cycle of Wagner's *Der Ring des Nibelungen* (1874) at the Metropolitan Opera in New York City in 1989. The idea of living on a mountainous acropolis (which was a highlight of Günther Schneider-Siemsen's set design), complete with great sets, soaring music, and high drama, proved strangely attractive.

We traveled for additional inspiration to the great sculpture parks of Europe: Louisiana Museum of Modern Art in Humlebæk, Denmark; TICKON Tranekaer International Centre for Art and Nature at Tranekaer Castle Park in Langeland, Denmark; Henry Moore Studios and Gardens in Much Hadham, England; Little Sparta in Dunsyre, Scotland; Glenkiln Sculpture Park in Dumfries and Galloway, Scotland; and Kröller-Müller Museum in the Hoge Veluwe National Park in Otterlo, Netherlands.

We went to Storm King Art Center in Mountainville, New York, soon after it opened in 1960, and ran through the sprinklers on a hot summer day. We were almost the only people there, and it felt like our secret. As Storm King grew and single-handedly created the modern world of outdoor sculpture, our own tastes grew with it. We were fascinated by how they would rearrange the land itself for the art, building a hill for the Isamu Noguchi sculpture *Momo Taro* or creating a rolling terrain out of the farm's formerly flat meadows in the early days of the center, as copiously documented by photographs in the archives of Storm King. One time we got to observe, from a distance, Mark di Suvero installing one of his pieces—a moment that shaped our lives. We talked about it, but we didn't realize then how much Storm King had become our dream.

Years later, after we moved out West, we thought back to the days at Storm King when there were only a few sculptures in the huge meadows and imagined how exciting it would be if each sculpture had its own environment—maybe a fence or a cabin ruin, a river running through a high mountain basin—and only one piece in sight to interact with rolling hills or snow-covered mountains.

Sculptor Henry Moore wrote in his notes in 1951: "Sculpture is an art of the open air. Daylight, *sunlight*, is necessary to it, and for me its best setting and complement is nature. I would rather have a piece of my sculpture put in a landscape, almost any landscape, than in, or on, the most beautiful building I know."

In a museum, a work of art is often surrounded by white walls, which become invisible, allowing us to focus on the piece itself. (Although, more recently, interactive museum presentations have become popular.) Out of doors, a work of art is like a house dog let loose in a field. Beside itself with joy, it whirls in circles, it runs ecstatically, it jumps, it twirls, its inner dog released. Works of art catch the light of a leaf, the bend of a bough, the curve of a meadow, the roller coaster of a hill. They reach up into the sky, or to the stars at night. They are mantled in snow or in birdsong. They root in the earth, and they fly. They are a different animal. Their inner sculpture is set free. But they also take the world in: they absorb clouds and woods, their lines are echoed by runnels and gullies.

The bystander, no longer innocent, becomes complicit. Your own dreams and visions of flying are released. You prowl, cavort, saunter, stalk. You have a relationship not only with the work but also with the grass and the temperature and the breeze.

When we had the idea of a sculpture park with outdoor concerts, we looked all over the world for many years for the kind of land that would accommodate the art we were thinking of (which in turn inspired art we never could have imagined). In the United States we looked in Hawaii, Colorado, Utah, New Mexico, and California.

There were various reasons why almost none of the sites worked. Most of the open ranges had power lines running across them, which ruined the scenic value. One gorgeous ranch had an access road so terrifying, with cliffs beneath every turn, that we always turned back halfway there. Another ranch was too hilly for sculptures. Another one would have required years of town

meetings, with no guarantee of success. One ranch had forest service roads that ran through it, and cars and snowmobiles would disturb the quiet. One had the owner's house, immortalized, in the middle. One owner wanted to remain and control the property.

Much of the Big Island of Hawaii, due to the continual eruption of the Kïlauea shield volcano, was covered in a constant "vog" (volcanic fog), which made breathing difficult; the volcano frequently deposited a thin layer of white ash on parts of the island, depending on wind direction.

Because of the laws governing agricultural land in California, to have an art gallery in such an environment one needs first to establish a vineyard and then a gift shop. Once there is a gift shop, one can have an art gallery. Once there is an art gallery, one can branch out into outdoor sculpture. But whether large sculptures would be permitted, and how many years of hearings it would take, was anyone's guess. Parts of Colorado were just too expensive. Some large ranches were in communities that would object to even occasional traffic. We began to bid on a beautiful ranch near Steamboat Springs, Colorado, but the owners wanted an extravagant 2007 price during the market crash of 2008.

But we had heard that Montana was the last frontier. We owed it to ourselves to see it before we settled for something less open.

And it was true. Montana was raw, wild. It was still frontier country. We looked all over the state, from grassy plains on the Hi-Line to river ranches in the Paradise and Gallatin Valleys to the isolated prairies of the Rocky Mountain Front and the smaller, more wooded ranches around Glacier National Park.

We always liked the rolling-hills parts of every ranch we looked at, but they were usually small parts of each ranch, with the rest of the land unusable for our purposes. We wanted to be able to hide sculptures in gentle canyons.

Finally, we found Bev Hall's ranch in Fishtail; it was exactly what we had been looking for. It had no bad parts; it was 100 percent good parts. It was all deeply rolling: our favorite kind

of terrain. It was covered in tall grass and sage, which brought to mind the Scottish Highlands and our many summers on Nantucket. It had few trees, so it would not be subject to the pine bark beetle kill that was turning much of the West into a firetrap. It was under the Beartooths, which was a revelation: alpine tundra that surrounded the highway for forty miles, scattered with tarns and meadows, and mountains that usually would take days to access but were here only minutes away, all on the road to Yellowstone National Park's vast valleys and prehistoric wildlife.

There were a few other abutting ranches available, and we put together eight of them to make one contiguous area. There must be spots as equally beautiful somewhere else, but in all the years of looking, this was the most amazing landscape we ever found.

In this part of the state, the land lightens. It goes from dark pines to endless horizons of hay. The air becomes radiant, as if it carries grasses from the plains. The mountains felt somehow comforting, accessible, while also being completely Jurassic. There was an eerie, otherworldly light and a Stone Age ambiance to the rocky fields.

We decided to name the ranch Tippet Rise. Tippet was Cathy's nickname for her mother. Cathy had been reading a book about a rabbit named Tippy, which she couldn't pronounce. One day she called her mother "Tippet," and it stuck. All of the kids called her that. She was a mentor to all of us. Sadly, she died very young. We thought it was about time she came back again; her spirit has been the standard with which we have conducted our lives. The people we love never really die. They rise again out of memory, out of dreams.

Only later did we learn that a sheep's coat slows in growth during the winter, but in the spring new growth resumes. This soft growth is called the "rise" and is easier for shepherds to roo—that is, to comb the wool from the sheep. We have always felt that sheep were natural accomplices of outdoor art—maybe we were inspired by Moore's sculpture park at Much Hadham, where ewes huddle

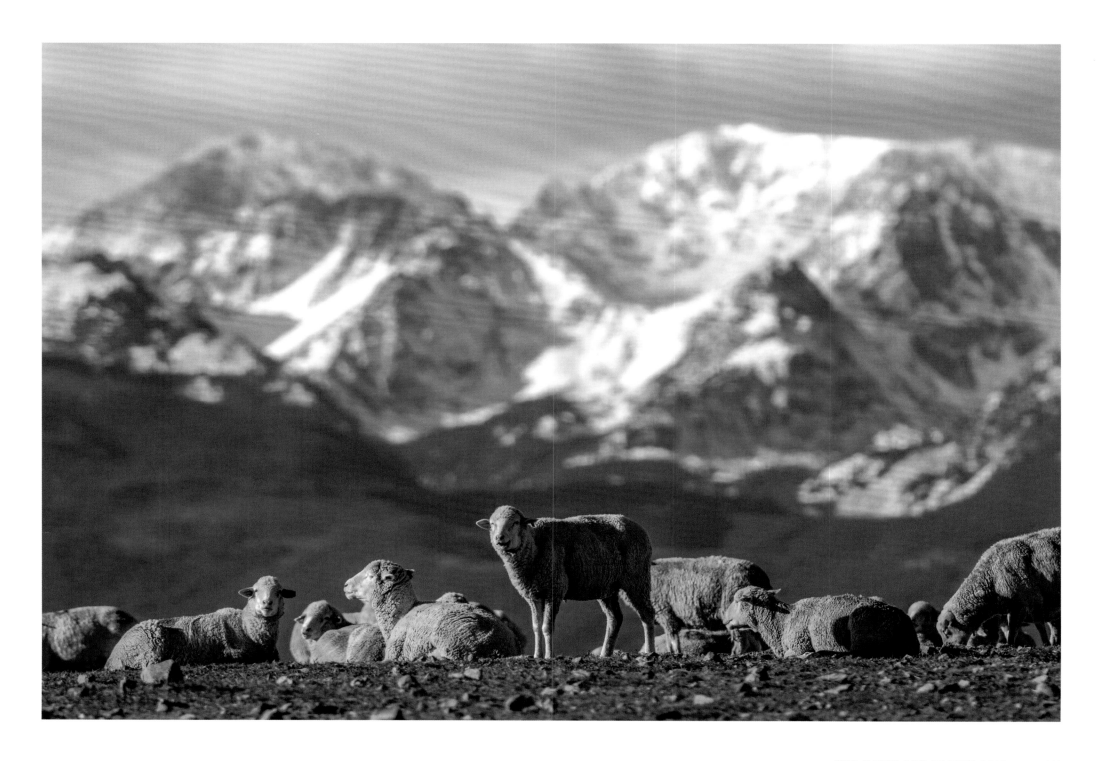

around the art, or by the fields around the Glyndebourne Opera, in England, where the audience strolls among sheep during the hopefully golden intermission. A rise is also a gradually upthrusting bench, as is our ranch.

We hope the experiences people have at Tippet Rise will fill them with the kind of silence out of which music rises or with the kind of darkness, free from urban lighting, filled with stars, that can no longer be seen from many places, and with the kind of spatial freedom from which our culture, literature, music, and history grow—the loping, descriptive ranch music of Richard Rodgers and Aaron Copland; the paintings of Albert Bierstadt and Thomas Moran; the novels of Thomas McGuane, Ivan Doig, and Rick Bass; the films of John Ford, Sergio Leone, and John Huston; and the road novels of Larry McMurtry and Vladimir Nabokov. Montana is in the corner of all of them.

Surrounded by waving rangelands, embedded in the twenty million acres of the Yellowstone ecosystem, visitors will be able to hear a concert underneath a labyrinth of wooden staves, cosseted by wind, with a 270-degree view of glacial valleys, alpine ridges, basins, and gorges, uncontained by walls but shielded from the spirals and shears of mountain thermals by the airfoils of Stephen Talasnik's *Satellite #5: Pioneer* (2016). Visitors can hear music the way Haydn heard it, in an intimate salon, with the exact proportions of the palace chamber where Haydn composed—elegant sounds in an informal Montana setting. Visitors can picnic in fields under the Beartooths while they listen to performances in a grassy amphitheater under di Suvero's seminal sculpture *Beethoven's Quartet* (2003) or around Ensamble Studio's megalith, *Domo* (2016).

All three of Ensamble Studio's structures were acoustically designed for musical performances, whether quartets or solo woodwinds or strings. Talasnik's sculpture has had John Luther Adams's *Inuksuit* (2013) played around it and can have a chamber group playing from its slatted latticework. Near the Olivier Music Barn, Patrick Dougherty has created the sculpture *Daydreams*

(2015) on the interior and exterior of a replica of a local schoolhouse, echoing the groves of willows and cottonwoods that surround it. Chamber music by the Ariel Quartet and cello solos by Matt Haimovitz have been performed inside the work. Both the Stillwater Residence and the dining pavilion, Will's Shed, are set up for high-resolution audio and video concerts.

With a direct view onto the Beartooths, the Olivier Music Barn is inspired by the intimate performance spaces where composers like Haydn and Bach would have premiered their compositions. The hall interior was designed by acoustics consultants at the engineering firm Arup, which designed the Oslo Opera House in Norway; the Royal Opera House at Covent Garden and Wigmore Hall in London; the Sydney Opera House in Australia; and Benjamin Britten's acoustically floating hall, Snape Maltings, in Suffolk, England. The seating, for around 150 people, is informal, on director's chairs. Concerts feel very intimate in such a small group, but videos of some events will be available to everyone online.

Our own lives have been changed by concerts that have accidentally become personal. At the Caramoor Center for Music and the Arts, in Katonah, New York, during a rainstorm in the summer of 1981, the pianist Ivo Pogorelich invited the entire audience of around eighty people to stand around the piano onstage. Somehow the nearness and the snow-day feeling of being liberated from the norm made the concert one of the memorable experiences of our lives. Since then, we have sought out such musical adventures.

On a hot summer day at Storm King in 1980, we ran through the sprinklers under the sculptures, and that moment, with its spontaneous revelations, remains in our minds thirty-seven years later. We would like to bring this sense of fun and community, with art freed from the confines of the indoors, to the great spaces of the West, for our children and our grandchildren, for anyone who might find themselves one summer afternoon wandering around the backcountry looking for answers—or questions.

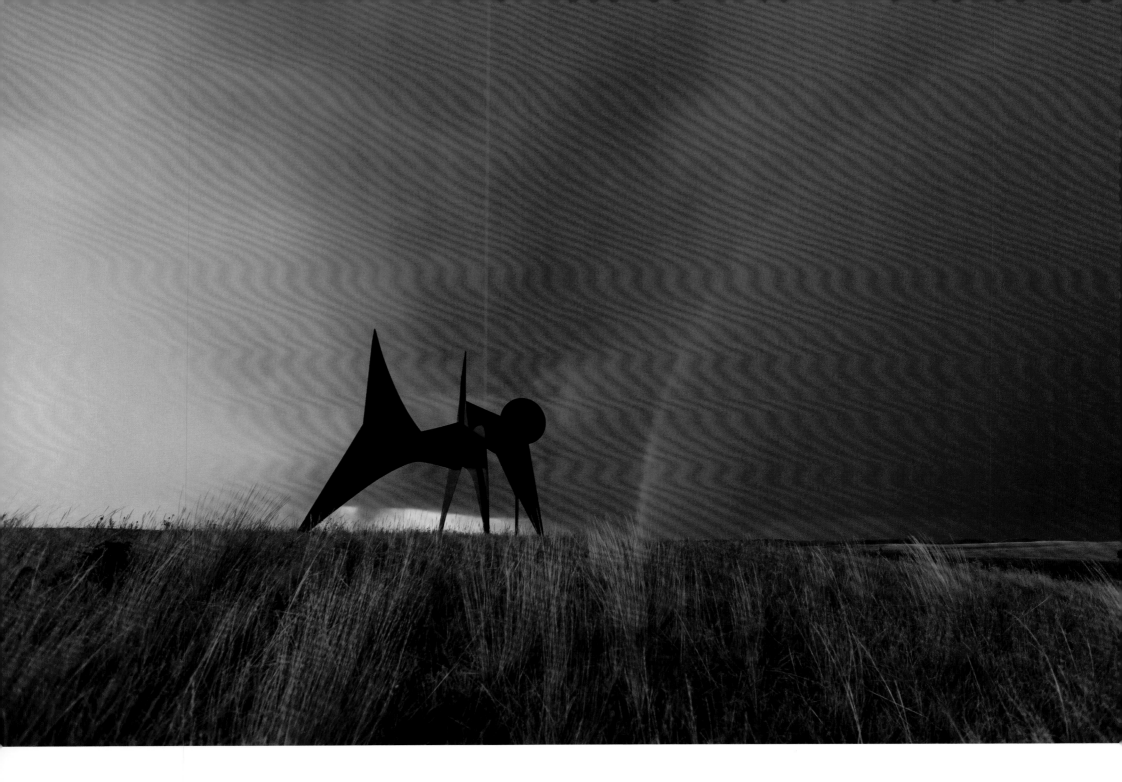

A DAY AT TIPPET RISE

Tippet Rise is set in a beautiful ranching valley, the Grove Creek Valley, in Stillwater County, just north of Yellowstone. It is the site of eight large outdoor sculptures, each with its own valley or pasture or geologic bench. Visitors can walk, bike, drive, or take van tours between the sculptures. They can control the amount of time they have alone with a work of art, or experience the thrill of a solitary stroll inside the rolling drumlins that open up on a cow pasture with a seventy-foot pendulum.

Tippet Rise is open from about mid-June to about the end of September. A typical winter—well, there is no such thing. A few years back we got fifteen feet of snow blown onto the roads over a couple of days. The sheriff called up everyone in the valley and said, "Stay home. Play with the kids. Watch TV. We can't even find the roads to plow them." Ben Wynthein, our ranch manager, drove the snowcat over the hilltops for some seven miles to get to the guesthouse to plow it out. The snow on the hilltops and the ridges was blown off by the wind, but still it took an entire day to reach the guesthouse. By the end of the week, the Chinook winds had come down from the Beartooth Mountains and the snow had melted, resulting in enormous floods that buried roads in ponds.

A minus-forty-degree night can morph into a sixty-degree day in the dead of winter. Summers can be cool and windy. Winters can be warmish and pleasant. You never know.

We have some twenty miles of fences and more than thirty wells, which use sunlight to pump springs up into buried cisterns on hilltops, from which the water flows slowly back down underground in soaker pipes. That way, instead of one muddy spring surrounded by cows, the water flows down all 360 degrees of the hill and the cows can spread out to graze in a more democratic pattern.

The area around us is quite pristine. Yellowstone has three million acres of wilderness west of us, but its actual ecosystem is more like eighteen million acres of mountains, immense valleys, coulees, rivers, forest, and untracked wilderness. The Gallatin National Forest is to our immediate north; although it is nominally a forest, it is in fact a continuation of the wild Absaroka Range of the Rocky Mountains. For a million acres, there is one road, which runs through wilderness and dead ends in wilderness, surrounded on both sides by the spires of the Absarokas.

To the south of us is sixty miles of what people call legacy ranches. During the Great Depression, wealthy industrialists and company owners were still making money but did not dare put it into stocks because of the frequent market crashes. One of the ways they continued to invest in the nation was to buy up ranches, where they would vacation with their families in the summer.

These are not just ranches; they are icons of the American West. Rolling grasslands, with cows, sometimes sheep, and the occasional old woodshed, lead directly into the mountains, where old log cabins await the visitor. And these are not just any mountains.

The Beartooths are the Gothic mountains that Albert Bierstadt painted around the time of the Civil War. As imagined as Bierstadt's mountains are, the Beartooths do a good job of

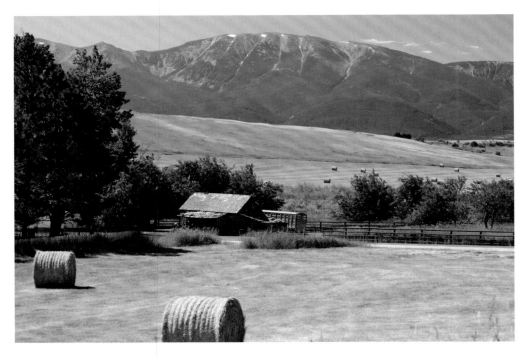

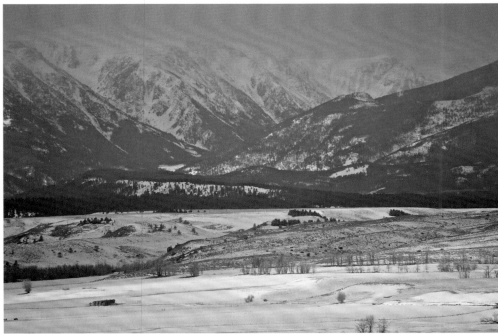

providing the swirling fogs, demonic overhanging geodes, frightening dinosaurlike pinnacles, and strange shapes and shadows out of which nightmares and dreams are born. They might be the Carpathian Mountains of Transylvania. In fact, stretching for a million acres just north of Yellowstone, they offer vast, untouched high-mountain tundra, hundreds of brilliant blue tarns set like emerald necklaces beneath Yosemite-like domes, easy day hikes on top of the world, or difficult weeks-long mountaineering treks across the fastnesses and sanctuaries deep inside the wilderness. Straight spires resembling sea stacks and stegosaurus spikes rise everywhere, like heat fins on amplifiers, as if giant three-hundred-foot shovels are being pushed up from hell. Warm air perfect for strolls in the highlands can turn into raging blizzards with howling winds a few hours later. Many summers when the Beartooth Highway first opens, the snow walls on both sides of the road are easily forty feet high.

The canyons that emerge from this fantasy world would be national parks in any other state. East and West Rosebud Canyons are Yosemite-like, wide ranchlands shadowed by immense walls and gargoyled cliffs, headed by large lakes and trails that curl up onto a dozen high steppes, with names like Froze-to-Death Plateau. Stillwater Canyon leads directly to Yellowstone (although the hike or horseback ride takes a few days).

Five blue-ribbon trout rivers flow out of the Beartooths and through the empty wildlands in this undiscovered and untouched part of the state.

On summer weekends, Tippet Rise offers electric van tours around the ranch. The photovoltaic panels that charge the vans also act as shade covers for gathering spots.

In order to erect the concert hall in the shape and size of a traditional Montana barn, we positioned an otherwise intrusive control station for the energy source—solar, geothermal, and normal powerlines—underground. This energy building also contains backup generators for the hall and the nearby artist residences, as well as the Heller Bench cottages hidden in a small valley nearby.

Although the concert barn looks agricultural, it is very high tech and allows concerts to be filmed in 4K video and nine-channel high-resolution surround sound. We are applying for Gold-LEED certification. It implements the patented Arup ventilation system, which pulls air into the building, cools or heats it with pumps as large as tractors, runs it up large ducts, and allows it to float back down onto the audience. The ducts are almost twenty feet wide, which keeps the rushing air completely silent. Gauges measure the amount of energy being used by the building.

There are twelve miles of all-weather roads and an equal length of hiking and biking trails in progress. Increasingly, visitors choose to get out of the van and walk, ensuring an even more personal experience with the sculptures and the valleys.

Tippet Rise has valleys of Aku-Aku-like rock formations, giant blocks of eroded dikes that seem to resemble people. There are lost canyons without names and distant pastures frequented by wild horses. We have a wolf den, eagles, bears, and coyotes. Grizzlies mostly keep to the isolated mountains.

Tippet Rise has a variety of concert sites that are classic "jewel boxes" based on the golden ratio found in the Parthenon and the Temple of Solomon. (Many of the halls for which Haydn, Bach, Mozart, and Beethoven wrote their music and in which they performed also share those dimensions.) In the years since the baroque and classical eras, concert halls have become enormous—designed for Romantic music and large orchestras—but the intensely personal sound of the golden-ratio hall is only accessible in a few venues in Europe. There is just one similarly proportioned hall in the United States: the acoustically powerful Olivier Music Barn at Tippet Rise. To hear live music shaped by the same kind of acoustic space in which Haydn heard it, you would have to travel to Europe—or to Fishtail, Montana.

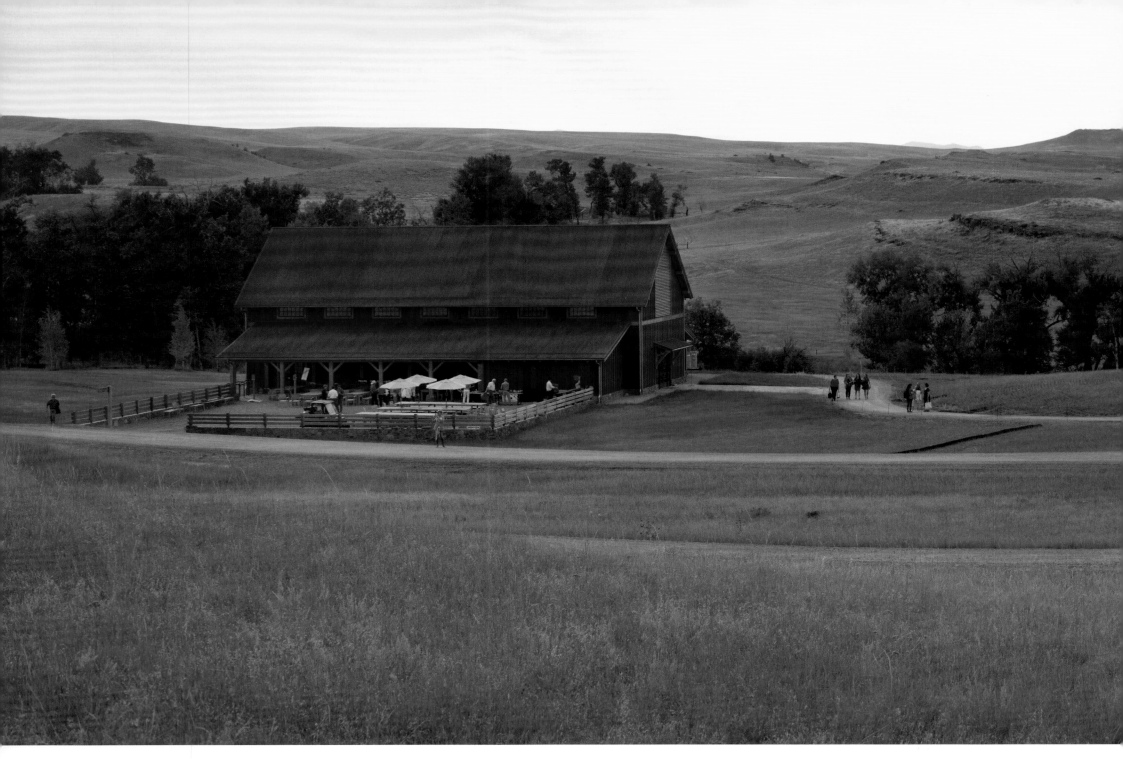

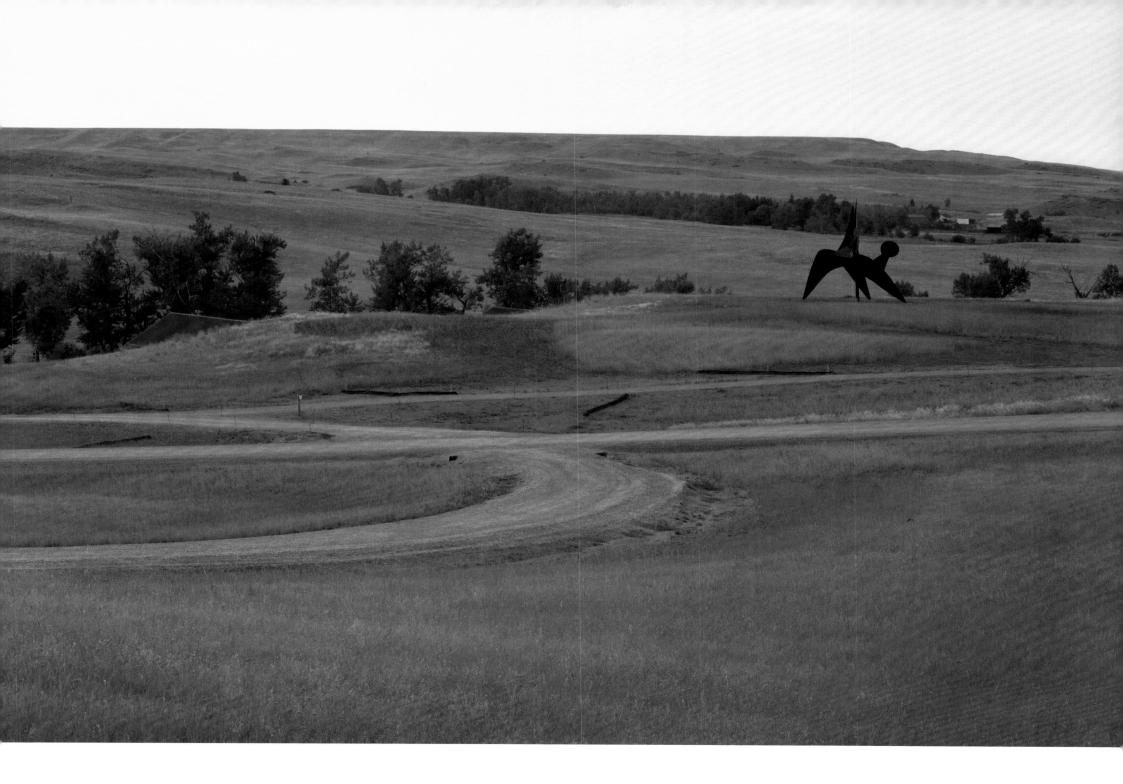

The deeply resonant sound is like being inside a cello, with rich tones digging deep into your ears.

Concerts are held late in the evening on weekends in the Olivier Music Barn (right, bottom) and also outside, near the sculptures, in the fields, around Calder's *Two Discs*, and in the unique Tiara Acoustic Shell (right, top and center). For our outdoor concerts, we asked our first director, Alban Bassuet, to design a shell, working with engineers at Arup. He came up with a unique amphitheater design in which only the top edge of the structure is built, at the point where the walls would meet the ceiling. The majority of the sound bounces off this area, conveying the acoustic sensation of being enclosed in a beautiful wood-paneled room, while, in fact, you are outdoors surrounded by nature.

The structure was built by Laura Viklund and Chris Gunn of Gunnstock Timber Frames in Powell, Wyoming—they also designed and built the Olivier Music Barn. The Tiara was fitted on a custom stone circle and can hold a hundred people as well as musicians. The unusually cossetting sound is astonishing, seemingly coming from nowhere.

Evenings are often preceded by dark skies, clouds that reach down to the fields like the muscled arms of Leonardo da Vinci's God. When the rubber band of nature is wound tight and certain doom seems inevitable, storm light emerges in the immense sky; a strange orange glow suffuses the fields; the air grows thick with persimmon, cinnamon, and clove; and rainbows burst out like codas over the rolling land. After a celebratory dinner, the musicians disperse for informal playing, out in the hills, until the inevitable morning call at 4:00 a.m., when they rush to meet the plane in Billings and move on to their next job, far away from Fishtail.

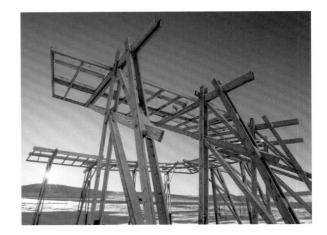

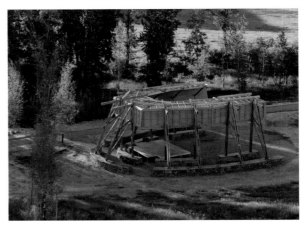

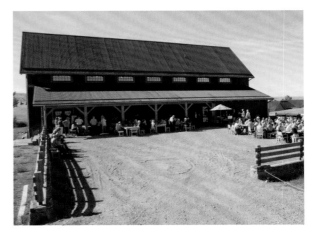

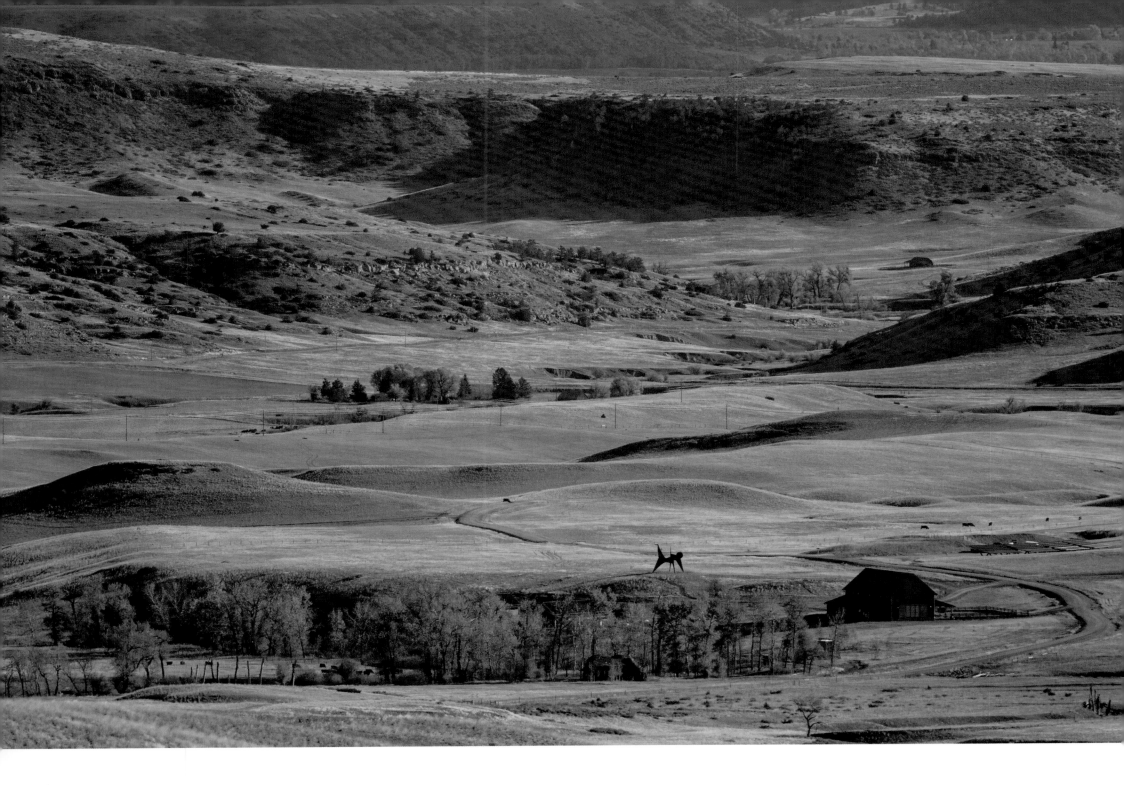

SCULPTURE AT TIPPET RISE

The outdoor sculptures we have commissioned or chosen relates to the invisible underpinnings of
the universe. Art at Tippet Rise is about what poet John Donne called "things invisible to see." It is about
what poet Wallace Stevens called the "harmonium" and composer Alexander Scriabin the "mysterium."
It is about metaphor, the unseen bridge between an inkling and a belief. The sculptures we have
commissioned or chosen are cairns. They are way stations that indicate a direction. They are not the
ends in themselves. They are windows through which we see the world framed.

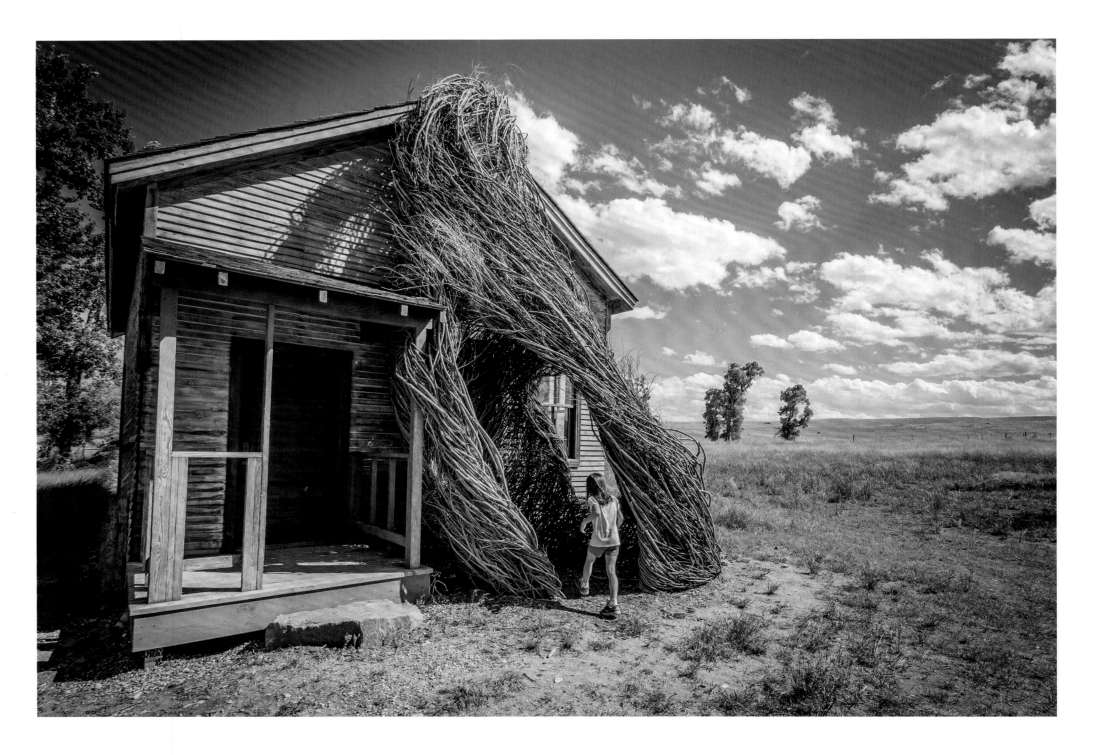

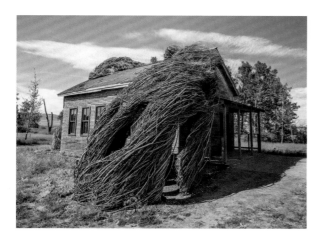

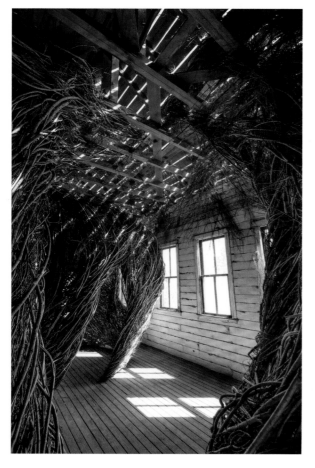

Patrick Dougherty

Daydreams, 2015

Working with his son, Sam, and Sam's friends, Dougherty created *Daydreams* on-site, with willows gathered over several months in the spring from neighboring ranches and streams by Pete Hinmon, Tippet Rise director of operations, and Ben Wynthein, Tippet Rise ranch manager. The saplings were soaked in a pond made by Wynthein to keep them from sprouting branches. Dougherty's weavings are like Vincent van Gogh's frenzied strokes of oil paint, but calmly reasoned and patiently bent into place, anchored around key branches.

Dougherty had the idea that a schoolhouse would be the perfect canvas. We copied a nearby structure, down to its missing shingles, which was then recrafted by the CTA Architects Engineers' office in Bozeman, Montana. After sitting in the school for a few days, Dougherty began to create his lazy students. Their daydreams make the only memories that most of us have of grade school. They spread out beyond the classroom and imitate the cottonwoods, living and dead, which indicate the presence of intermittent springs around the site. As the poet Richard Wilbur wrote in "A Wood" (1969),

> . . . small trees of modest leanings,
> Contend for light and are content with gleanings.

Stephen Talasnik
Satellite #5: Pioneer, 2016

Working with Laura Vyklund and Chris Gunn of Gunnstock
Timber Frames, Talasnik began this latticework in a warehouse in
Cody, Wyoming, and then finished it on-site with advice from
Arup. It is made from yellow cedar logs and slats, linked by special
connectors devised by the artist and with steel tubes to prevent
moisture from wicking into its seven points of contact with the
earth. The sculpture is an exact copy of the original small maquette
(the size of a shoebox) devised by Talasnik for a project on the East
River in New York City. *Pioneer*'s construction proceeded by trial
and error, as the artist and his assistants enlarged the original bamboo
model by a thousand. While building it, they were forced to analyze
the stresses and trajectories of the structure, an unprecedented
shape, to ensure its stability. It is one of a series; this one is named
for the satellite launched in 1973 to view the dark side of the moon.

Talasnik's affinity for negative space can be seen in the way
the holes in *Pioneer* make their own negative sculpture, projected
on the snow or on the grass by moonlight. This floating labyrinth
embodies Talasnik's fascination with roller-coaster scaffoldings,
basket weaving, the string cities of Italian futurism, and the tragic
photos of explorer Sir Ernest Shackleton's ship *The Endurance*,
frozen in ice in the Weddell Sea off Antarctica. (Adventurer Frank
Hurley photographed the crew as the men struggled, successfully,
to survive for ten months in 1915.)

Talasnik chose the site so his satellite would have berth, an
acoustic environment, and a natural bowl to frame it inside the
enormous moonscape of Tippet Rise. In winter, it seems to have just
landed on an alien planet. Its shadows and angles change with the sun
and the position of the viewer. It has three rooms inside, and it has
sheltered hundreds of listeners during a performance of John Luther
Adams's *Inuksuit*. It is a cat's cradle with enormous theatrical and
musical possibilities.

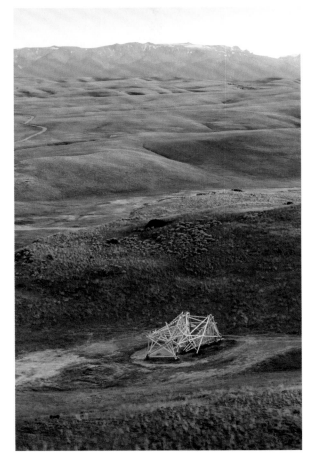

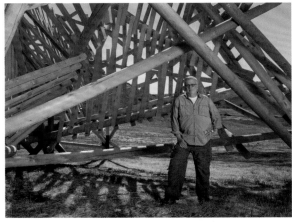

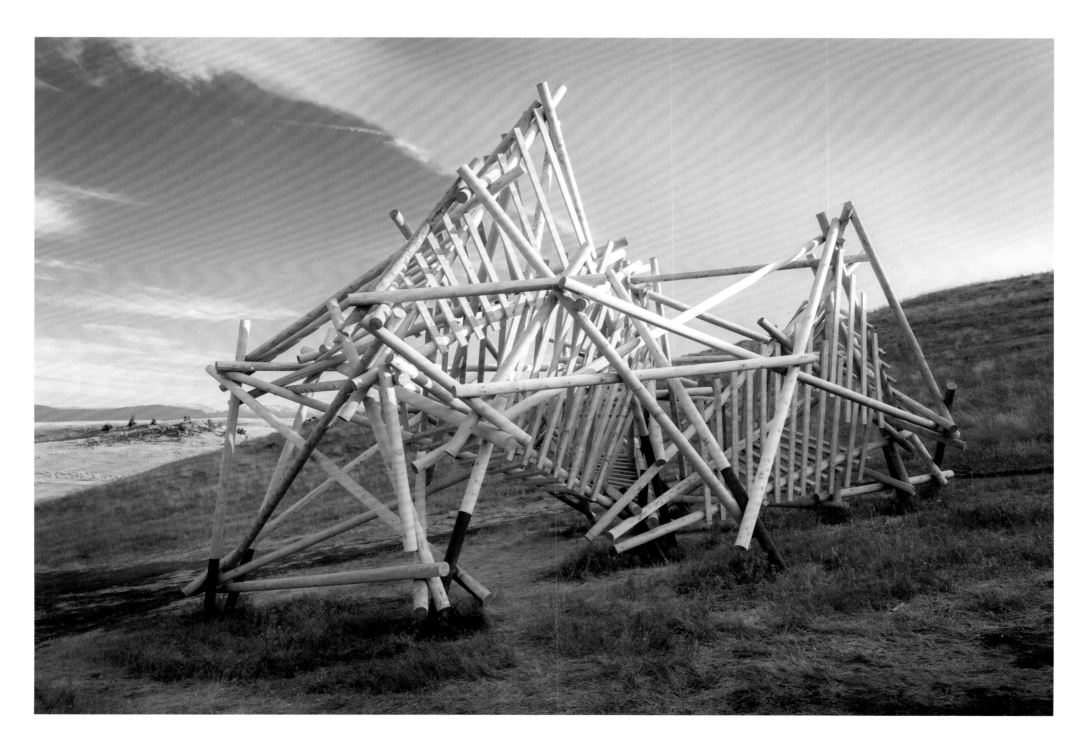

Ensamble Studio

Beartooth Portal, 2016, and *Inverted Portal*, 2016

The manual for the *Portals* would speak of the shadow of the sun cast at the solstices and the equinoxes. The *Portals* are gates, but also sundials. They are gnomons, the obelisks on the dials, the cairns that serve to locate time in space, as we ourselves are cairns, the point of sun, the focus of time.

The *Portals* are aligned with the stars and with each other, a spoke in a constellation projected onto earth. Like a Hopi *sipapu* ("place of emergence"), a symbolic hole in the floor of kivas, at Mesa Verde National Park, these are wormholes through which man is born to earth from space. Like the departing cliff—a promontory from which it is believed the soul leaps to an afterlife—present on all the islands of the South Pacific, they are also windows through which the soul migrates into time.

Weighing four hundred tons, they required four cranes and six months to erect. They are made from the land beneath them. Like with the lost-wax process, they were poured into a plastic-lined mold cut into the land. The folds of the earth and the plastic were shaped specifically so they would be retained by the final cast.

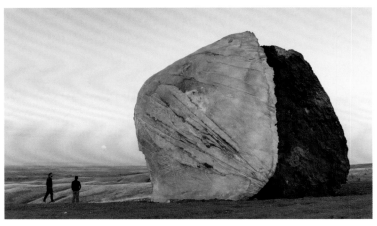

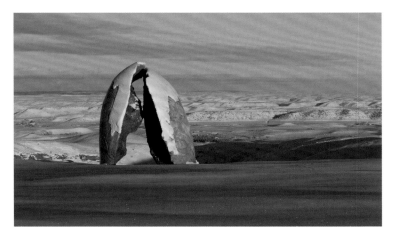

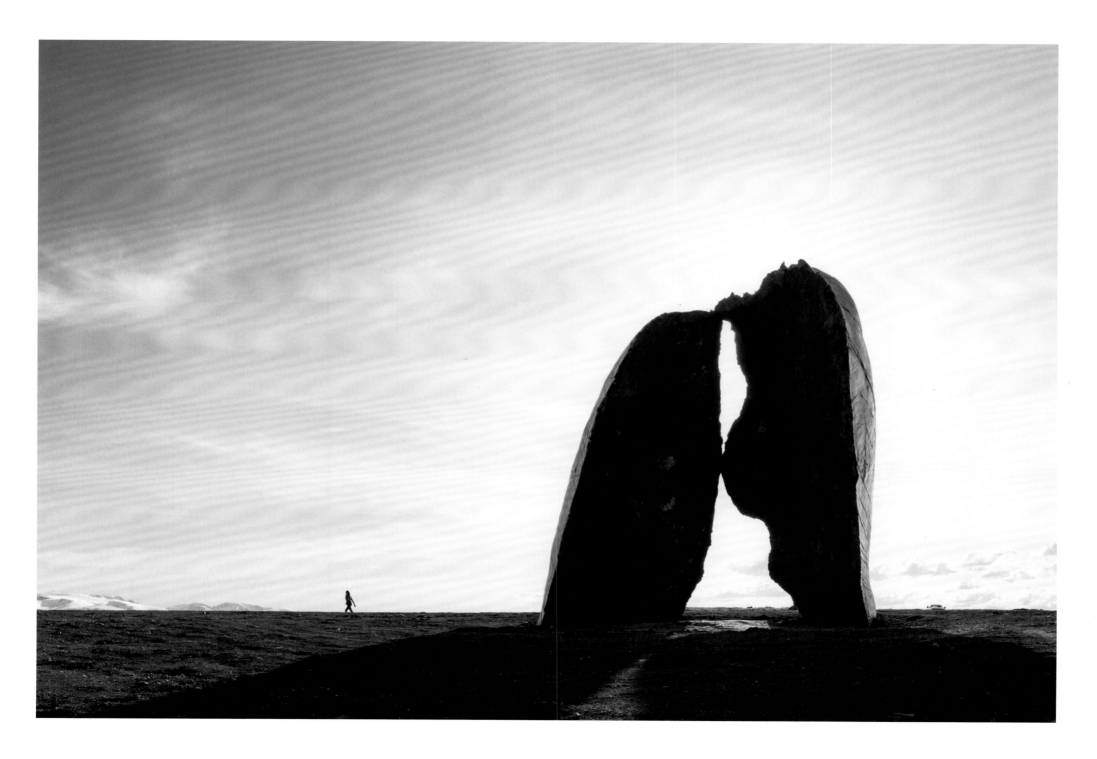

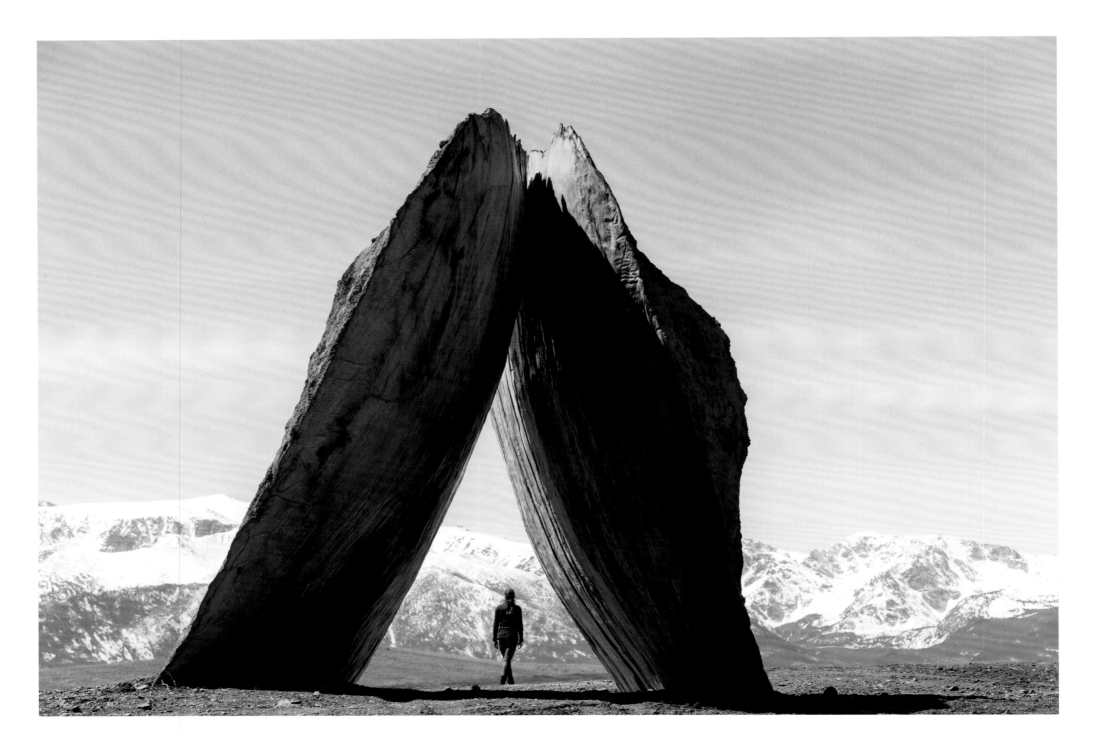

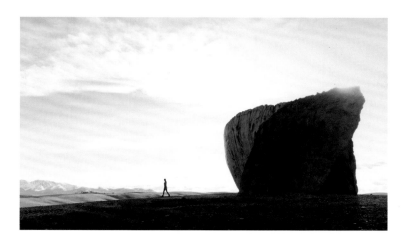

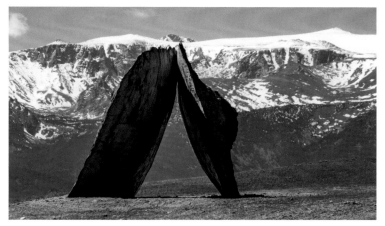

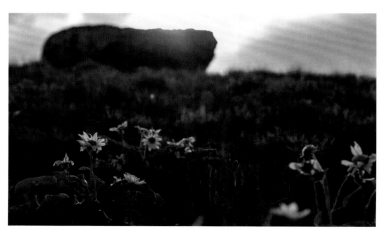

They seem autochthonous, sprung from their own energy, without ancestors, without creators. They were in fact designed as a set of thirty-four primitive shapes to suggest the geology of the land, scoured from volcanic residue by glaciers, ploughed from quartz, zinc, silica, and lava into alluvial till and eroded by weather into clay, minerals, and diatomaceous earth, made from diatoms, microscopic fossilized algae fifty million years old.

Tippet Rise was once a seabed. The enormous volcanic caldera now part of Yellowstone pushed up the surrounding tectonic plates, forming the Beartooth Mountains. The Beartooths themselves are named for the Red Lodge palisades, toothlike spikes up to six hundred feet tall that protrude from the cliffs like shark fins. The *Portals* reprise this local phenomenon, found only in the Absaroka-Beartooth Wilderness immediately to the south of Tippet Rise.

Ensamble Studio

Domo, 2016

Domo is a dolmen straight out of prehistory. It is a house, a domus, made of earth and stone by Ensamble Studio of Madrid and Boston, headed by the married couple Antón García-Abril and Débora Mesa, working with their team members, Ricardo Sanz, Artemio Fochs, and Javier Cuesta, as well as On Site Management of Bozeman and Jackson Hole, Wyoming. Like the Janusian gods of the household, it has several entrances and exits.

The many doors of *Domo*, like the *Portals*, are for the many lives (and concerts) it hosts inside its labyrinth. Although it seems to come from nature, its ceiling was acoustically designed for superior sound projection. You can hear a pin drop inside the *Domo* when standing five hundred feet away in any direction.

As a Stone Age plinth, it is the equivalent of a pyramid: an elegant transport into the new life of whatever is placed inside it. It was poured into the land and then excavated by bulldozers, in an inverted lost-wax process. Plastic tarps were used to create the folds in the stone, like a cloak by da Vinci. The entire structure weighs around twelve hundred tons. It is composed of fifteen hundred cubic yards of concrete, stone, and earth, with 180 tons of rebar inside providing strength.

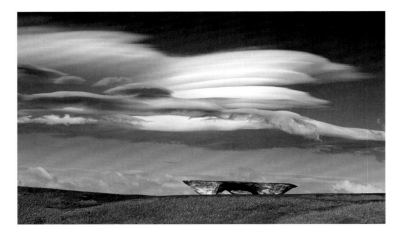

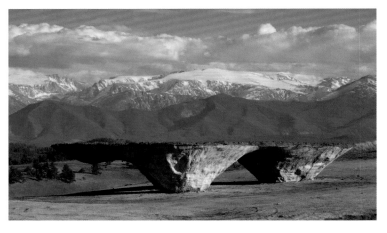

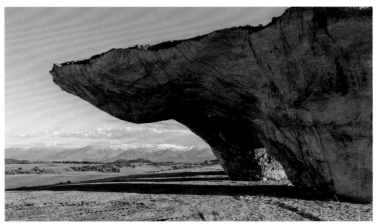

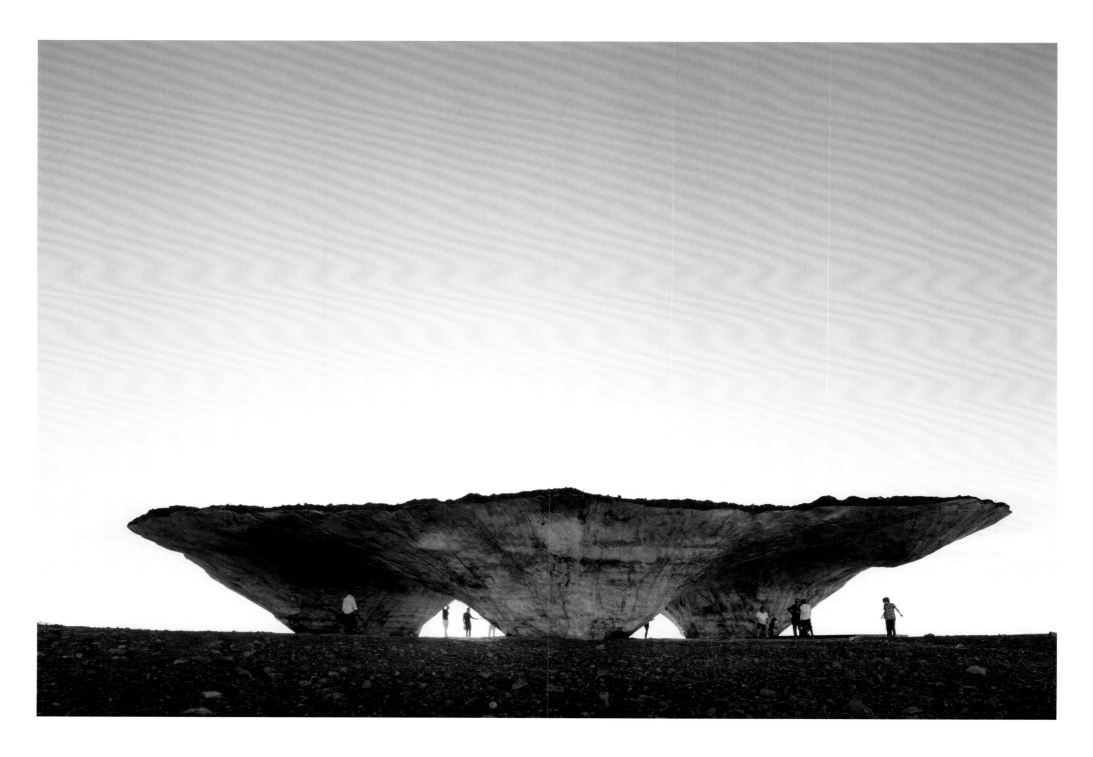

Mark di Suvero

Beethoven's Quartet, 2003

Installed at Tippet Rise by the artist in 2016, *Beethoven's Quartet* was formerly at Storm King Art Center. This tripartite monster is about the late quartets of Beethoven, which, like Stonehenge, does double service as both object and tools with which the universe can be uncovered. As the novelist Thomas Mann wrote in *Dr. Faustus* (1947): "Nature itself is too full of obscure phenomena not altogether remote from magic—equivocal moods, weird, half-hidden associations pointing to the unknown...." Time and space are curved, like the Möbius strip suspended from the sculpture's classic superstructure.

Between the lines of a musical staff, between the scaffolding of classical forms, hanging like vines on the trellis of what can be observed, is the mystery of what can only be suggested.

The late quartets of Beethoven are the ultimate voice of a future too ethereal ever to arrive, too unearthly ever to become entirely clear to us. They are Beethoven's vision of the future, his hymn to always elusive celestial gears, and, to di Suvero, the supreme example of human achievement. He also loves the music.

This was the first time that di Suvero had bent steel entirely by force (a "cold bend"), using his crane, rather than by heating it. It took a year. The striations of the battle remain on the steel. As well, the roseate pattern in iron also took a year and was just as difficult.

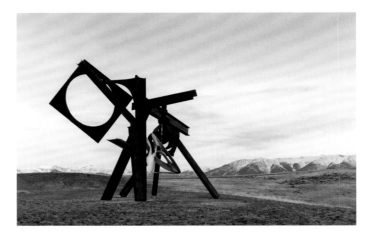

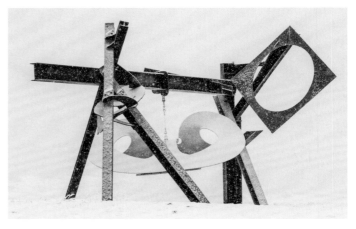

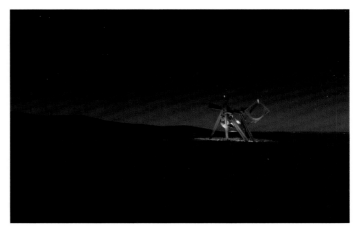

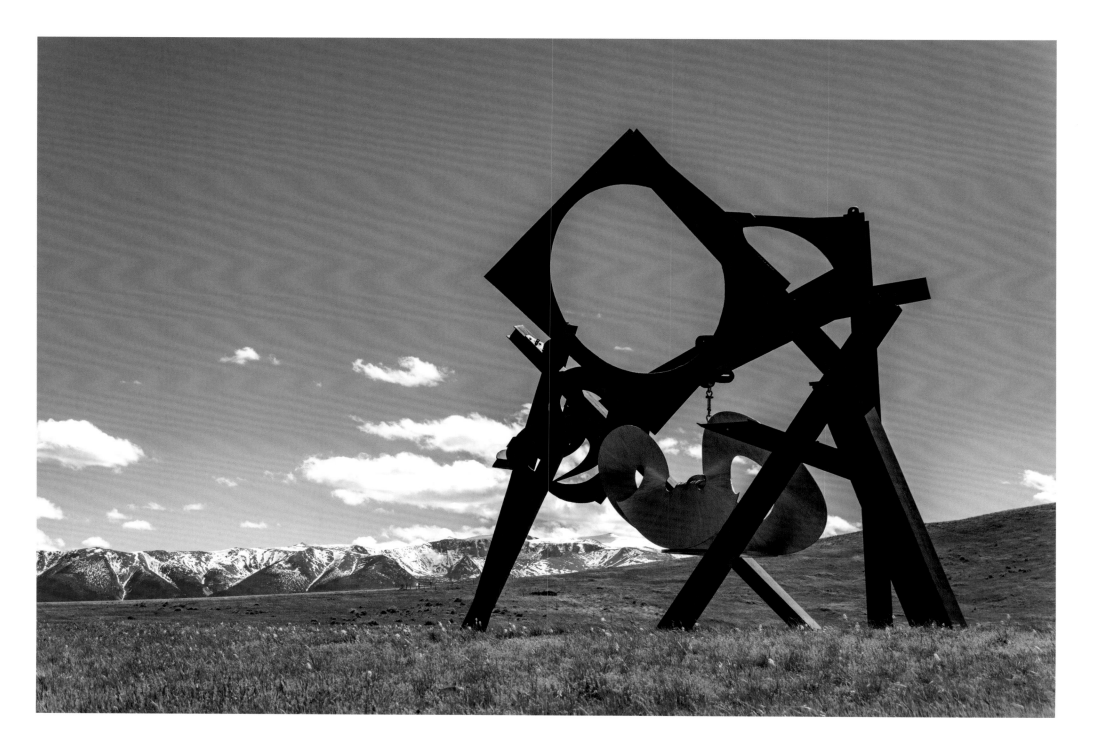

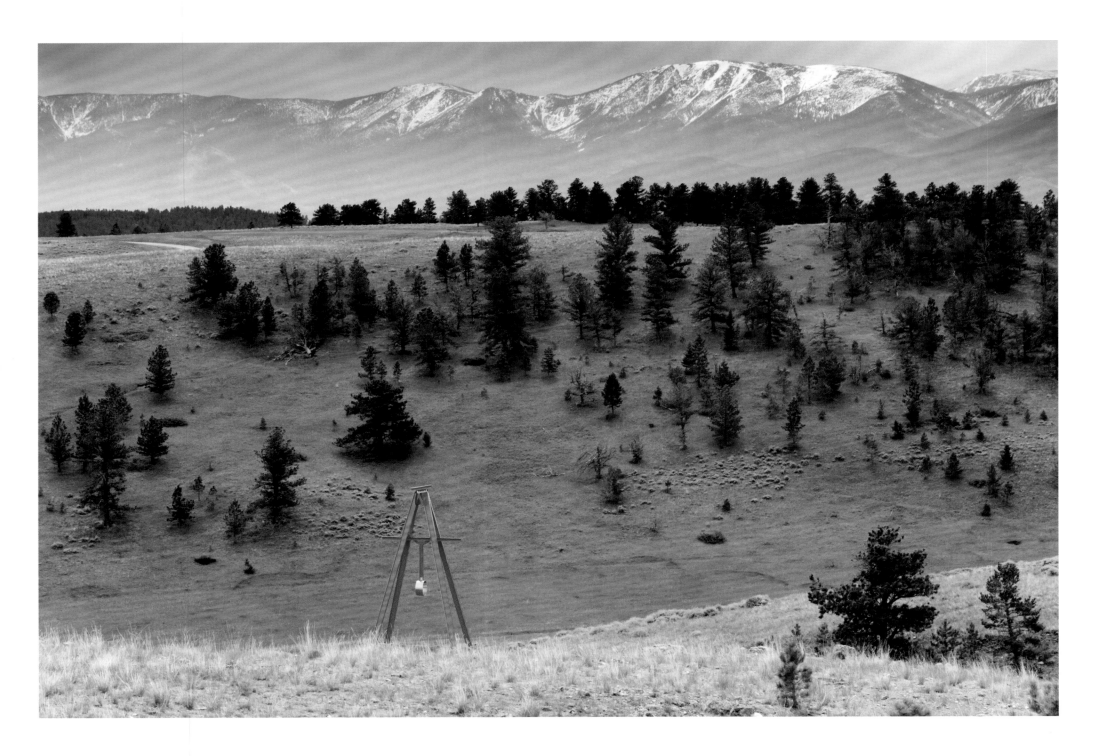

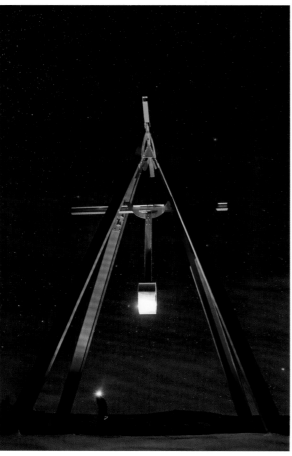

Mark di Suvero

Proverb, 2002

Proverb was formerly installed in front of the Morton H. Meyerson Symphony Center in Dallas before coming to Tippet Rise in 2015. The sculpture is composed of four sixty-foot red steel girders, which were hoisted by a crane and pulled into position by the artist. The wind was blowing some sixty miles an hour the day of installation, so you did not want to be in the way of one of the girders when it was swinging, but di Suvero and his crew used the momentum of the wind to help them.

The pyramid of *Proverb* is equally a metronome, a pendulum, a pair of calipers, a straight-edged ruler, a protractor, and a compass. Like the simple, catchy expressions meant to impart universally held truths, *Proverb* can be seen as providing measured solutions to eternal mysteries.

Explorers and geographers have traditionally used tiny machines like theodolites, calipers, sundials, and metronomes to measure the enormous distances of space and time. Against giants, we throw stones. By making a machine that is an amalgam of several of the above machines, but on an enormous scale, di Suvero makes the point that even an enormous ruler fails to measure up to the vast scale of the universe. Small tools cannot measure the vast world, but small algorithms can transport us across it. Our dreams are thus both foolish and entirely valid. *Proverb* evokes a dual irony: shock at our credibility and shock that simple dreams can also come true.

Alexander Calder

Two Discs, 1965

Two major works by Calder are on loan from the Hirshhorn Museum and Sculpture Garden, the Smithsonian Institution's museum of international modern and contemporary art, located on the National Mall in Washington, DC.

With dark steel arches that invite viewers to walk beneath it, the monumental sculpture *Two Discs* is a cornerstone of the Hirshhorn's collection. It had been installed outside the Hirshhorn's entrance for forty years, ever since Joseph Hirshhorn endowed it—along with six thousand additional works—to the museum named after him when it opened in 1974. The museum now holds twelve thousand objects in its collection.

For many decades, it was the first work of art encountered by visitors to the Hirshhorn. Today, *Two Discs* stretches out beneath the Beartooths on a geologic bench above the Tippet Rise concert barn, surrounded by cows and sheep on over ten thousand acres of land. The ranch livestock re-creates the uncanny resemblance to the farm animals of *Two Discs* that Calder loved to imitate.

From one angle, *Two Discs* resembles a crouching, almost predatory figure with a cape, very much like the double-crested dinosaur Dilophosaurus, with its large neck ruffles. The figure takes on very different identities when seen from various angles. One angle finds it having a shark tail and jellyfish globules in front. Some angles present it as a contiguous image, while others exhibit its wildly fractal assemblage, its sections bearing no relationship to one another. This is why photographs often betray the plethora of possibilities in a piece. In a way, you can see in *Two Discs* the precursor to di Suvero's *Beethoven's Quartet*. They are both animalistic.

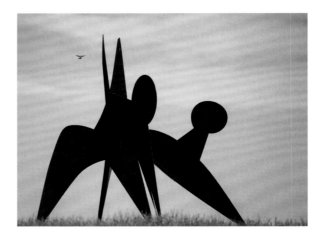

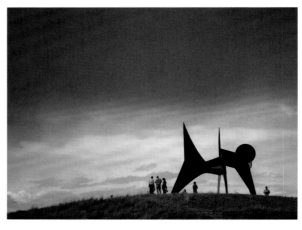

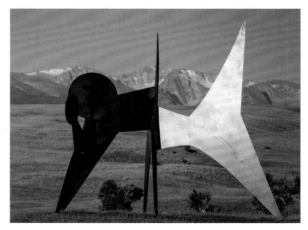

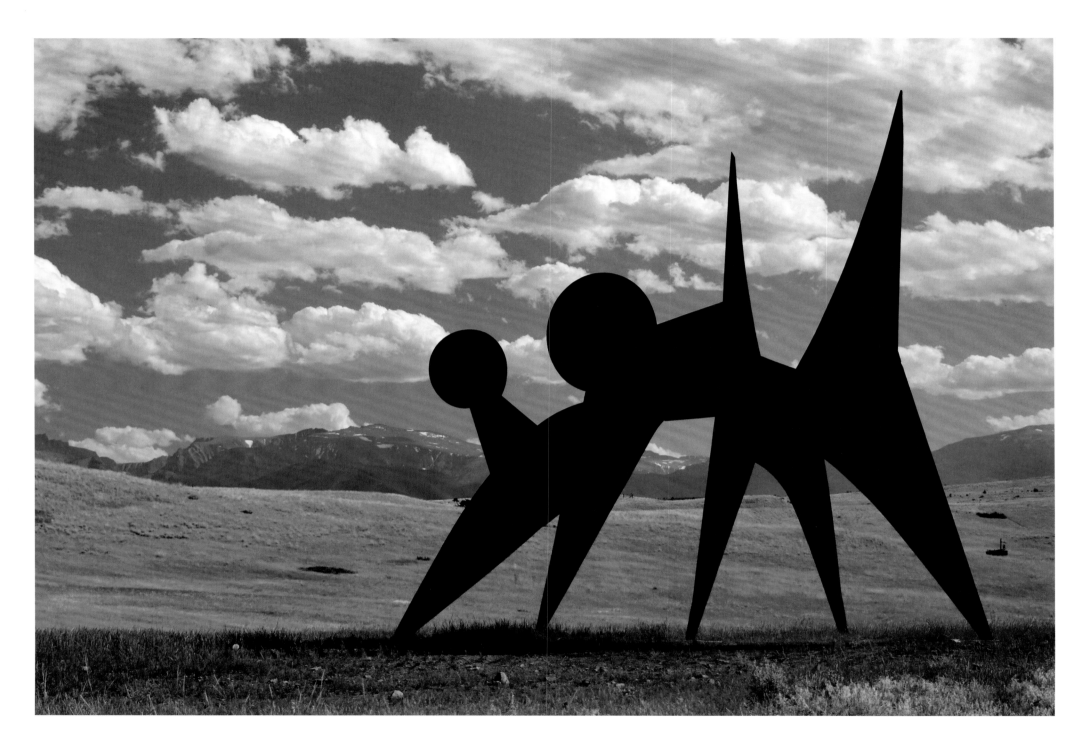

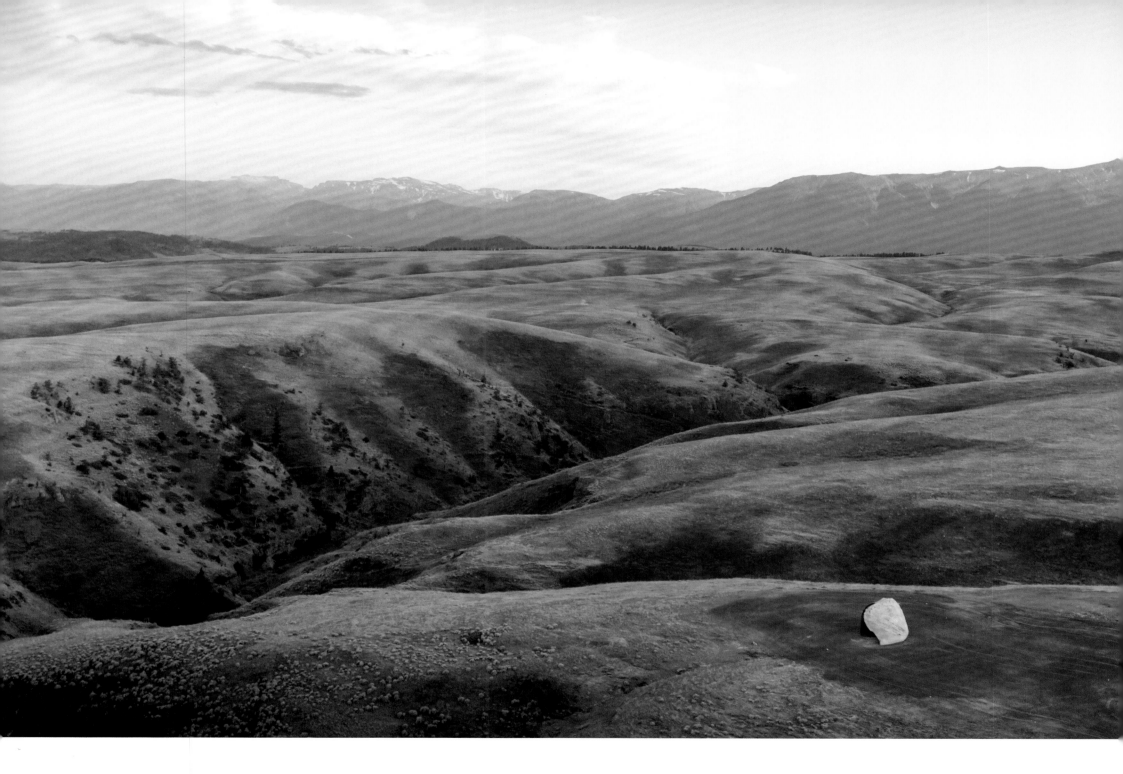

THE SYNERGIES OF TIPPET RISE

Music is not about notes. Sculpture is not about shapes. Land is not just about dirt. All are metaphors, collaborations, triangulations that work by suggestion, nuance, hints. They operate in the offing, just over the horizon, in a world just out of sight, on the tips of our tongues, not entirely visible.

Only when we allow art to open up the world with a larger vocabulary; when we allow music to be about science and meaning; when sculpture is about direction, astronomy, the night sky, the Northern Lights; when land is about choice, and life, and family (as all of us who live in large spaces realize), only then can we begin to form a picture of elements intentionally thrown together to transcend their state, to rise above our normal conditions, to offer a path out of chaos and above the clouds into a bright, uncluttered day where all the clues of the light speak to us in harmony and new orders of material coalesce and shine.

Things have to collaborate with, correspond to, and refer to each other before they can run, leap, transcend, illuminate. When music becomes a language like our own speech, when a work of art becomes a sound, when the arts crisscross, then we begin to see how the brain needs all the things in the room to become the world we hope that babies will discover, the sky we hope our children will inherit, the night of our dreams.

Humans are the beneficiaries of a cosmos uniquely attuned to them. We are composed of atoms found only in stars. The earth is made from the sun. The frequencies that result from the rotations and orbits of planets, asteroids, and stars provoke a physical response in us. That is, the music of the spheres is embedded in our own music. Frequency is a matter not of entertainment but of survival. Losing their frequency causes asteroids to turn into meteorites and fall into the gravity of nearby planets. The proportions noted by philosophers throughout the ages, such as the divine ratio, figure not only in our great art and architecture but also in our music.

It is not just the physical materialization of intangible values that infuses our concepts of art and architecture; it is the synergies such elements inspire among us. For instance, filmmaker Djuna Zupancic made a film in a blizzard of di Suvero's sculpture *Beethoven's Quartet*, which formed the basis of a poem I wrote about Shakespeare's birthday entitled "Storm," which in turn moved di Suvero to work on a chapbook, *Fluorescence* (published in 2016), in which his drawings are paired with my poems.

Di Suvero's sculptures in some ways spring, as does *Proverb*, from his work in philosophy, his fascination with space time, and his love for poetry. *Proverb* is a sixty-foot compass, calipers, or protractor. By exaggerating its size, di Suvero makes the ironic point that no matter how big our small tools, they still are not big enough to presume to measure the universe. In the same way, my 2007 poem "Slide Rule" makes the point that compasses, meant to work on flat maps, cannot measure the many dimensions that shape our galaxy. Here, the abacus is used as an ironic metaphor for the infinity of space.

In addition to cosmological explorations into the future, di Suvero's constructions reach back into the past to the Romantic era and are in turn echoed by sculptors like Talasnik, who has been inspired by Italian futurism. *Beethoven's Quartet* resembles Romantic painter Caspar David Friedrich's *The Sea of Ice* (1824)—di Suvero's jutting girders reach into space for help or advice, the way the masts of the ruined and rimed ship in the Friedrich painting do. The alluvial till moraines at Tippet Rise heave like Friedrich's frozen waves. (The landscape at Tippet Rise was once the bottom of the inland sea during the ice age.)

The rigging and spars that are similarly embedded in Talasnik's skeletons seem to weave into the lunar landscape at Tippet Rise, and the megalithic resonance of the geology of the area is reflected in the latticework of his "satellites," his reticulated living spaces that resemble space stations in the landscape. This has, in turn, inspired the creation of music by composers Aaron Jay Kernis, Antón García Abril, and others.

Other synergies take the form of bricks-and-mortar partnerships. For example, we have partnered with the Hirshhorn Museum and Sculpture Garden in Washington, DC, to support ARTLAB+, a digital lab founded to help students develop marketable skills in new technologies. We cofounded the Digital Scholarship Lab at Brown University to provide digital facilities and training for university students. We are working with the Sidney E. Frank Foundation, the Adrian Brinkerhoff Foundation, the National Theatre of Great Britain, the Royal Shakespeare Company, Shakespeare's Globe Theatre, the Mariinsky Foundation of America, and other organizations to create programs on a number of themes: classic poetry, classic theater, classical music, film as an educational medium, sustainable ranching, sustainable technologies, education, and related arts.

We have chosen the artists, and the art, at Tippet Rise to reflect the unity of reason and passion and also to stress the need for symbols, for metaphor in sleuthing out the street maps of

Storm

The white of snowfall muffles
All, although it hides
A thread inside: a key
To a labyrinth that guides
Lost travelers back home,
The way a blank page shuffles
Everything unsaid
Into versions of infinity—
A hidden dome, an offing
Where revolves and grows,
Like waves at night, the aura,
The overtone of things unseen,
Shapes of the unknown
That surround a hand, a string
Quartet, the Aurora
Borealis—filigrees

Made obvious by night,
The universe's bright debris
Hanging in the sky, stalactites
Traced by energy,
Like iron filings by a magnet.
Mystery at the heart of things—
Mystery is the way
Underlying worlds set
Their deeper orbits into play,
The invisible but also huge
Trellises that spawn
A storm's impelling centrifuge
Where drifting lives are drawn
Into nature's whirling sieve:
The page's human white where
Only cosmic dreams can live.

Slide Rule

How can one-dimensional
Compasses apply
To our incalculable
Abaci?

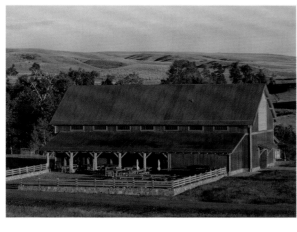

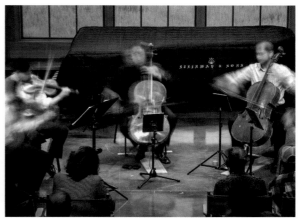

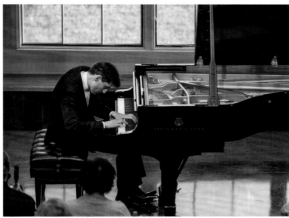

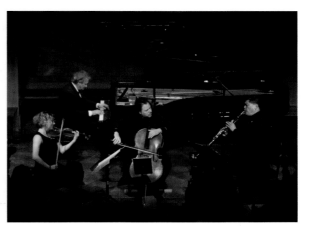

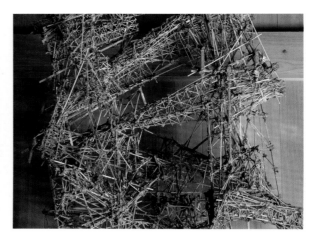

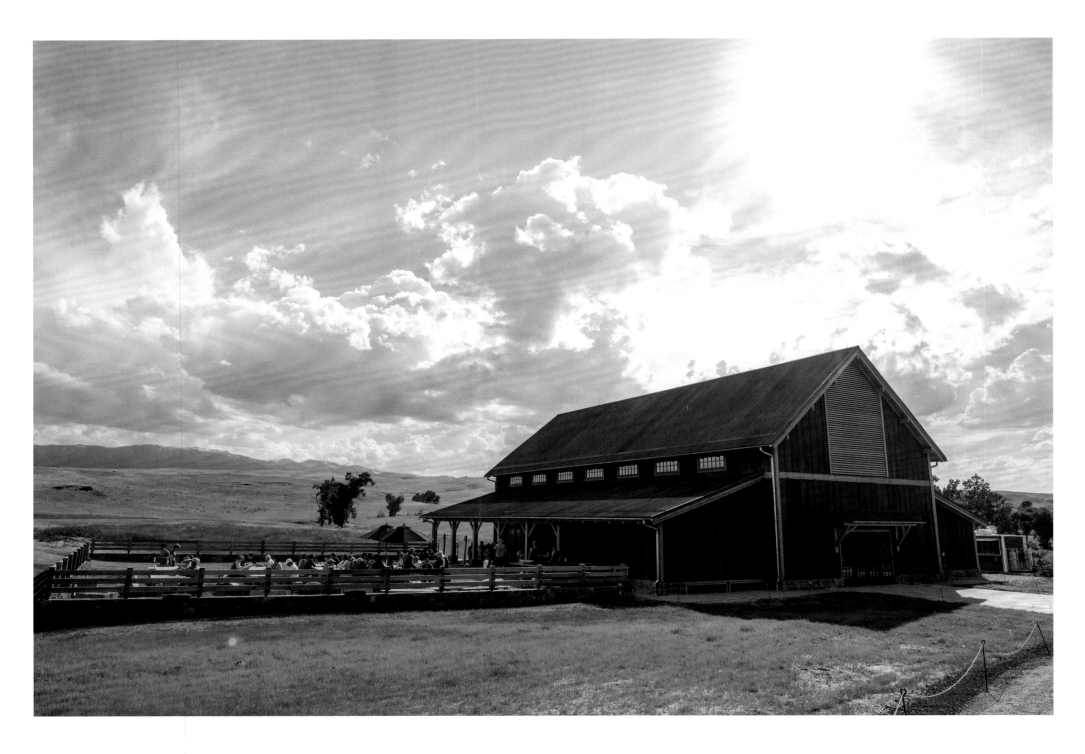

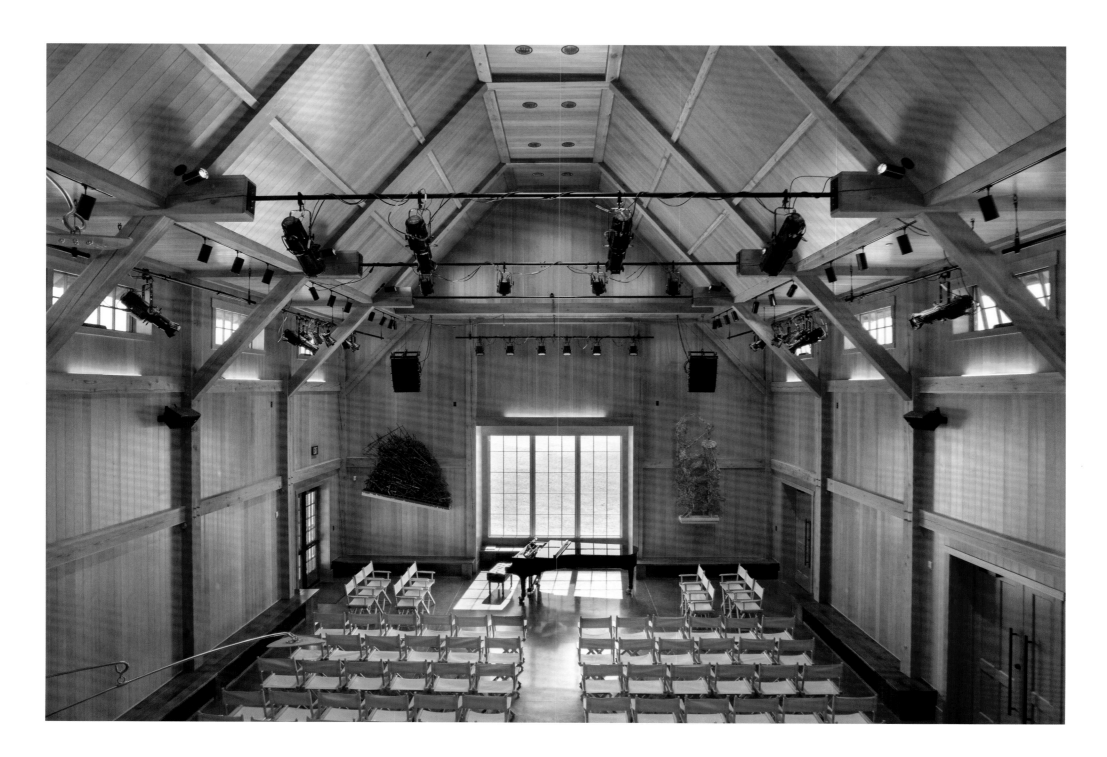

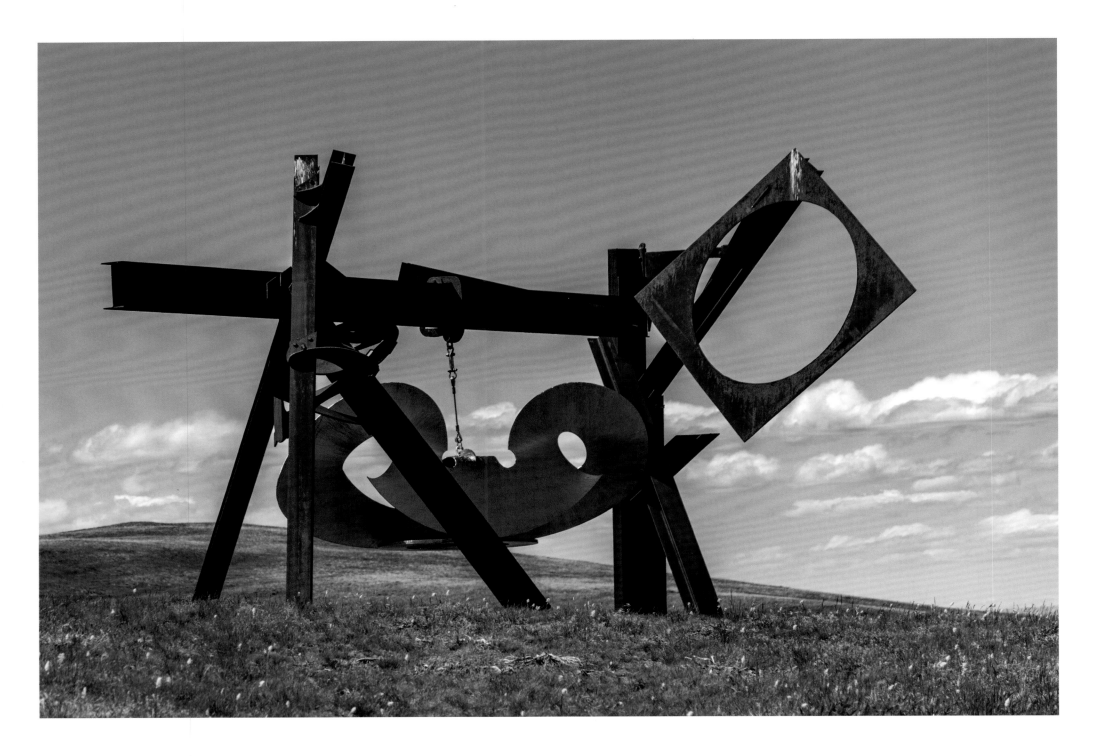

existence. It's like giving a party and saying, "Let's not invite Goethe. Let's ask Leibnitz." You might be missing certain necessary revelations.

The world exists not only in accepted numerology and equations but also in the nets and gears of seemingly lesser symbols. It is this crisis to which di Suvero's *Beethoven's Quartet* refers: the need for a cat's cradle, Schrödinger's cat, a Möbius strip, the almost romantic pairing of particles and notes in the heavy steel scaffolding we use to determine fate.

The sculpture is an iron version of a cat's cradle, a child's string webbing in which imaginary animals nest. Schrödinger's cat nests there as well, a cat who is only alive or dead when we open the box and observe it—it is our presence as an observer that creates the conditions under which life happens: when we stop looking, the world changes. When we close our eyes, the sun goes out.

Di Suvero hung a Möbius strip from the girders of *Beethoven's Quartet* because such a strip is a twisted piece of paper. This simple twist intermingles two dimensions, so that a pencil can draw on both sides of the paper without having to be lifted into the second dimension (height). That is, the pencil changes dimensions from the flat world into the second dimension of height and back to the flat world on the other side of the paper without ever having to enter the second dimension of height. The twist in the loop creates a "wormhole," or portal into a second dimension, as the twist of space in a three-dimensional universe creates a window into the higher dimension of time (the fourth dimension).

And so these simple analogies are in fact devices that measure the phenomena of space and time. Not all metaphors are logical. They are equally ironic, comic, kennings that "jump the life to come," to quote *Macbeth*.

We feel that it is from the hypotheses of geniuses, whether poetic or sculptural or mechanical, that society advances and that we should be expanding the party to include the poets left waiting at the gate in writer Franz Kafka's "Before the Law," the parable within his 1925 novel, *The Trial*. We should include the great sagas, the metaphysical explorations of playwright Tom Stoppard, artist James Turrell's cosmic alignments, architect Filippo Brunelleschi's projective geometries, the paradoxes of artists M. C. Escher and René Magritte. As cultural historian Lynn Gamwell writes in *Mathematics and Art: A Cultural History* (2016), philosophers Friedrich Nietzsche, Kurt Gödel, and Ludwig Wittgenstein depend as much on intuition and enigma as on theory. Theory is, in fact, a dry scientific version of the lusher cryptologies of writers and painters.

We ignore, at our peril, patterns in nature, mysterious alignments of parallel universes, science-fiction exchanges of distant energies, the impact of Romanticism on the Copenhagen interpretation of quantum mechanics, Russian twelve-tone serialism on modern symbolic logic. Without the analytic philosophy of poet T. S. Eliot, our vision of the world is reduced as much as if we lost mathematician Georg Cantor's arithmetic of infinite sums. Those infinite sums have been brought to light as much by artists Piet Mondrian and Giorgio de Chirico, from where they fan out to influence physicists Werner Heisenberg and computer scientist Alan Turing. Chaos and structure snowball over each other as do the varying masks of invention.

Revelations can exist in literature and sculpture as much as in theoretical physics. As Juliet says to Romeo,

> . . . that which we call a rose
> By any other name would smell as sweet.

Metaphors, bridges, leaps only become real when they begin to refer to everything all at once, when colors and sounds and words and images work together to fill in the blanks with familiar scents, when nature talks with our own voices, when science becomes a hymn and the world whirls around us like a word.

As our friend the pianist, poet, and painter Stephen Hough wrote, "To play at Tippet Rise is to be reminded that the earth was making music before human beings learned musical scales. The performer shares the stage's wings with singing birds; the soundproofing, like the roof, is only required to exclude a storm; and beyond the stage, through the skylit eye of a vast window, the landscape dances in more complex rhythms than could be imagined by even the most sophisticated artist."

We try over and over to prove what we only suspect. Poets write one poem over and over to bring the clues they dream into focus, to bring galaxies down into everyday life, and our range of sight up into galaxies. Every concert and every walk in the fields is just a new attempt at integrating our thoughts, at composing our own symphonies, at organizing the chaos of each day into comfortable cubbyholes, of transforming our lives into a chess game in which we understand all the moves and how we got to where we are and how to get where we are going.

At Tippet Rise we hope there already exists a sensory experience that pairs the geologic structure of large-scale sculptures with the cosmological origins of the landscape it emulates. There is a subliminal correlation between the harmonic relations of notes in a Bach fugue and the position of stars in our invented constellations. The way the stars seem so close in the vast night sky (although they are not) makes the sculptures correspondingly vaster (although they are not). Such optical and mental aberra-tions create an out-of-body atmosphere at Tippet Rise, which is remarked on by many of our performers and guests. There is a synergy between music that is tuned to the earth and the earth that has been shaped over millions of years by the sky.

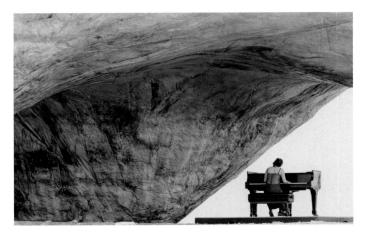

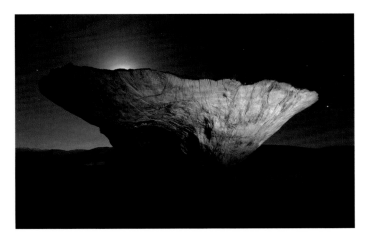

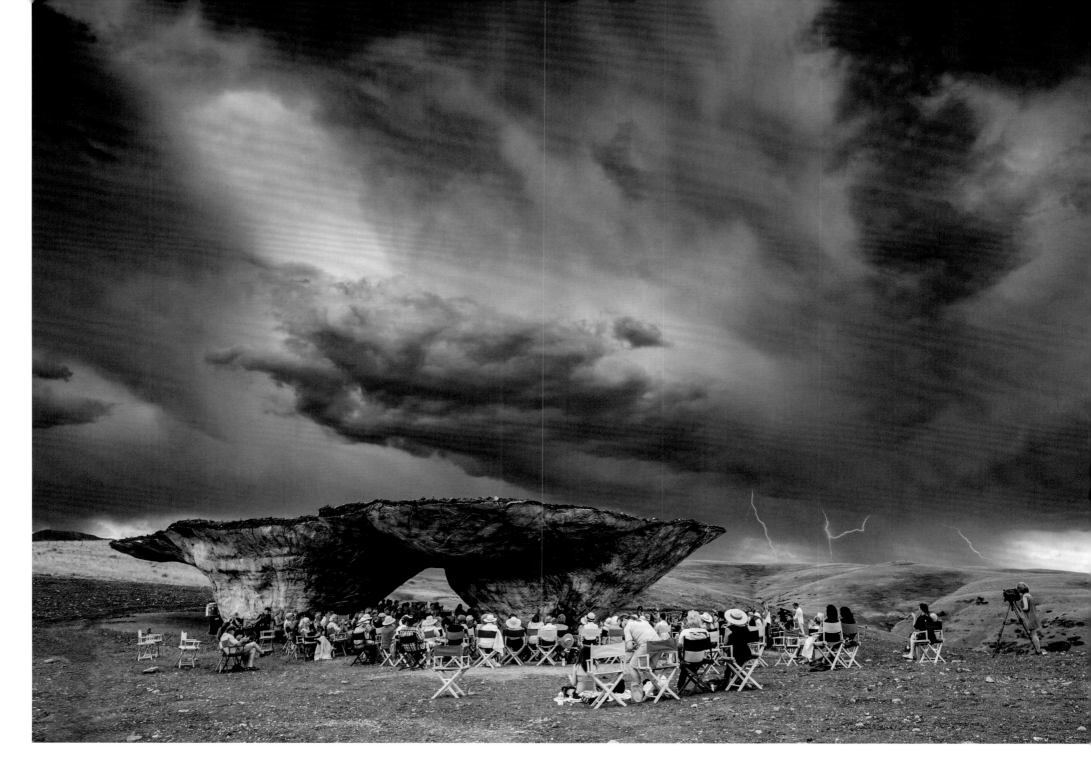

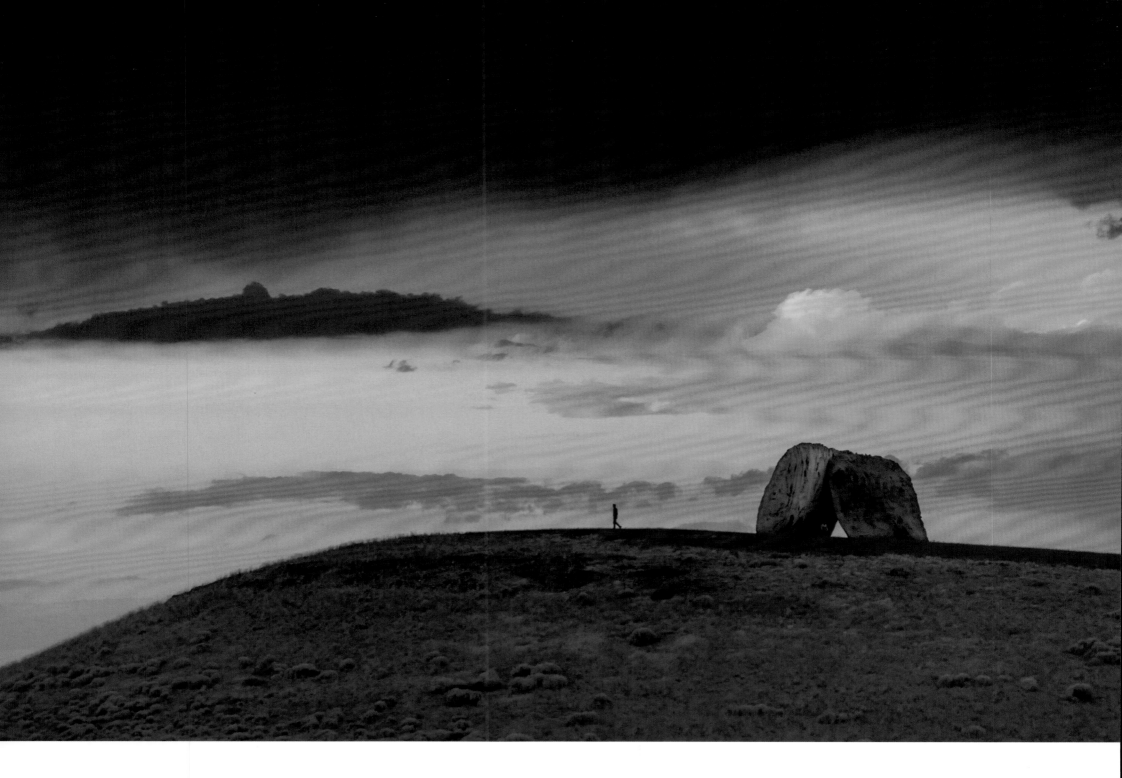

COSMOLOGY BROUGHT DOWN TO EARTH

There is land so surreal that it cries out for dialogue. Building on such land reduces it to an appendix of something human. It reduces it to a building site. But a sculpture leaves such land alone. It even apotheosizes it. It gives us a way of understanding its message, a window into its special infinity.

At Tippet Rise, the strange apocalyptic sunsets, the frightening storm cells—when clouds reach down to land like hands—the intense colors on treeless high prairies set the mind racing, the heart beating. We expect an alien touchdown, the appearance of a prophet, a time warp. We all have our own fantasies, which come out when we are disoriented by a landscape that seems otherworldly.

I myself feel both this alienation and an intense sense of connection lost (and found) in the enormous rolling seascapes of Stillwater and Carbon Counties of Montana, as if the sea, which roiled this area millions of years ago, were frozen into blades of grass instead of waves. I am reminded of wild spaces in Wales, Ireland, Scotland, Iceland. Blood fills with adrenalin, time slows down, and everything becomes suspiciously memorable. Add in the almost nuclear colors at the end of the day, which can last for hours, and you have all the conditions for revelation.

This unreal beauty is what draws people to the area. It seems clear to anyone who has witched a well that there is magic and magnetism in the air. (Witching is a medieval form of dowsing whereby a willow stick will point to a water source, as a Ouija board will suggest letters. It is mostly done by geologists who understand how the folds of land indicate underground streams or springs. It is decried by scientists, but every rancher knows that it works.) Minerals lie in rich veins close to the surface, which seems to make the land unusually magnetic. Storm cells produce rich ionic pockets of air. Such ionic concentrations can be exhilarating or depressing. They can make animals race around wildly. (Although rich in minerals, the land around Tippet Rise has never yielded productive oil, instead proving quite sludgy in these Cretaceous basins.) There are places where clocks stop and compass poles are reversed. We can explain these phenomena through science. But we'd rather make up a scary story.

This is maybe why Ensamble Studio was thinking about pharaohs, druids, the Pinnacles desert in Western Australia, Zion Canyon and Bryce Canyon National Park in Utah, and artifacts such as dolmens, Bories, and even the local Red Lodge palisades, unique giant spikes found nowhere else, driven up from the hellish core of the planet by the pressure of tectonic plates. After these landmasses morph into life, storms erode them into their current finlike shapes). Made from the limestone of the Beartooth plateau, where seismic pressure has caused formerly horizontal shale plates to bend into large upright fins, or bear's teeth, these "teeth" can be six hundred feet tall, resembling giant cairns or the spikes on a stegosaurus's tail.

Ensamble Studio made a dolmen, or prehistoric table-shaped altar (*domo* in Spanish), and two sets of standing stones, or steles. These ancient rocks are often venerated and carved with

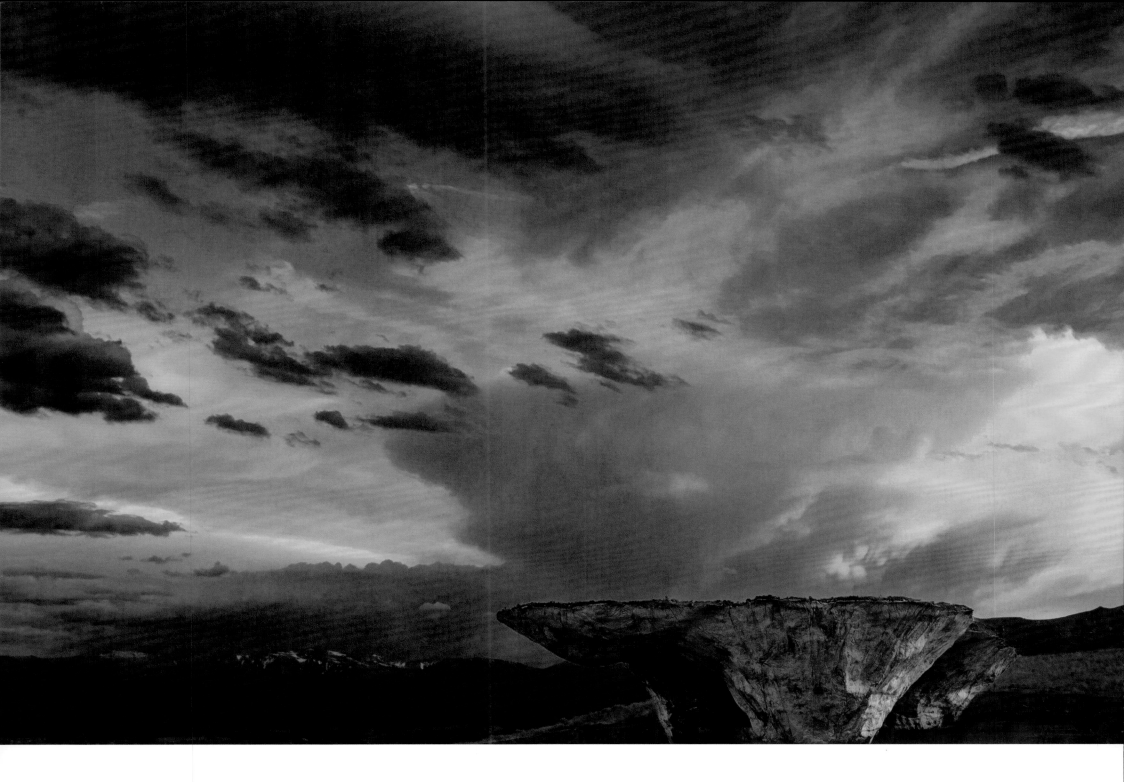

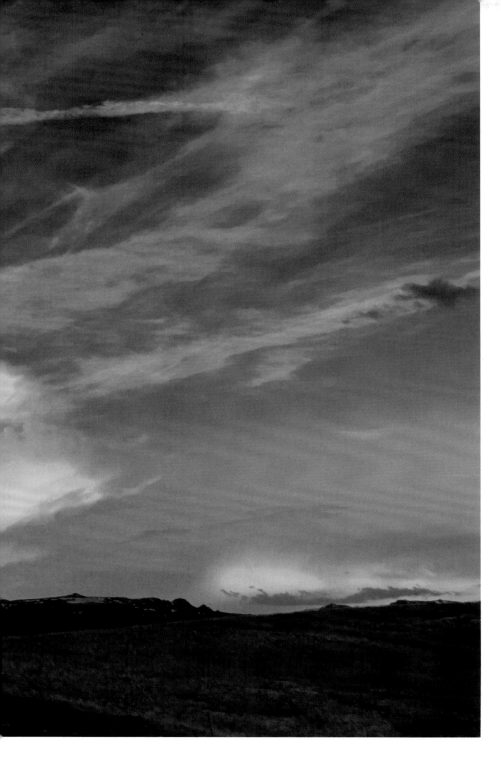

hieroglyphics, or mystic symbols of the afterlife, like obelisks, pyramids, the Washington Monument. Ensamble Studio's artifacts have mysterious striations resembling Mayan carvings, Persian cuneiform, codices, runic inscriptions, earth scratched by priests before there was language. These will, in time, be worn by weather into symbols further etched by space.

Ensamble Studio's structure *Domo* has already been the site of performances of metaphysical works by composers Alexander Scriabin and Olivier Messiaen, who each believed in the power of music to transfigure human consciousness. Scriabin's goal was the *Mysterium*, a weeklong celebration of music and other arts leading to an apocalypse. We feel ethereal links to a mystical conception of the cosmos on *Domo*'s high hill. (Henry Moore felt that his sculptures came alive outside, as he stated in several interviews he gave in 1951. See "Sculpture at Tippet Rise," pp. 158.) Ensamble Studio's *Portals*, Stonehenge-like menhirs, megaliths rising like two ears out of the ground from which they were made, are vertical recording environments for woodwinds and string instruments.

Given these cairns, it has made sense to perform the works of John Luther Adams outside near our sculptures. The title of his piece *Inuksuit* is a word that means "cairns" in Inuit, a language spoken in Alaska, as well as in Greenland, Siberia, and the arctic regions of Canada. Inuit is the language of the far North, of the Northern Lights. The Inuits think of a cairn as something that looks like a man but is not. As the audience wanders through the cairns of drummers, perspectives change. Our aural experiences become closer to what musicians themselves experience.

When the master cellist Matt Haimovitz played Bach, Adams, and Luna Pearl Woolf under *Domo* during the opening season of Tippet Rise, it was a pairing of living composers and their pentimentos, with the echoes of the land and sky. It drew up a window into the heavens, a bolt of lightning. A connection

opened between the earth and the sky, which is what music should do at its most basic. The three sculptures by Ensamble Studio, devised in 2015 and built in 2016, give music the excuse to echo the land. They provide the eidolon, the mandala, the visual personification of the transmigration of souls, which makes it easier for the mind to link the great symbolist achievements of poetry, surrealism, and alchemy, the transmutation of matter between forms that seems like witchcraft but is what happens with any poetic metaphor worth its salt.

There is a cosmic synergy that the sculptures create between architecture and music. Their relation to the land and to the vibrations created between the metaphysics of frequency, sight, and harmonics is one of their secrets.

There is a spookiness in suddenly coming upon a pillar made randomly of stones placed by passing hikers, looming up out of the fog (which frequently spirals around the land here, as the cold winds sweeping down from the Beartooth wilderness meet the hotter air below).

I saw *Inuksuit* performed three times last year, and it reminds me of the Palace of the Winds, the Hawa Mahal, near Jaipur, India (also home of the Taj Mahal). There, breezes wind in and out of windows called *jharokhas*, carved in a honeycomb of a sandstone wall. The cooler temperatures inside the palace lure winds in, a Venturi effect that is also exhibited by *Domo*, which creates its own weather as it pulls in ghost breezes that do not exist ten feet away from the structure.

Like many curious people, we try to put a name to experiences that seem unusual. If we can name them, we can tame them. Richard Wilbur has pointed out that a tiger does not seem at all scary once we have given it a name. But nameless, it is a myth and a monster.

Ensamble Studio calls its creations Structures of Landscape, since they aren't exactly buildings or residences but seem to arise from the earth itself. They are summoned into being by the landscape. Ensamble Studio designed thirty-four of these structures, of which we all agreed on three to be built for Tippet Rise.

Domo is a thing of shades and light, a chiaruscuro of barometric drops and weather shifts. Standing in one of its caverns is like visiting Plato's cave, where unexplained shadows that leap upon its walls are caused by a campfire inside it. Plato said they were shadows of the essences, of things outside the cave, as we ourselves are shadows of our larger personalities. At no single moment does anything we do describe our entire personhood. Our lives are a collage of individual events, like Marcel Duchamp's cubist painting, *Nude Descending a Staircase, No. 2* (1912).

It is the spring, the leap, between the shadow and its essence, between the fractal fragments of Duchamp's nude, that creates the possibility of metaphor. The earth and the sky must be linked through such symbols, in our minds, before metaphor is born. As the poet Archibald MacLeish wrote in "Thunderhead" (1951–52):

> Rock and loam must smoulder with desire
> Before the haycock of the heart is struck on fire.

We seek salvation in the distant reaches of mountains, in deserts, on cliff faces, in high waves. In the unreachable places, the inscrutable works of art, against the immensity of meanings, we stand a boulder up and face it to the stars. It is a cry for understanding: to understand, to be understood.

Lightning forms a connection between the magnetic earth and the static sky before its current becomes visible. We ourselves form similar connections with the earth and the sky, before the mind is struck on fire.

The land at Tippet Rise, from which springs the impulse, the cosmic pulse of lightning, makes the blood run fast.

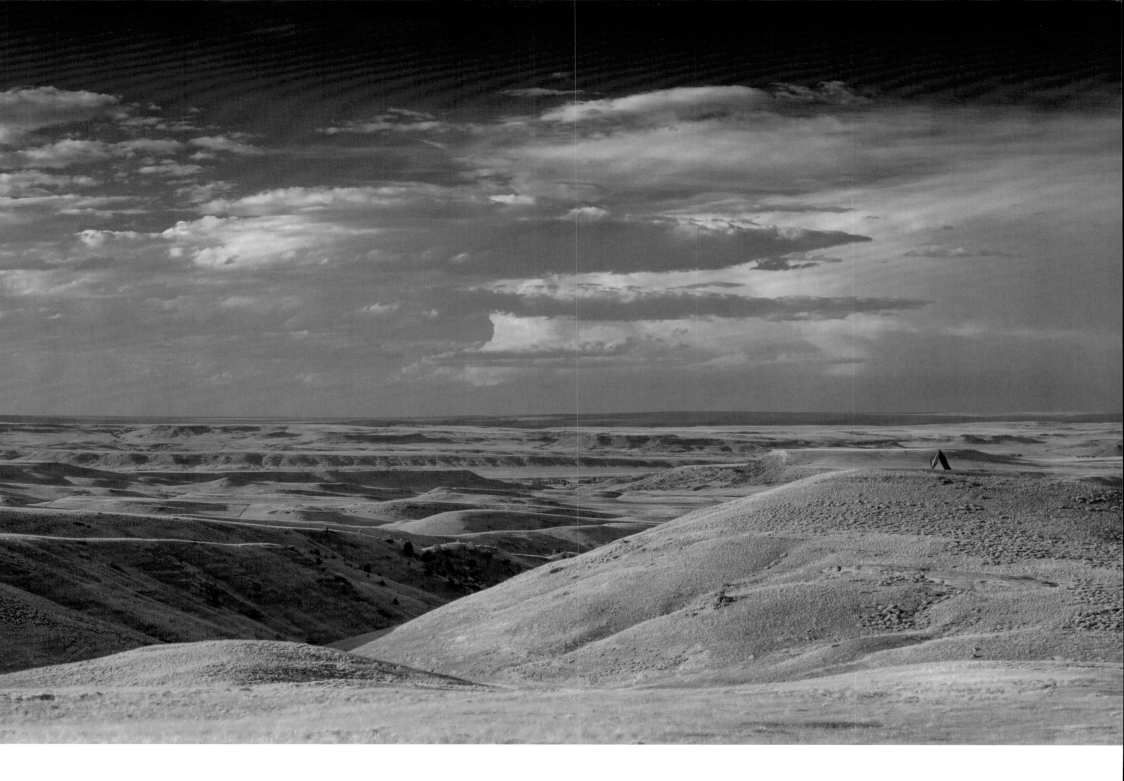

It quickens the human pulse, the electrical circuits that fire the mind like compositions by the electronic music composer Tristan Perich. It produces in us a form of human Fata Morgana, the destiny of Morgan le Fay (King Arthur's nemesis)—the music of Mozart's Queen of the Night from *The Magic Flute*, leaping impossibly across the coloratura range. This is the energy of the aurora borealis transferred to music, the waves of magnetic curtains of the Northern Lights changing colors as the solar storms change moods, our own fates reflected in the solar hurricanes that make the skies dance with nocturnal music.

Music inspired by stars, night, and the universe is something we think about in Montana every now and then. The piano is incantatory. Its chants summon sprites out of thin air—the air at eleven thousand feet pushed brutally down to the Olivier Barn by the ghosts of wind.

Music at Tippet Rise has an otherworldly, unearthly ambiance. There is a musical event, and then there is an extramusical event. Colored by the light, by the weather, silence, darkness, it is obvious to all of us. People come up to us all the time and mention getting shivers from such moments.

We have to try to define what moves us so strangely about such savage land under such an immense sky. We have to be affected by the enormity of what is beneath us and what is above us. In these preternatural settings, some primal chord is struck inside us.

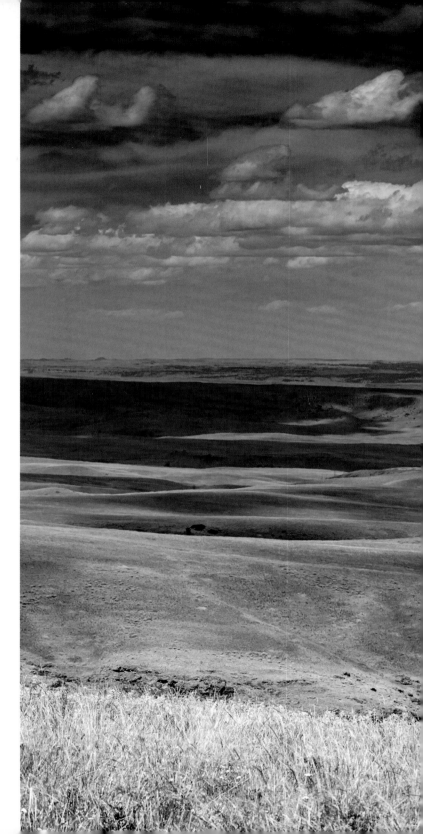

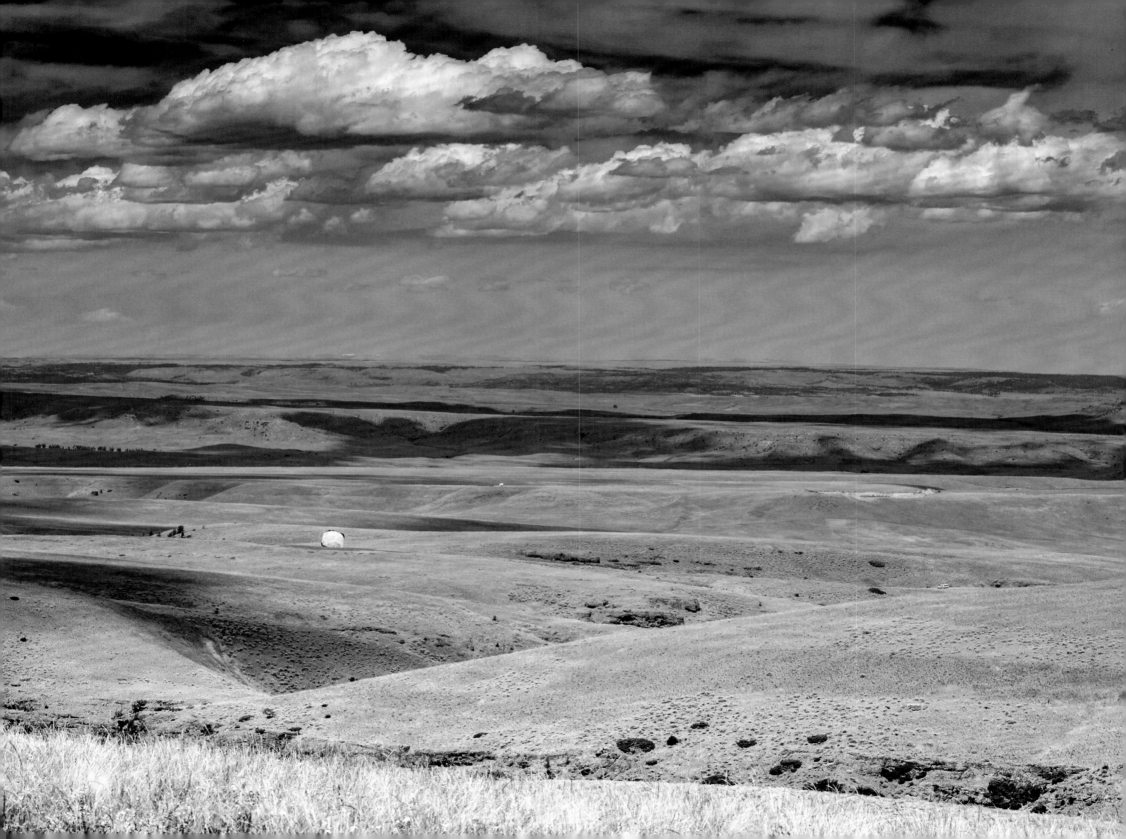

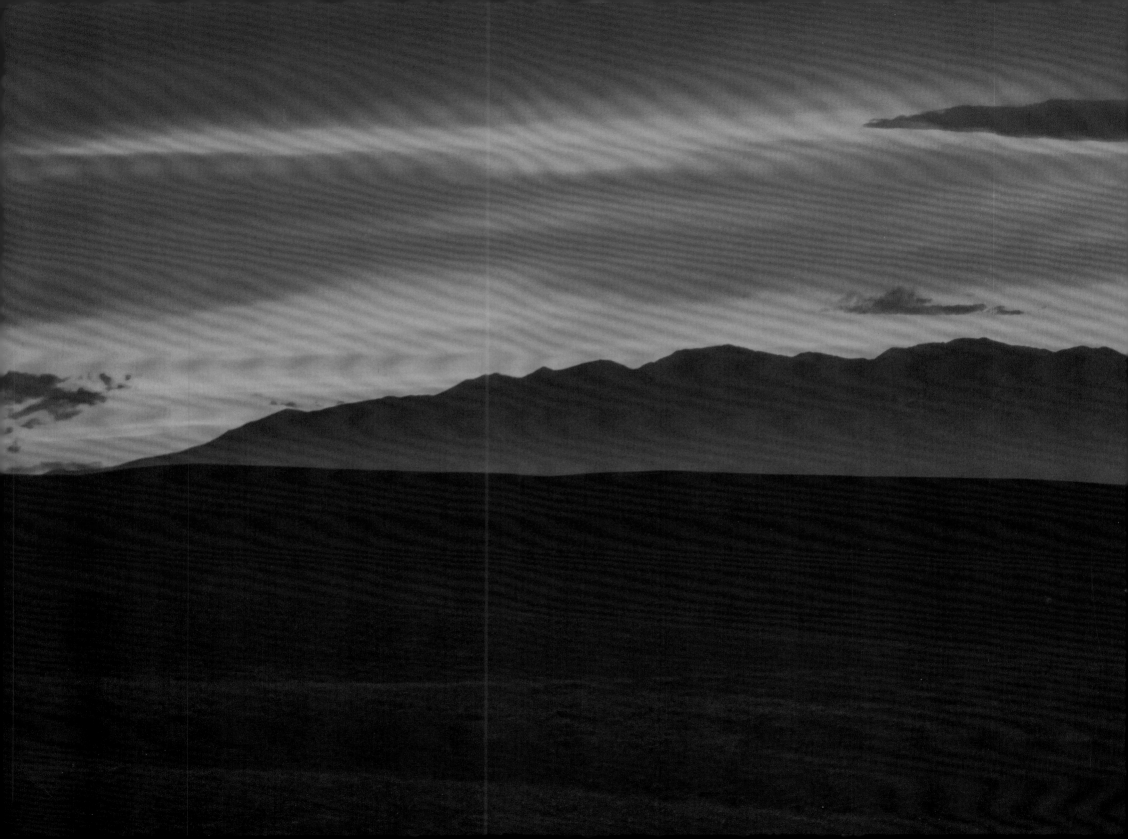

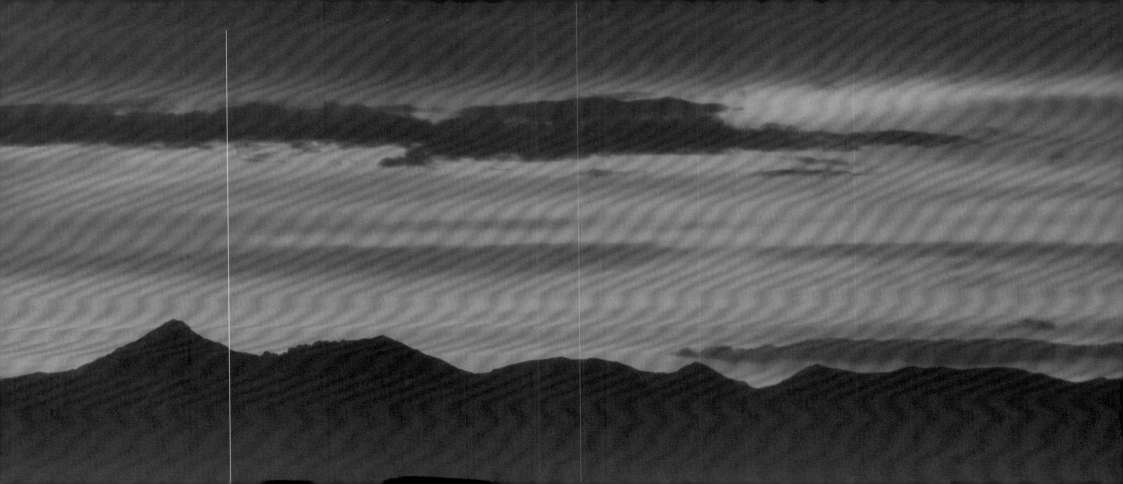

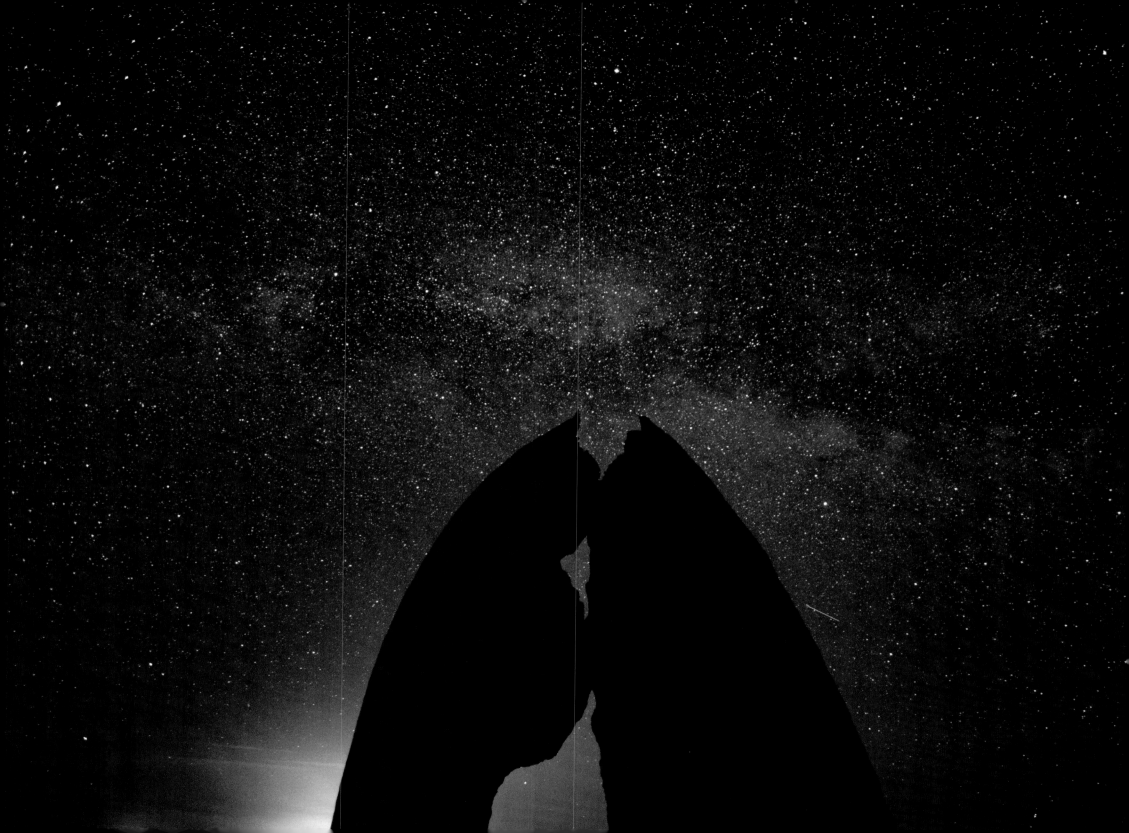

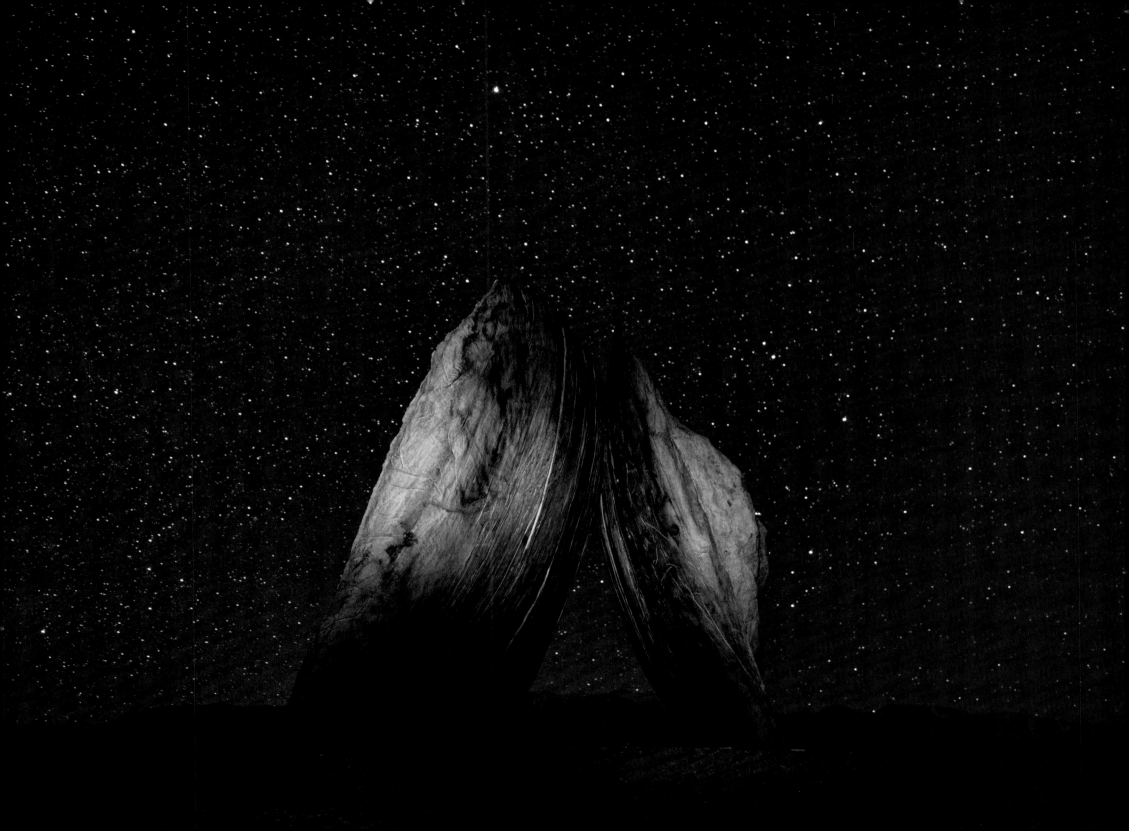

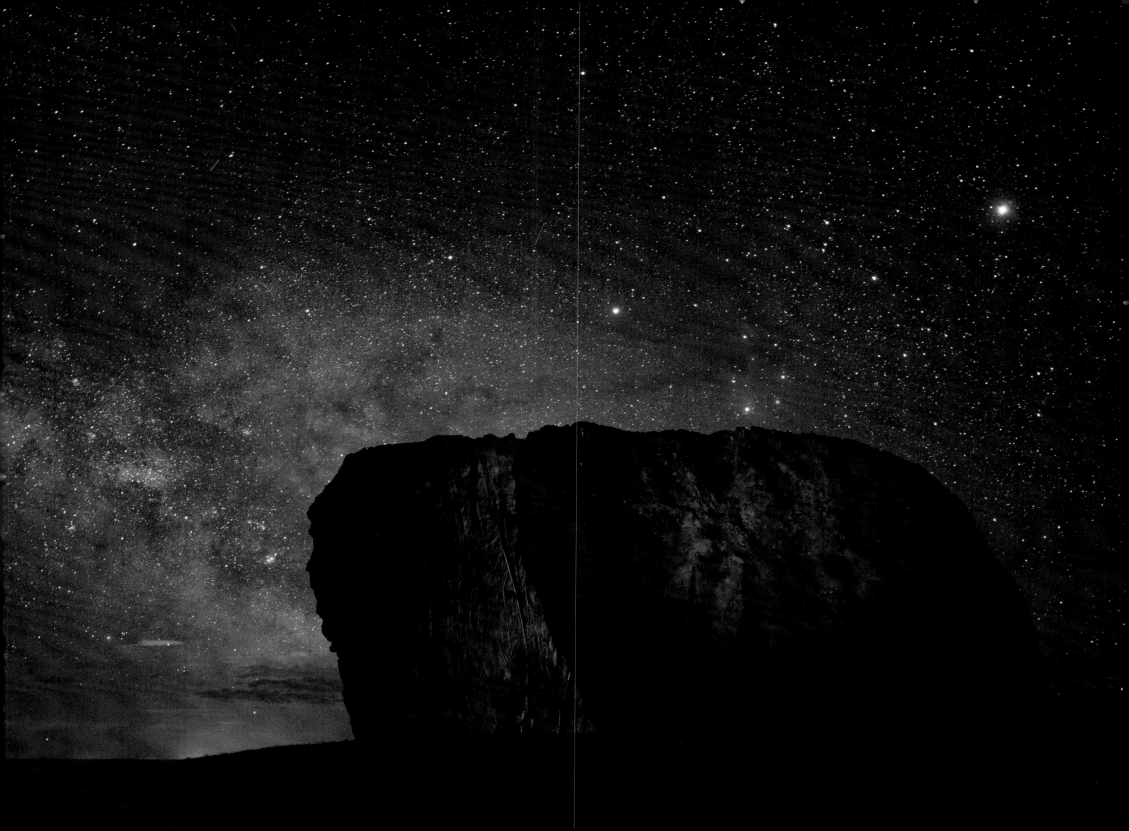

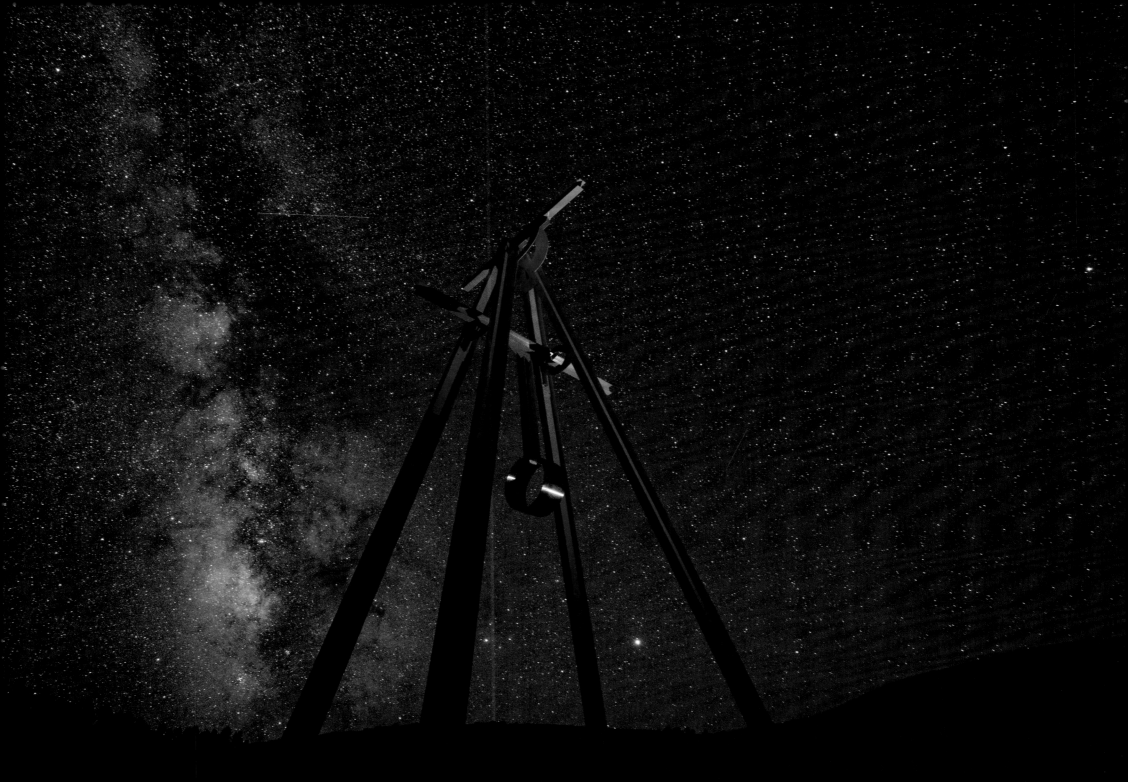

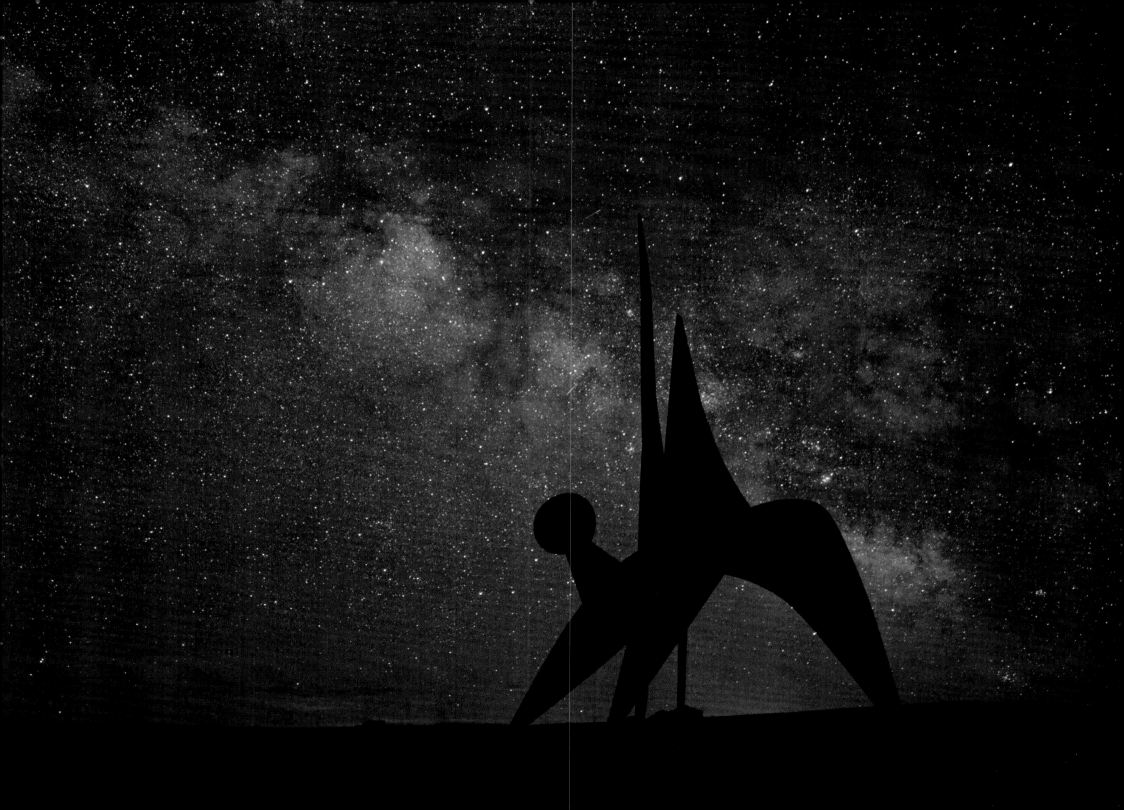

Tippet Rise Site Map

Tippet Rise Art Center is located in Fishtail, Montana, off of Highway 78, between Billings and Bozeman and at the north end of the Greater Yellowstone Ecosystem (some eighteen million acres around the immense caldera of the park). It is buffered on the south and west by the Beartooth and Absaroka Mountains, rising to the highest summits in Montana and encompassing roughly a million-acre roadless wilderness. To the west is the Custer-Gallatin National Forest, anchored by the northwestern terminus of the Absaroka Mountains. Southeast of Tippet Rise is Red Lodge, a small ski and mountain town at the lesser-known fifth entrance of Yellowstone National Park.

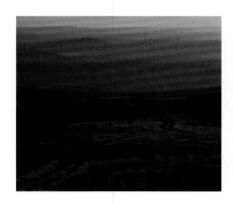
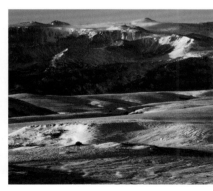
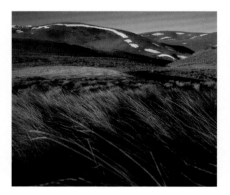
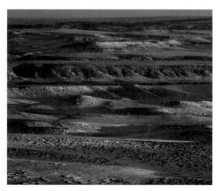

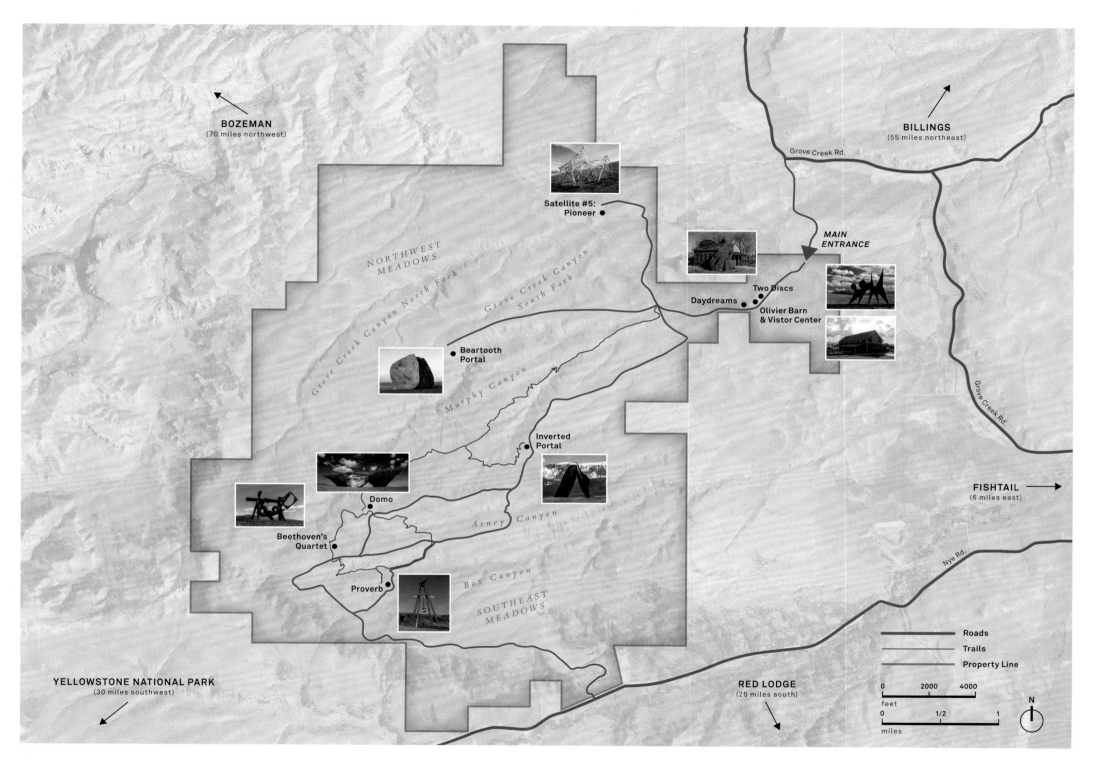

BOZEMAN
(70 miles northwest)

BILLINGS
(55 miles northeast)

Grove Creek Rd.

Satellite #5:
Pioneer

MAIN
ENTRANCE

NORTHWEST
MEADOWS

Grove Creek Canyon North Fork

Grove Creek Canyon South Fork

Two Discs

Daydreams

Olivier Barn
& Vistor Center

Beartooth
Portal

Murphy Canyon

Grove Creek Rd

Inverted
Portal

FISHTAIL
(6 miles east)

Domo

Arney Canyon

Beethoven's
Quartet

Nye Rd.

Proverb

Box Canyon

SOUTHEAST
MEADOWS

YELLOWSTONE NATIONAL PARK
(30 miles southwest)

RED LODGE
(25 miles south)

Roads

Trails

Property Line

0 2000 4000
feet

0 1/2 1
miles

N

Acknowledgments

We would like to thank our friends, the sculptors and musicians, videographers and photographers who make Tippet Rise what it is every day. Art only happens when you see it or hear it. It's different every day. Each piece, whether a sculpture or a sonata, changes daily with the light and the time.

But there are also all the people who support the artists—their spouses, their children, their teams. Elsa Hoffman, who directs Patrick Dougherty's studio, and Patrick's wonderful wife, Linda, and son, Sam, and Sam's friend Eric Schopler, spreading out like branches around Patrick's stick works. Stephen Talasnik's lovely wife, Nadine, and their son, Liam, who anchor Stephen's home life. Our warm friend Ivana Mestrovic, poet, artist, and régisseuse, who, along with Matteo Martignoni, Chris Yockey, Dan Roberts, and Sean Paul Loentz—all of them talented beyond belief—helps Mark di Suvero. The Ensamble Studio team, led by Antón García-Abril and Débora Mesa, with Javier Cuesta, Ricardo Sanz, and Artemio Fochs, artists all. And, of course, Antón's parents, the great composer and gentleman Antón García Abril senior and his wife, muse, and publisher, our dearly departed Aurea Ruiz.

We couldn't get through a single day without our wonderful stewards at Tippet Rise, Pete and Lindsey Hinmon, who accomplish everything, and their talented and charming team members, Melissa Moore, Beth Huhtala, and Lexy Adams. Craig and Jeanne White, who handle all things publishing and programmatic, as well as marshal artists and managers. Our courtly and omniscient artistic advisor, Charlie Hamlen. Our consummate piano technician, Mike Toia, who keeps our fifteen Steinways in battle condition throughout the year. Our ranch manager, Ben Wynthein, and his charming family members, Cristi, Elaina, Gretchen, William, Audrey, and Geneva. Our friend and interior designer Cindy Waters, who has planned with great spirit every piece of furniture in the many locations of Tippet Rise with us over the years. Our consigliere in Montana, Renée Coppock, her beautiful daughter, Cierra, and her husband and soccer dad, Dave. The very genial Dan Luttschwager. Our resourceful human resources advisor, Bruce Fain.

Our resident architect and craftsman, Laura Viklund, and her husband, Chris Gunn, who have designed and built almost everything at Tippet Rise. Our general contractor, Jeff Engel. Our perspicacious landscape architects at OvS, Lisa Delplace and Liz Stetson.

The many members of our brilliant team at Arup in New York City: Raj Patel (now an Arup Fellow), Willem Boning, Joe Digerness, Brian Markham, Matt Jackson, Shaina Saporta, and the many others who have helped us during our long association with the engineering firm.

The one hundred local contractors and workers who worked long hours over two years to create the infrastructure of Tippet Rise.

Our brilliant acoustician and first center director, Alban Bassuet, and our first music director, Christopher O'Riley.

Our audio-video team, the sublime Mickey Houlihan, the energetic Kathy Kasic, the legendary engineer Richard King, and their staff.

Our experienced and dynamic team from Wildflower Kitchen, Nick Goldman, Wendi Reed, and the inimitable Benji Goldman, who have been feeding hundreds of guests and workers at Tippet Rise every day for years, and who have only become more enthusiastic and protean in their diversity of dishes.

The witty and dynamic team of Melissa Chiu and Trinh Doan of the Hirshhorn Museum and Sculpture Garden, and the eminent and learned David J. Skorton, the thirteenth Secretary of the

Smithsonian Institution, who have graciously loaned us two spectacular Alexander Calder pieces.

Melissa Berman, Amy Holmes, Jennifer Kong, Berit Ashla, Joanne Schneider, Donzelina Barroso, Sueli Shaw, and Theresa Boylan of Rockefeller Philanthropy Advisors, who have shepherded Tippet Rise into existence and guided this book to print, along with the staff at Princeton Architectural Press—namely, Jennifer Lippert, Abby Bussel, Linda Lee, and Paul Wagner.

And our community chips in. We couldn't do this without our many repeat summer volunteers, many of whom are neighbors.

We'd also like to thank our extended community in Red Lodge, Nye, Dean, Fishtail, Absaroka, Columbus, and Billings; the Billings Symphony Orchestra & Chorale and their Yellowstone Chamber Players, with whom we partner in many ways; Robyn Peterson and Bob Durden of the Yellowstone Art Museum in Billings, our collaborators on the Isabelle Johnson book *A Lonely Business*; the Nye Community Foundation and the Red Lodge Area Community Foundation; our wonderful schools and their teachers; the Carbon County Arts Guild; the Stillwater Protective Association; the Northern Plains Resource Council; everyone at our wonderful Fishtail General Store, which is all things to all people; all of our friends at Montana State University and the University of Montana, Missoula; the ebullient Kevin O'Dwyer of Blackfoot Pathways: Sculpture in the Wild International Sculpture Park; and our wonderful governor, Steve Bullock, and his wife, Lisa, whose efforts to bring education and art to Montana resonate within every one of us.

About the Authors

Peter Halstead is a pianist who studied with Russell Sherman in Boston and Irma Wolpe in New York City. As an organist, he trained with Charles Courboin at St. Patrick's Cathedral in New York City. He is also a nature poet. Three of his volumes of poetry are available: *Sea Sun* (2003), *Blinds* (2009), and *Poems of Earth* (2017). Two albums, *Pianist Lost: Excesses and Excuses* (2010) and *Pianist Lost: Sunken Cathedrals* (2013), featuring piano pieces in D Flat and pieces about water, are available from Albany Records. He and Mark di Suvero collaborated on a chapbook of drawings and poems entitled *Fluorescence* (2016).

Peter's great aunt, Welthy Fisher, founded World Education in 1951 and built "literacy villages" in the Indian cities of Lucknow, Kolkata (Calcutta), Chennai (Madras), and Allahabad. Her vision has helped more than half a million families in over fifty Asian countries achieve a better quality of life.

Cathy Halstead is an abstract painter who has shown at galleries in Los Angeles, Chicago, New York City, Berlin, and Haifa, Israel. Her mother, Tippet, loved art and collected it in the 1950s and '60s in New England and while living on the French Riviera. She and her husband, Sidney Frank, helped popularize the Israeli artist Yaacov Agam, introducing him to family member, and publisher, Walter Annenberg, who subsequently collected his work, as did former French president Valéry Giscard d'Estaing. Sidney later manufactured Agam's kinetic paintings, called Agamograms. Agam has a gallery dedicated to his work at the Centre Georges Pompidou in Paris. Tippet also collected sculptures by Henry Moore and Alexander Calder.

Cathy's father established the Sidney E. Frank Endowed Scholarship Fund at Brown University in 2004, which has provided a college education for over three hundred and fifty students to date.

Peter and Cathy are trustees of the Sidney E. Frank Foundation, which funds some ninety projects annually in the United States and England. They are also the trustees of the Tippet Rise Foundation, and trustees of the Adrian Brinkerhoff Foundation. Peter and Cathy cofounded the Digital Scholarship Lab at Brown.

They have two wonderful daughters, Liza and Jenny, and two adorable grandchildren, Tia and Olivier.

tippetrise.org
adrianbrinkerhofffoundation.org

About the Artists

PATRICK DOUGHERTY

www.stickwork.net

Patrick Dougherty grew up in North Carolina, where he roamed the woods as a child. In the early 1980s, he combined his carpentry skills with a love of nature and began to build sculptures using tree saplings as construction material. His work quickly evolved from single pieces on conventional pedestals to monumental-scale environmental works that required saplings by the truckload. He has built more than 280 of these massive works in countries all over the world, including Scotland, Japan, Australia, and in many locations in the United States. He lives near Chapel Hill, North Carolina, with his wife, Linda.

STEPHEN TALASNIK

www.stephentalasnik.com

Originally from Philadelphia, Stephen Talasnik attended the Rhode Island School of Design and did his graduate work at Temple University's Tyler School of Art program in Rome. In addition to living in Tokyo for three years, he traveled throughout the Far East, including Thailand, Korea, and the Philippines, for fifteen years, studying the engineering of houses, boats, irrigation systems, bridges, and water towers built by hand. He has also spent time living and working in Berlin, Amsterdam, Vienna, and Dublin. His works in drawing, sculpture, and installation are in numerous public collections, including at the Albertina, Vienna; the Centre Georges Pompidou, Paris; the British Museum, London; the National Gallery of Art, Washington, DC; and the Metropolitan Museum of Art, New York City.

ENSAMBLE STUDIO

www.ensamble.info

Antón García-Abril and Débora Mesa are architects and principals of Ensamble Studio, a cross-functional firm established in 2000, currently based in Madrid and Boston. Balancing education, research, and practice, the office experiments with new lines of approach to architecture that lead to ingenious spaces, structures, programs, and technologies, diluting unproductive boundaries between disciplines. Their work has been extensively published in both printed and digital media, exhibited worldwide, and awarded international prizes. In addition to their professional careers, García-Abril and Mesa maintain active research and academic agendas: in 2012 they founded POPlab (Prototypes of Prefabrication Laboratory) at the Massachusetts Institute of Technology to advance their investigations.

MARK DI SUVERO

www.spacetimecc.com

Internationally renowned sculptor Mark di Suvero was born in Shanghai in 1933. A pioneer in the use of steel, he has exhibited his public sculpture worldwide. Di Suvero is a lifelong activist for peace and social justice. In 1986 he established Socrates Sculpture Park at the site of a former landfill on the East River in New York City. Through his leadership, a four-and-a-half-acre parcel was transformed into a public art park that has hosted the work of more than twelve hundred artists. In 2010 di Suvero was a recipient of the National Medal of the Arts.

ALEXANDER CALDER

Alexander Calder, whose illustrious career spanned much of the twentieth century, is one of the most acclaimed and influential sculptors of our time. Born to a family of celebrated, though more classically trained, artists, Calder utilized his innovative genius to profoundly change the course of modern art. In the 1920s, he began by developing a new method of sculpting: by bending and twisting wire, he essentially "drew" three-dimensional figures in space. He is renowned for the invention of the mobile, whose suspended, abstract elements move and balance in changing harmony. From the 1950s onward, Calder devoted himself to making outdoor sculpture on a grand scale from bolted sheet steel. Today, these stately titans grace public plazas in cities throughout the world.

Image Credits

Artists Rights Society (ARS)

Two Discs by Alexander Calder @ 2017 Calder Foundation, New York / Artists Rights Society (ARS), New York.
Photographs: Pages 25, 164, 168–69, 172, 188–89, 215

Iwan Baan

www.iwan.com

After his studies at the Royal Academy of Art, The Hague, Iwan Baan followed his interest in documentary photography before narrowing his focus to recording the various ways in which individuals, communities, and societies create and interact within their built environment. Baan's method gives matters of architecture an approachable and accessible voice.
Photographs: Pages 170 (center), 176 (top), 177, 178 (top and center), 179–80, 181 (top), 183, 184 (top), 190, 198 (top), 217 (*Beartooth Portal, Satellite #5: Pioneer*)

André Costantini

www.andrecostantini.com
www.sillydancing.com

André Costantini is a photographer and filmmaker who works with artists and humanitarian organizations worldwide.
Photographs: Pages 181 (center), 182 (center and bottom), 185–86, 196, 211–15, 217 (*Beethoven's Quartet, Inverted Portal*)

Peter Halstead

Photographs: Pages 156, 159, 166, 189, 217 (*Two Discs*)

Paul Johnson

www.pauljphoto.com

Paul Johnson is a Minneapolis-based photographer, graphic designer, and artist creating work at confluence of art and the processes and cycles of the natural world.
Photographs: Pages 182 (top), 184 (bottom), 198 (bottom)

Kevin Kinzley

www.kinzleyphotography.com

Kevin Kinzley resides in Red Lodge, Montana, where he is co-owner and photographer for Kinzley Photography Fine Art Gallery and Studio. Apart from his fine artwork capturing landscapes and nature, Kinzley's experience includes photojournalism, freelance commercial work, and archival reproduction.
Photographs: Pages 168–69, 170 (bottom)

OEHME, VAN SWEDEN | OvS

Base image courtesy of the U.S. Department of Agriculture Farm Services Agency Aerial Photography Field Office.
Map: Page 217

Erik Petersen

www.erikpetersenphoto.com

Erik Petersen has been photographing life in Montana and around the world for nearly two decades.
Photographs: Pages 1, 6, 10–17, 19–23, 25–45, 47–61, 63-115, 117–55, 161–62, 170 (top), 172, 176 (bottom), 178 (bottom), 181 (bottom), 184 (center), 187–88, 193–95, 216–17 (*Daydreams, Domo*, Olivier Barn, *Proverb*)

Yevgeny Sudbin

www.yevgenysudbin.com

Yevgeny Sudbin has been hailed by the *Telegraph* as "potentially one of the greatest pianists of the twenty-first century" and in 2016 was nominated for Gramophone Artist of the Year. He performs regularly in many of the world's finest concert series and has worked with some of the best orchestras and conductors from across the globe. In his spare time, he is a photographer.
Photographs: Pages 2–5, 198 (center), 199–200, 202–4, 206–9

Rowene Weems

Rowene Weems lives in Powell, Wyoming, where she is the director/curator of the Homesteader Museum. With a BA in fine arts from Kenyon College, she has been exhibiting her photography for more than thirty years, receiving awards and recognition throughout her career.
Photographs: Pages 164, 171, 174–75

List of Poems

by Peter Halstead

PUBLISHED BY
Princeton Architectural Press
A McEvoy Group company
202 Warren Street, Hudson, New York 12534
Visit our website at www.papress.com

Princeton Architectural Press is a leading publisher in architecture, design, photography, landscape, and visual culture. We create fine books and stationery of unsurpassed quality and production values. With more than one thousand titles published, we find design everywhere and in the most unlikely places.

EDITOR: Linda Lee
DESIGNER: Paul Wagner

Special thanks to: Ryan Alcazar, Janet Behning, Nolan Boomer, Abby Bussel, Benjamin English, Jan Cigliano Hartman, Susan Hershberg, Kristen Hewitt, Lia Hunt, Valerie Kamen, Jennifer Lippert, Sara McKay, Eliana Miller, Nina Pick, Wes Seeley, Rob Shaeffer, Marisa Tesoro, and Joseph Weston of Princeton Architectural Press
—Kevin C. Lippert, publisher

LIBRARY OF CONGRESS CATALOGING-IN-PUBLICATION DATA
Names: Halstead, Peter (Pianist), author. | Halstead, Cathy, author.
Title: Tippet Rise Art Center / Peter and Cathy Halstead.
Description: First edition. | Hudson, New York : Princeton Architectural Press, 2018.
Identifiers: LCCN 2017039512 | ISBN 9781616896492 (alk. paper)
Subjects: LCSH: Tippet Rise Art Center. | Arts facilities—Montana—Fishtail. | Fishtail (Mont.)—Buildings, structures, etc.
Classification: LCC NX805.F57 H35 2018 | DDC 711/.57—dc23
LC record available at https://lccn.loc.gov/2017039512